The language of heraldry is basically as artificial as that of mathematics, and for the same reason—the need for precision. Indeed, the language can be so precise that heralds who have never compared notes will inevitably come up with the same reading for the same arms. Heraldic rules exist to avoid confusion, and since any consideration of symbolism is found to involve heraldry, it is best to keep the simpler ground rules in mind.

The single word "arms" applies to the shield alone. The word "crest" applies only to some form of symbol designed to be mounted on top of the helmet, either springing from a wreath or a coronet. Crests were designed for purposes of recognition, since the features of a man in armor were simply not visible. Other forms of headgear appropriate to the nonmilitary professions are placed above the shield as something by which the shield is "ensigned." Thus, the arms of the Diocese of London is a red shield with two gold swords crossed in X-fashion, points upward, and the whole is "ensigned" with a mitre.

Positions in the arms are determined by fixed rules. The left-hand side of the shield as one looks at it is described as *dexter,* the Latin word for "right," since that side of the shield is on the shield's own right. The right-hand side of the shield as one faces it is called *sinister,* the Latin word for "left."

If the shield is divided in half horizontally, it is said to be divided "per fess" (FIG. 78); if vertically, it is "per pale" (FIG. 79); if from upper left to lower right, it is "per bend" (FIG. 80); if from lower left to upper right, it is "per bend sinister." If divided by a reverse-topped V, it is "per chevron" (FIG. 81); if divided X-fashioned, "per saltire" (FIG. 82); if in quarters, "quarterly" (FIG. 83).

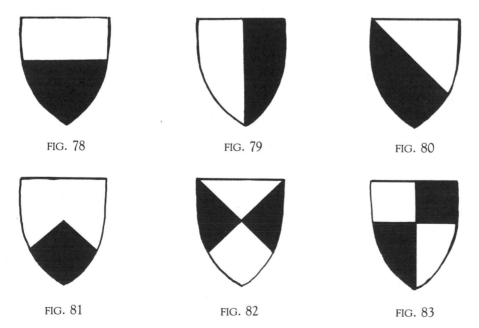

FIG. 78 FIG. 79 FIG. 80

FIG. 81 FIG. 82 FIG. 83

The lines of division (FIG. 84) need not be straight. They may be "wavy" or "nebully" (like a series of interlocking pieces), "indented" (like the teeth of a saw), "dancetty" (like broad-spread W's), "embattled" (like the crenellations on a castle), or "potenty" (like a continuous series of rectangular dovetails). These may be added to the multiplication of simpler forms; so "fess dancetty" means that the central third of the shield moves from dexter to sinister as a seemingly continuous series of W's.

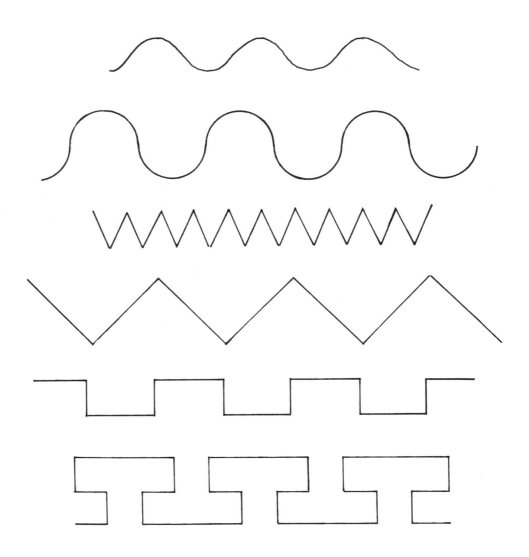

FIG. 84

The "pale" is a vertical central division of the shield. A shield "paly" means that there will be a number of pales of equal width, creating a vertical striped effect. There will generally be six pales, but whatever the number, it will always be even.

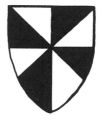

FIG. 85

The combination of "quarterly" and "per saltire" produces the "girony of eight pieces" (FIG. 85), a famous instance of which is the arms of the Campbells with the colors gold and black.

The "tinctures" are the colors used in heraldry, and correct usage of the technical language is essential, since most classic heraldic definitions are devoid of punctuation. The metals are "or and argent." "Or" always means the metal gold and never "a possible substitute," while "argent" means silver but, save in continental heraldry, is always reproduced as white. The standard colors are "azure" (blue), "gules" (red), "vert" (green), "purpure" (purple), and "sable" (black). The safest rule (with several notable exceptions) is that no metal should go on a metal, or color on color.

The various heraldic furs are indicated by different combinations of colors and metals. "Ermine" means black spots on white. "Ermines" means white spots on black. "Erminois" means black spots on gold, and "pean" means gold spots on black. The regular handling of skins and tails is covered by variations on the word *vair*.

If, instead of assigned heraldic colors, an object or figure is shown in natural color, it is described as "proper." The abbreviations for all the metals and colors are sufficiently clear provided one remembers that there are no abbreviations for the furs, and the accurate one for "proper" is "ppr."

The "chief" is basically the top third of the shield. The description of the "chief" always follows that of the rest of the shield.

An "inescutcheon" is a small shield placed in the center of the arms that indicates some augmentation or recognition of an allied family.

A "canton" is a rectangle in the upper left ("dexter chief"); it must always occupy less than one quarter of the whole shield.

The "fess point" is the exact center of the shield; the "honor point" is halfway between the fess point and the top of the shield.

The phrase "coat of arms" dates from the thirteenth-century word *surcoat*, describing a protective garment that was worn over the armor both to diminish the heat and to guard as much as possible against rust. Again, for purposes of recognition, large representations of the person's arms covered the whole surcoat, one set at the front and another at back.

A shorter version of this was a "tabard," which not only had the arms on

front and back but also on the shoulders. Tabards still exist in the formal habits worn by the heralds of the College of Arms.

Without question, heraldry is not only one of the most complicated of all fields of symbols and decoration, but also one of the most popular. This is not the place to discuss the thousands of details heralds love to argue, such as who does or does not have the right to bear arms. Let it suffice here to note the incredible wealth of material available in this field and listed in the bibliography of this book.

FIVE

Symbols Drawn from the Imagination

THE HEBREW MIND is basically not a graphic mind. In common with most literate minds, the Hebrew mind thinks verbally, creating pictures with words, and what it pictures is often true. The word *cherubim* in Hebrew means "otherworldly monsters"—probably envisioned as being about as tall as the Empire State Building. These otherworldly creatures, totally at the command of God, were part of another order of existence about which we do not think at all.

Or consider the *seraphim.* The Hebrew word means something along the lines of "gods and lightning storms." When the seraphim call to one another—the *qadosh* in Isaiah's inaugural vision in the sixth chapter—the call means, "Holy, holy, holy is the Lord of Hosts." The seraphim are not gentle. The verbal description of these beings includes many wings; some cover the feet, some cover the body, some cover the head. There is no visible form of a figure whatsoever, only a cloud formation that "reads" as wings. This is a colossal, powerful symbolic representation.

But although the Jews were aware of enormous great creatures, they were always at a loss as to how to portray them. Nobody knows what the Ark of the Covenant looked like, but the most learned Hebrew drawings suggest colossal, otherworldly monster figures at either end with a peculiar structure in between them known as the "Mercy Seat." This structure, the Ark, contained the Ten Commandments and other relics.

Other, non-Hebrew cultures have been better able to portray mythological animals, the most attractive and familiar of which is the unicorn. The unicorn

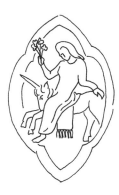

FIG. 86

has a long history of pre-Christian associations. For the Egyptians and the Persians, it was the symbol of purity and strength. Their legend of the unicorn is a fascinating piece of imaginative theology. The unicorn—wild, powerful, and fierce by nature—could only be tamed by a spotless virgin. This legend was later used to convey the Church's understanding of the Incarnation. FIG. 86 shows the Blessed Virgin seated upon a unicorn, and the whole is a symbol of chastity. The more modern version (FIG. 87) is one of the endlessly attractive forms made popular through heraldry.

The unicorn, a symbol of our Lord, has inspired elegantly beautiful art, the Unicorn Tapestries at the Cloisters being just one of many examples. The unicorn (FIG. 88), the *reem* in Hebrew, is a powerful creature, literally "a roaring animal" but always good and always a symbol of purity.*

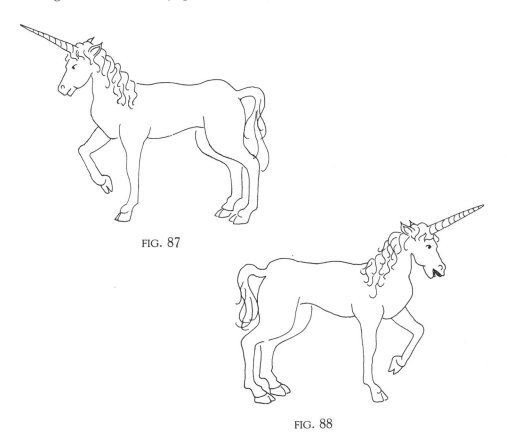

FIG. 87

FIG. 88

*It is interesting to note that a rhinoceros also has the speed of a horse, a great horn on its forehead, and highly developed ears. The same description, minus the rhino's tonnage, fits the unicorn perfectly.

Symbolic creatures offer us some curious inconsistencies. The "Lion of the tribe of Judah" is one of Israel's most distinguished symbols, but as a predator the lion is a forbidden food. Eventually, the forbidden beast died out in Palestine, and Israel was left with a natural symbol they were no longer familiar with as part of their religious life. As a result, their understanding of what a lion was became increasingly fantastical. If you describe a cow to a New York City child who has never seen one and then ask the child to draw the cow, the result is likely to be a fantastical, otherworldly creature.

Something similar happened when the serpent, a forbidden—hence, unfamiliar—beast, was incorporated into religious symbolism. The devil himself appeared in the form of a serpent who was, Scripture informs us, "wiser than any other beast that the Lord God had made." The power attributed being enormous, the natural serpent was simply not large enough to embody it. This powerful creature had to be able to move itself, so it picked up wings. It was a dangerous creature, too, so it acquired the foreclaws of an eagle and the back claws of a lion. When completed, it had become a full-blown medieval dragon.

The Byzantines were the most cultured people in the ancient world, apart from the Chinese. They knew what the West didn't learn for close to a thousand years—that the earth was round—and they knew there were no dragons in the Aegean. Therefore, they felt perfectly free to use them as symbols.

FIG. 89

In Revelation, the dragon becomes a symbol of heresy, a most dangerous power that the great saints must fight. Consider the pictures of Saint George rescuing a young girl who is being threatened by a dragon. This is the symbolic way of saying that George was saving youth from heresy.

There are many creatures that symbolize unmentionable wickedness, including the cockatrice (FIG. 89), a creature so evil, so wicked, that medieval artists outdid themselves in depicting its horrors. (The actual word in Hebrew, TSIPHONI, means a basilisk, adder, or viper.) Then there were the unclean creatures that Jews were not permitted to tolerate in any way, such as lizards, snails, moles, ferrets, chameleons, weasels, mice, and tortoises. Yet the dragon (FIG. 90) remains the classical symbol of heresy, darkness, and superstition.*

FIG. 90

*It is interesting to note that in China and Japan, the festivities in honor of the dragon have always marked a people's search for the good harvest, of which the dragon was the guardian.

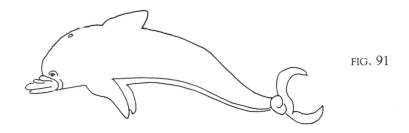

FIG. 91

Of all loving creatures, the dolphin (FIG. 91) is probably the most appealing. It is the traveler's protector and the sailor's friend. The Pegasus, or winged horse (FIG. 92), was dear to the ancient pagan world and was revered for its insistent stamping on the Mountain of the Muses to make poetry flow. Because it was a symbol of the soaring of the human spirit, it soon endeared itself to Christian mythology as well.

Then there were in-between creatures, neither evil nor loving, who were regarded as awesome but stable. The griffin (FIG. 93) is a creature conceived of as being half eagle (with wolves' ears) and half lion, thereby embodying symbolic characteristics of both eternity and vigilance.

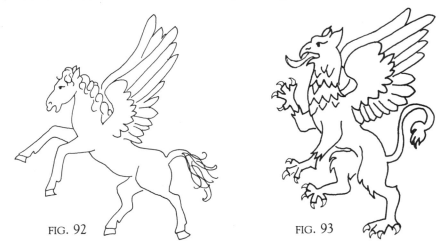

FIG. 92 FIG. 93

The dove and the eagle, from their earliest representations, symbolized peace and strength. There were other "good" birds as well: the phoenix (FIG. 94), which, reborn from its own cremation ashes, became a symbol of the Resurrection. A popular symbol of Christ was the pelican (FIG. 95), which, according to legend, fed its young with its own blood.

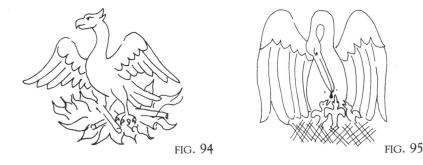

FIG. 94 FIG. 95

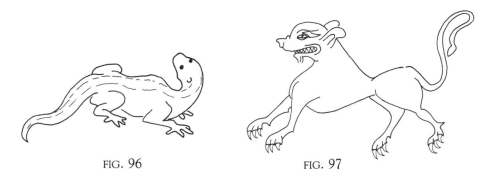

FIG. 96 FIG. 97

Many symbolic creatures, of course, are combinations. A dragon was a serpent and a flying creature with an eagle's beak and scales. It was forbidden; it did not chew a cud. It was terrifying. The point is made. Of wicked, malevolent creatures, the cockatrice, or basilisk, was the worst. Even its breath could kill, and the only way to defeat it was to face it with a mirror—the sight of itself would kill it. The poor salamander (FIG. 96) was regarded as a creature so cold that it could survive any fire, and indeed it flourished in the most violent flames imaginable. Werewolves (FIG. 97) frequented every country but flourished in Central Europe.

Among the ugliest of the mythical creatures was the manticora (FIG. 98), a truly hideous combination of horse, lioness, griffin, and human with the tail of a basilisk or scorpion. Occasionally, the manticora had dragon's wings as well. One of the most learned authors in this field notes that the manticora "derived from distorted memories of the rarely seen man-eating tiger or the carrion-feeding laughing hyena."* Dreadful creatures were largely related: thus the wyvern (FIG. 99) was first cousin of the cockatrice and had the same

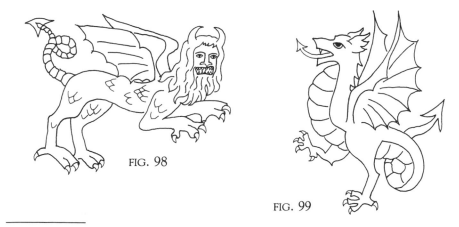

FIG. 98

FIG. 99

*Ernst and Johanna Lehner, A Fantastic Bestiary, p. 69. New York: Tudor Publishing, 1969.

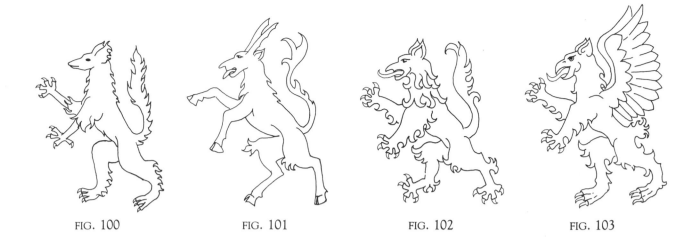

FIG. 100 FIG. 101 FIG. 102 FIG. 103

lethal eyes. Other unpleasant creatures of medieval mythology included the enfield, the heraldic antelope, the opinicus, and the tyger (FIGS. 100–103).

Strangely enough, serpents have not always been used to symbolize evil. Entwined serpents (FIG. 104) were a symbol of spiritual union; a serpent alone (FIG. 105) was a symbol of immortality; and the two serpents at the head of the pastoral staff of an Orthodox bishop (FIG. 106) certainly refer to the biblical admonition to be wise as serpents.

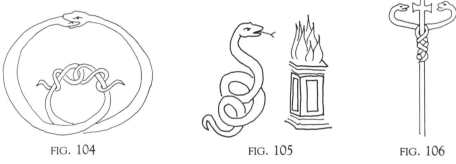

FIG. 104 FIG. 105 FIG. 106

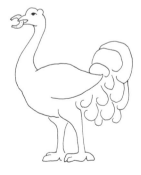

FIG. 107

Heraldic symbolism came to include some of the extraordinary theories of popular medieval science. One of them—dear to alchemists and by no means unknown to the Church—was the conviction that the ostrich (FIG. 107) could consume anything. Actually, the ordinary name for *vitriol* was "ostrich stomach." Thus, in heraldry the ostrich is always shown holding in its claw or in its beak an iron horseshoe—regarded as its regular diet.

Mythical birds and beasts are actually what the adjective suggests: symbols that have come to indicate agreed-upon qualities and functions of the human soul on its spiritual journey. Unicorns, for example, have a symbolic popularity that can be accounted for only by the fact that they express something lodged deeply in the unconscious undergirding of the human memory—something that must be expressed in order to meet a human need.

SIX

Symbols Drawn from Flora

TREES AND FLOWERS have always been symbols of virtues, persons, and dominating passions, whether good or bad. The way these qualities and flora are associated varies widely from place to place. Many symbolic plants are the redesignation of ancient pagan associations. In short, any association of plant with virtue or vice listed here might perhaps be balanced by a completely different association elsewhere.

Many of the plant symbols found in the Western church have very ancient origins. The acacia bush harks back to the burning bush out of which the voice of God came to Moses. The acanthus refers to the peace of Eden, the almond to the choice of Aaron as priest (hence, Aaron's rod), and the apple to the Fall.

The rose is one of the happier Christian symbols, as in the rose of Sharon that signifies Christ. The mystic rose represents the Blessed Virgin; the Christmas rose, the Nativity. Crowns of roses are, in turn, the symbols of St. Cecilia, St. Dorothy, and St. Theresa. The cypress was an ancient symbol of death and mourning. When combined with palm and olive, it becomes a symbol of the Blessed Virgin.

In general, the symbolic associations that follow are common to the Christian world.

THE BLESSED VIRGIN MARY: There are a number of flowers associated with Mary: the almond recalls the budding, blooming, and blossoming of Aaron's rod; the violet suggests humility; jasmine's white color and fragrant

scent symbolize the Virgin's purity and sweetness; and the bloodlike spot in the center of the cyclamen recalls the piercing of her heart. Lily of the valley, thanks to a reference in the Song of Songs, is regarded as a symbol of the Immaculate Conception. The iris, also called a "sword lily," is another reference to Mary's suffering and is also a symbol of the Immaculate Conception. But the lily has become the primary symbol of the Blessed Virgin, whether it be in the fleur-de-lis or in portrayals of the Annunciation from the Middle Ages on. (As is noted elsewhere, the archangel was originally shown carrying a spear rather than a lily.)

CHARITY: the plane tree, because of its sheltering quality.

CHASTITY: the chestnut tree, surrounded by thorns but not itself hurt by them.

CHRIST: the cedar of Lebanon, from a mystic reading of the Song of Songs: "his countenance is as Lebanon, excellent as the cedars."

CONTEMPLATION: Christians in the Far East have adopted the lotus for their own use. Contemplation is certainly one of the concepts the lotus symbolizes, but this flower—sacred to the Indians, the Chinese, and the Japanese—is primarily a symbol of the endless cycle of existence. The lotus, also sacred to the Egyptians, Assyrians, and Greeks, dominated Egyptian architectural ornament.

CORRUPTION OF THE CHURCH: The cockle, a weed that corrupts good fields, is referred to in the Book of Job.

DEATH: the cypress tree. If cut, it will never grow again.

DIGNITY: the elm tree, because of its calm majesty and perfectly balanced growth.

EUCHARIST: grain and grapes, for obvious reasons.

EVIL: the apple, assumed for symbolic purposes to be the fruit involved in the corruption of Adam and Eve.

FALL OF MAN: From Genesis is derived the account of the Tree of Knowledge of good and evil. According to one legend, a seed from the tree lodged in Adam's skull and was buried on Golgotha, the Mount of the Skull; it later grew up into the tree that became the cross. According to another legend, Eve planted a branch of the tree on Adam's grave. This branch took

root, and the tree that grew from it became part of the Temple grounds. Cast into the Pool of Bethesda at the time of the Exile, it was eventually recovered and its wood used to make the cross.

FRUITS OF THE SPIRIT: any handling or grouping of fruits, twelve in number, from the Pauline listing of the fruits of the Holy Spirit: love, joy, peace, long-suffering, gentleness, goodness, faith, meekness, patience, modesty, temperance, and chastity. Note: each virtue was ordinarily identified by its own flower.

GOD'S CARE: The grapevine, an identification of God with his people, shows up both in the Old Testament and in the New. In the Old Testament, the House of Israel is God's vineyard; in the New, Christ says, "I am the vine, ye are the branches."

GOOD WORKS: the strawberry, from ancient times the emblem of the righteous man whose fruits are good works.

THE GOSPEL: the willow, which continues to flourish no matter how much it is pruned.

THE HOLY SPIRIT: the columbine, derived from *columba,* the Latin word for "dove."

HOPE: the hyacinth, from the pagan account of the flower springing from the blood of the slain youth.

HORROR: the aspen, based on the fascinating legend that it alone among all the trees would not join in sorrow at the Crucifixion and in punishment must tremble forever. A related legend concerns the dogwood, whose flower has four petals (technically, bracts) and is therefore cross-shaped. At the extremity of each petal is a bloodlike stain in a semicircle, as though marking wounds in flesh. At the center of the flower, the stamen and pistils resemble the crown of thorns. Legend holds that, having supplied the wood of the cross, the dogwood was relieved from ever having to undergo such a horror again.

HUMILITY: the bullrush, the humble setting of the rescue of Moses. Also the hyssop, mentioned in the Miserere, Psalm 51.

IMMORTALITY: acacia or ivy, because they are forever green.

INNOCENCE: the daisy, which opens at sunrise and closes at sunset (hence, "day's eye"), because it sees things only by the pure light of day.

JOY AND GOODNESS: the cherry, particularly in medieval England.

LOVE: The myrtle, having a pagan association with Venus, is the ancient symbol for love. It is one of the trees suggested as providing the wood for the cross. It is interesting to note that myrtle trees grow only in the Holy Land and in Oregon.

LATENT STRENGTH: the acorn, since it grows from and into the mighty oak.

LUST: the fig tree, a reference to the fig leaves with which Adam and Eve covered their nakedness when they were no longer innocent. Along with the pomegranate, the fig, because of its vast number of seeds, has become a symbol of fertility.

MARTYRDOM: the red rose, evoking the color of blood. Also, the crown of thorns, for obvious reasons.

MONASTIC PIETY: the fern, which has to be sought out if it is to be seen. Ferns grow in the depths of forests, not by highways.

PASSOVER: bitter herbs, part of the prescribed diet for Passover. These are, of course, also associated with the Passion. Another symbol for the Passion is the reed, in reference to the attempt to comfort Jesus on the cross.

PATIENCE: the fir tree, because of its height and independence.

PEACE: the olive branch. This is, of course, the symbol of safety that the dove brought back to Noah after the flood.

PILGRIM: the gourd, mentioned in Jonah, but also popular as one of the items carried by pilgrims going to Santiago de Compostela.

PURITY: the burning bush, in Moses' vision burned but not consumed. In terms of morality, the symbol is the white rose; in terms of love, the red carnation—the color of the heart's blood.

SLEEP: the poppy, because it is and always has been used to avoid wakefulness and pain.

SORROW: the anemone, associated with Golgotha. Also the thistle, starting with a reference in Genesis and going all the way to the tortured path of the *Via Crucis*, the same path that for the Blessed Virgin is the *Via Dolorosa*.

STABILITY: the chrysanthemum. This adornment to the autumn in the Northern Hemisphere is dearly loved by Christians. The notion that it symbolizes stability is actually derived from the Japanese, who distinguish between the dynamism and progress of the rising sun on the national flag and the unvarying symmetry of the formalized depiction of the chrysanthemum on the imperial standard. In Italy, the chrysanthemum is regarded as a symbol of mourning.

STRENGTH: the oak—yet another tree suggested as the wood of the cross.

THE TRINITY: the clover, because of its three leaves. Used by St. Patrick as an illustration, it became permanently endeared to the Irish as the shamrock.

VICTORY: the laurel. The ancient victor's crown at the religious games of classical Greece is given a new association by St. Paul, who contrasts it with the imperishable crown awaiting the Christian.

VOCATION: the almond, famous thanks to Aaron's Rod.

WELCOME: the pineapple. This symbol was popular in the eighteenth-century as an architectural enrichment of doorways.

SEVEN

Symbolism Derived from Fauna

DR. HERBERT FRIEDMAN, in *A Bestiary for St. Jerome*, defines *bestiary* as "a collection of moralized animal tales, a combination of natural history, legend and mythology, oriented to convey ulterior meanings."* This means "animal," of course, in the sense of *fauna.*

The medieval mind found a symbolic use for every living creature and even devised formulae for picturing the invisible. This use of fauna is generally successful, but there is a danger in it. The misuse or loose use of symbolism can easily foster a sentimentality that ultimately defeats its very purpose. For example, the "Dogs of the Lord"—*Domine Canes*, as in *Dominicans*—simply can't be conveyed by the picture of a bug-eyed little puppy perched on top of a carpet slipper. Bishop Manning, the tenth Bishop of New York, was wont to say that people who reduced robust symbolism to sentimental calendar art ordinarily introduced their point of view by saying, "I like to think . . ." The Bishop's rejoinder was, "Why don't they?" Sentimentality can easily lead you to make anything you want mean anything you want it to mean. Along this path lies absurdity and, ultimately, the breakdown of symbolic language.

Yet there are ways in which particular fauna are appropriate representations of particular saints or concepts. Many of the associations with the saints are derived from the legends about them. St. Jerome removed the thorn from a lion's paw, after which the lion was the saint's companion and protector the

*Herbert Friedmann, *A Bestiary for St. Jerome*. Washington, D.C.: Smithsonian Institution Press, 1980.

rest of his life and, later, his symbol. Elijah was fed by a raven, hence that bird became the prophet's symbol. Particular reasons for particular choices may well be lost to history, surviving only by common agreement and associations likely to be a part of the corporate memory of mankind. (Joseph Campbell would point out that they speak to our unconscious awareness of the world around us.)

The following list is (loosely) arranged alphabetically, though by their very nature symbols become related to one another, both in style and usage. Naturalism simply has to be avoided if one is going to portray the first one on the list, the ant. The very first thing to be agreed upon is that the ant will not be shown ant-sized.

The ANT is a symbol of industry and will doubtless remain such forever. A little reflection on the ant's humanoid qualities—as in Proverbs or in T. H. White's *The Once and Future King*—is all that is needed to see how the ant picked up its symbolic associations.

The Old Testament considers the BEAR a dangerous and killing animal. Proverbs describes a wicked ruler as being "like to a roaring lion and a raging bear." In the New Testament the bear is mentioned but once—in Revelation, as part of the composite making up the ten-horned beast rising out of the sea. In positive terms, the bear became a symbol of the missionary effort, because of the legend that bear cubs are given their shape by their mother after birth. Hence the phrase "licked into shape"; thus does the missionary lick the newborn Christians into shape.

The BLACKBIRD is regarded as an emissary of the devil. Ezekiel includes "ravenous birds" among the destroyers, and the black thrush, which we know as the blackbird, is indeed a relative of the omnivorous raven. The blackbird's supposedly lethal propensities enabled medieval men to regard it as the devil, inviting trouble through the sins of the flesh. One of the legends of St. Benedict contains such a reference.

A BULL is the symbol of St. Sylvester, the bishop of Chalon-sur-Saone who was venerated throughout all of France for his gift of working miracles. One of these, according to the legends, was the restoration of life to a dead bull. The negative use of the bull as a symbol is a reference to the death of St. Eustace and his family, who died inside a great brazen bull under which a flaming pyre had been built.

The CAMEL is associated with John the Baptist, who was described as being clothed with camel's hair and with a leather girdle about his loins.

The COCK (or ROOSTER) is associated with St. Peter: "Verily I say unto thee, that this day, even in this night, before the cock crow twice, thou shalt deny me thrice."

CRABS and SCORPIONS are also regarded as symbols of evil because they are unclean by the strict standards of Deuteronomic regulations.

The CRANE, thanks to its sleeping habits, is regarded as a symbol of monastic life. According to legend, the crane stands on one foot, holding a stone in the other. Were the crane to sleep, the stone would fall and the bird would wake.

The EGG is a long-standing symbol of the Resurrection because of the way the chick breaks through the shell at birth. The Slavic world values eggs as an essential part of the celebration of Pascha, and in our own country the hunts for eggs still go on at Easter among people for whom the original meaning has been lost.

FLIES are just as bad symbolically as they are in actual life, and the devil is indeed the Lord of the Flies.

FROGS and LOCUSTS, which picked up a bad reputation in Exodus, are regarded as symbols of earthly attachments.

The GOLDFINCH became a symbol of the Passion because it was believed to live entirely upon thorns and thorny plants.

The HART (or ROEBUCK or STAG) is a gentle animal admired for its unquestioning dependence on others: "Like as the hart desireth the water brook . . ."

The HARE (or RABBIT) is not only a symbol of fecundity, but because of its nature also a symbol of helplessness.

The LIZARD is "a seeker of salvation," as cited in the *Physiologus*, which is essentially a medieval history of beasts. The appropriate legend tells of the aged lizard going into a crevice to await the healing of the rising sun.

The OWL originally represented the devil, but today stands for solitude, wisdom, even Christ himself as the light-giver, unsleeping and always aware. The association of wisdom with the owl is actually Greek rather than Hebrew. The owl—by the unblinking quality of its eye, by moving only when it needs to and with absolute precision—came to symbolize intelligence and absolute control to the Greeks. The owl is, in fact, a dangerous creature indeed to its natural enemies. This is a good example of the way a creature's symbolic meaning can change and even reverse over the years. Yet the symbols will ultimately sort themselves out, reaching a universality of acceptance that finally determines what the symbol means.

The SNAIL offers us another example of this sort of symbolic shift. One interpretation sees the snail as a symbol of sloth and spiritual laziness—satisfaction with the world just as it is. Another, suggested by no less a person than Tertullian, sees the snail as the symbol of Christ: the snail's hibernation is seen as a symbol of burial in the tomb and its awakening in the spring as a symbol of the Resurrection.

The SWALLOW, who vanishes and then reappears in the spring, came to symbolize Christ for the same reasons.

WOLVES, whether tamed by kindness or not, are symbols of cruelty and, in the Old Testament, ecclesiastical corruption. The worst possible thing a cleric can be is a wolf rather than a shepherd to his flock.

Various symbolic creatures have biblical authority behind them, at least in terms of the Vulgate Bible and medieval pictorial piety. HORSES are a symbol of the power of God. CAMELS and DROMEDARIES are regarded as useful animals not only as a means of transport but as symbols of royalty and dignity, as in Isaiah 60:6: "The multitude of camels shall cover thee, the dromedaries of Mydian and Ephah; all they from Sheba shall come: they shall bring gold and incense; and they shall show forth the praises of the Lord." This reference accounts for their association with the Wise Men of the East. WHALES (FIG. 108) and GREAT FISHES serve God's purposes. The "behemoth" probably meant HIPPOPOTAMUS, a symbol of God's strength in the Book of Job. The LEVIATHAN in the same book is a great water animal who waits upon God to be fed.

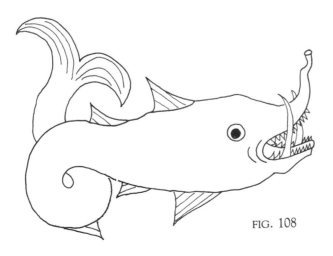

FIG. 108

In medieval terms, the PARTRIDGE is a symbol of the Evil One because it was generally supposed to prey on the young of other birds. When associated with St. Jerome, it refers to the methodology of the Enemy. The QUAIL is a reference to the account in Exodus of God's provision for his people. The HERON became a symbol of Orthodoxy on the theory that it does not tolerate anything either dead or decaying (this may not be the most attractive aspect of dogmatic symbolism), whereas the HYENA prospers on the decaying corpse of false doctrine. The BUTTERFLY and the PEACOCK are immemorial symbols of the Resurrection.

The gentle animals associated with the life of Jesus have been fondly handled by the Church since earliest times, the OX and ASS of the manger appearing in the Roman catacombs. These two animals, both constants in Christ's lifetime, came into their own in the setting up of the manger at Christmastime, a practice made popular by St. Francis (FIG. 109).

The STAG or HART, as in the Psalter, was an extremely popular symbol in the Roman catacombs (FIG. 110), being associated with the waters of baptism. When flanking a vase (FIG. 111), the whole stands for the waters of salvation.

The LAMB's extraordinary symbolic significance emerges along at least

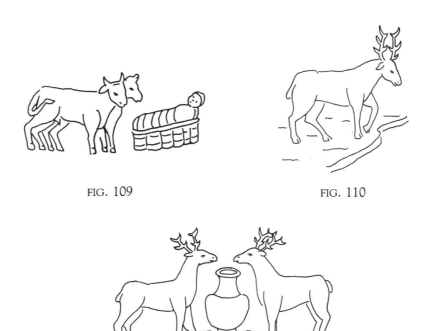

FIG. 109

FIG. 110

FIG. 111

two lines. The first is as the absolutely faultless creature to be offered as a burnt sacrifice to God. This sacrifice, it should be noted, was a *holocaust*, a total burnt offering, not a way of saying grace and having roast lamb. In this total offering it was the lamb that mattered—the loved one, dear to its shepherd. This is essential to understanding the phrase "Lamb of God" as applied to the Lord.

The second way to think about lambs is from the vantage point of the Good Shepherd. Consider the lamb that the shepherd carries over his shoulders, holding the feet in one hand. Our Lord talks about the shepherd's leaving the ninety and nine and going out into the wilderness to find one lost sheep. It is not good economics to leave ninety-nine unattended—with wolves lurking—and go off after one silly little creature. But God is like that.

Then there are the SHEEP, who surely must be the stupidest of all created beings. (The phrase "all we like sheep have gone astray" is not a compliment.) We must be very careful with our symbolism here. There is the Agnus Dei, the spotless Lamb of God, and there is the shepherding quality of our Lord. And then there is the stupidity of sheep. Proper symbolism will keep them all in balance, but many pious people, when one talks about sheep, think of the lamb. This is a mistake: we are the sheep, foolish and lost; the Lord is the Lamb of God.

While the attributes of animals are usually what gives rise to symbols, the position of an animal is sometimes very important. Thus, a dove rising and a dove descending carry two different messages about the Holy Spirit. The eagle with raised wings and the eagle with his wings lowered are saying two different things about both the Gospel and the Gospeller, John. The lion passing by and the lion gazing at you are saying two different things about the missionary effect of Mark's Gospel.

In some cases, the qualities for which a creature is known become generalized. Take the ape, for instance, or the infinitive, *to ape*. *Ape* can be a verb as well as a noun. The word for this amusing animal who copies everything changes the symbolic understanding of the animal. One never, in Western religious art, sees a monkey as a religious symbol, because "aping" is not right; it is not the same thing as growth. *Squirrel* has undergone the same kind of transformation.

The BAT, though a creature of the night, is by and large not dirty and not dangerous. In fact, bats eat many bothersome pests, and several states keep careful track of their bat population for this reason. And yet, as creatures of the night with an ability to fly without light, bats strike terror into the human psyche.

In considering bats, swine, cats, or any of the other creatures forbidden by dietary laws, we must remember that the diet involved was not a matter of health (in spite of nineteenth-century pious assumptions) but rather of dealing with animals sacred to other religions. For example, no word appears about cats in the Bible because they were a sacred Egyptian symbol. The Gadarenes held the swine to be sacred, so it was forbidden to the Jew. The Jews might not partake of any animal sacred to some other religion. Hence, the portrayal of these creatures was considered as reprehensible as was the consumption of them. They were symbols, and for the Jewish religion symbols of something totally wrong. The restrictions based on the dietary laws were still current in New Testament days (and are still current today, for that matter). They left a permanent mark on the symbolism available to the early Church.

Scripture's handling of the great beasts of the sea is enormously touching. The Old Testament writers apparently realized that the whale was a mammal and carefully distinguished the leviathan from the great fish. The word *leviathan* in Hebrew actually means "great water animal." The creature in Jonah, for example, is not a leviathan but a great fish. Whales are among the better of this planet's creatures, and the only horror about them is the way we are permitting them to be destroyed. In another generation there may not be any left.

As to other creatures of the sea, there is some appreciation of turtles in symbolism. The turtle is a big, tough, and curiously self-contained creature, capable of withdrawing into what is technically called its *carapace* and of living for many years. The turtle, also appearing in tortoise form, is far more common in Eastern religions than in the West. In the East, the tortoise is very important because of its incredibly slow but absolutely direct way of moving. In the fable of the tortoise and the hare, the tortoise never stops. It just keeps on going at its own pace. The silly rabbit hops along and then falls asleep, so the tortoise ultimately wins the race.

There are a number of calm observations in the Old Testament about the leopard's inability to change its spots. This concept delighted the Hebrews—we don't know quite why, but we know it cheered them immensely. Many of these observations have since passed into sermon notes. *

*If the Jew faced the fact that the Ethiopian could not change his skin, he also faced the fact that Moses had married an Ethiopian woman, and that Miriam's leprosy was her reward for speaking against the woman. There was equal concern for the eunuch. In Isaiah, we read of God's promise to provide eunuchs with a different, but even more valuable, kind of progeny than that which might have been theirs. Indeed, eunuchs as metaphor are much valued in St. Matthew's Gospel. One of the greatest fathers of the early Church, Origen, took the text quite literally. The Church ultimately ruled against any such practice, but it regarded chastity as a voluntary, spiritual if not physical, form of the same.

If mankind, birds and beasts, and creatures of the deep are all taken seriously, then each has some symbolic message. Some are transparently clear, both for good and ill. The ultimate ambition must be to see them all in place, living with each other and conveying their own creatureliness in the least complicated way.

EIGHT

Symbolism Representative of Saints

IN VICTORIAN DAYS, when the faithful were rediscovering (or, technically, *discovering*) the incredible riches of symbolism, they told the story of a little boy who was shown an endless number of stained glass windows. Afterwards, his parents asked what he thought a saint was. His reply: "A person the light shines through."

This is, of course, a truism, and the trouble with a truism is that it says something we've always known and so are impatient about being reminded of—even if we've heard the truism, but not what it *says*, before. A truism is so named because it is true—it is absolutely characteristic of the reality, mentality, and activity of the person to whom it refers.

There are a great many truisms about saints. The saints are God's friends, even when they let him down or oppose him—just think of the people St. Paul called saints, and of his opinion of their behavior. Saints are people writ at their largest. When tested by a wicked world they remained constant, some as martyrs, some as confessors, and some simply as ordinary citizens entrusted with the meaner and less glamorous job of daily living. Yet all of the saints came to a point in their lives when love and pain were inseparable, and all of them triumphed.

In approaching the designation of particular animals or other symbols to individual saints, it must be remembered that the background of such a choice is verbal rather than pictorial. The "beasts" that appear in Ezekiel and the Revelation of St. John the Divine originated as word-pictures rather than as two-dimensional drawings.

The four evangelists seem to have been the first of the saints to receive some visible token of recognition, becoming identified with the four "living creatures" of Revelation. * Although there was originally little agreement as to which creature represented which evangelist, there has been, since about the fifth century, a popular consensus. St. Jerome had this to say:

> The first face, that of a man, signifies Matthew, who begins to write, as of a man, the book of the generation of Jesus Christ, the son of David, the son of Abraham; the second, Mark, in which is heard the voice of the Lion roaring in the desert, 'Prepare ye the way of the Lord'; the third, that of the Calf, prefigures Luke the Evangelist, commencing his history from the priest Zechariah; and the fourth, the Evangelist St. John, who, having taken the wings of an Eagle, and hastening to loftier things, speaks of the Word of God.

While St. Augustine disagreed—believing that the lion symbolized Matthew and the angel, Mark—St. Jerome's iconographic representation of the four evangelists is now common to the whole Church, East and West.

MATTHEW—the most human and popular of the Gospellers, which is why his Gospel was placed first in the New Testament—is symbolized by the face of a man. In order to understand another of Matthew's symbols, we must remember that he had been a tax gatherer and as such was despised by his fellow Jews. The Roman Empire delegated tax collections to natives of their subject lands, asking only that the collectors pay a certain sum every year. Many collectors took as much as they could get from the subject people, then paid the government its sum and pocketed the difference for themselves. A tax gatherer was seen as a traitor to his own people, exploiting them in the interests of a foreign governing power—hence, the scorn one sees for Matthew in Scripture. His name appears not only as *Matthew* but often as *Levi* (whether or not he was originally two people, we do not know). His symbol is three money bags.

As one of the evangelists who actually saw Jesus, MARK gets more mention by name than any other save John. It is assumed that he is the young man who fled naked from Gethsemane, that he is the John Mark mentioned by Luke in the Acts of the Apostles, that he is the son of the Christian housewife named Mary, that he was the cousin of Barnabas, and the disciple

*If one wishes to gain the greatest understanding of Revelation, one ought to stand up at a lectern and read it at the top of one's lungs and just as fast as possible, without any break at all. The incredible buildup of the language provides in itself an extraordinary experience of symbolism. That is the way that Revelation was intended to be conveyed, not as pictures for us, the future generations.

first of Paul and later of Peter. His Gospel is the message of Peter and must be viewed as the classic expression of commitment to the healing ministry. Tradition has him as the first Bishop of Alexandria, ultimately martyred by Hadrian. The artistic world knows him best for the glorious cathedral in Venice of which he has been patron saint since the year 829. Mark was aggressively forthright and had little "give," and so he is symbolized by the lion.

The bucolic aura surrounding LUKE, symbolized by the ox, is comfortable and reliable. Luke is accepted as "the beloved physician" who wrote not only a Gospel but also the Acts of the Apostles. In the latter, he writes in the first person, as having been with Paul during the second and third missionary journeys. Patron of physicians, he is also the patron saint of icon painters and other religious artists. The reason, as has been mentioned before, is his loving skill in portraying in words the birth and nurture of God's son, Mary's child. He is said to have died in Greece in his eighties, a living icon of the sanctity of which he wrote.

Also reflected in the New Testament is the aged ST. JOHN—the mysterious figure who is the fourth evangelist, or the source of his material.* Besides the Gospel we have letters of this aged and angry presbyter. John is frequently cited as the one responsible for the apparent anti-Semitism of the New Testament. This is the result of the failure to recognize that his was a Jewish ministry to Jews who followed the Way of the Nazarene. An American who meets all crises with the statement "There ought to be a law—" is not anti-American—he or she is an American making the observation to and about his or her own people. John's anger is that of the aged pastor seeing his people suffer under a system of which he too is part; persecution within the larger Church—Jewish or Christian—neither started then nor stopped then. The anti-Semitism of the New Testament must be viewed only in the light of division and heartbreak within the same family. The sixteen hundred years of failure to face this fact have resulted in the ghettos and pogroms that have defaced Christian history.

In terms of symbols the Church has never really made up its mind about how John the Evangelist died. Legend has it that he was boiled in front of Rome's Latin Gate, and yet survived. Later, in Ephesus, some of his enemies presented him with a cup of wine. Just as he took the cup, he saw a vision of

*Scholars increasingly face the possibility that the intrusion at the beginning of the Gospel, "There was a man sent from God whose name was John, the same came to witness the light," refers to John the Evangelist. "There was a man come from God . . ." is the prologue. The epilogue comes at the end: "This is the man who spoke these things. We know his saying is true."

a deadly serpent in it and did not drink, which furnished medieval heralds with one of his two popular symbols, the cup and serpent. The truth is, nobody really knows how John met his end.

Red is not used as a basic color for St. John because he is not a certified martyr, and the feast of St. John is always a white feast, even though it occurs in the middle of several red feasts—first St. Stephen's and then the Holy Innocents'.

These animal symbols for the four Gospellers have been in use since classical times. Indeed, the representations on the royal doors of the iconostasis in any classic Orthodox church will hardly vary at all from the seventh-century manuscript known as the Durham Book (FIG. 112).* The superb

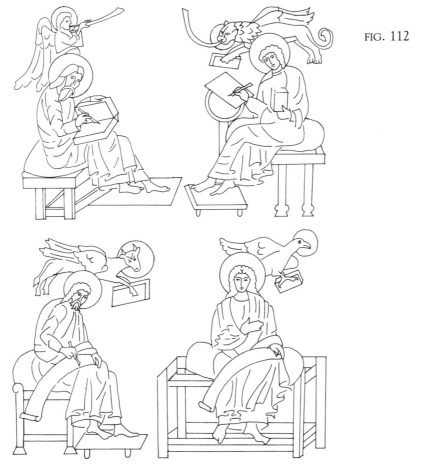

FIG. 112

*In icon painting the perspective is reversed. In this illustration, for example, the bench of Matthew, the footrest of Mark, and the bench of John grow larger as they recede—the whole point being that the icon is looking at you, rather than you at the icon.

FIG. 113 FIG. 114

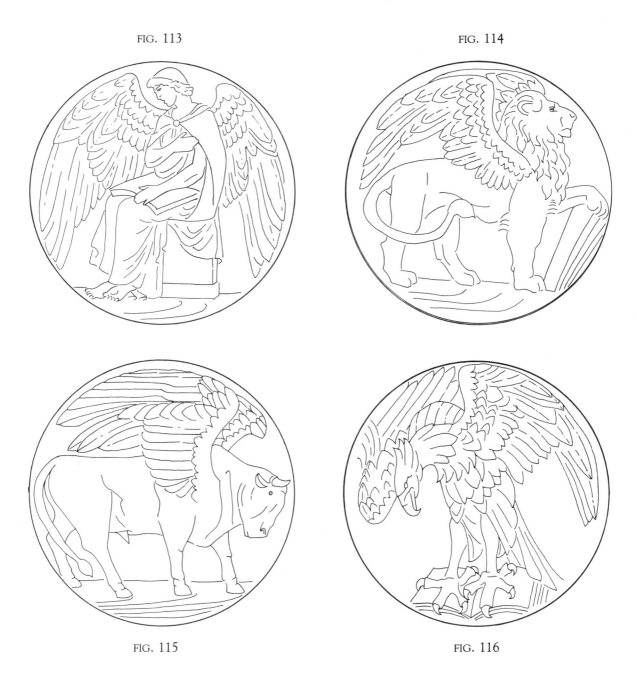

FIG. 115 FIG. 116

designs on the great bronze doors of New York's Cathedral of St. John the Divine are among the best modern expressions of these time-honored symbols (FIGS. 113–116). The *majestas* at the central portal of the same cathedral portrays the seated figure of Christ reigning in the heavens, surrounded by the seven lamps, which are the seven spirits of God, and flanked by the symbols of the four evangelists (FIG. 117). The composite symbol for the four evangelists is a cross with four open books in the spaces between the arms (FIG. 118).

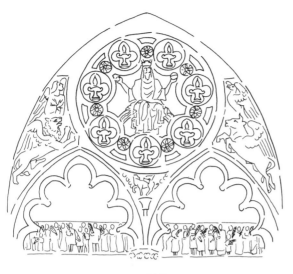

FIG. 117

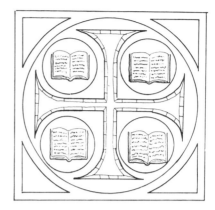

FIG. 118

ST. STEPHEN, the first martyr, was a particularly popular figure in the early Church, having been one of the seven deacons chosen to do the social service work of the Twelve Apostles. His glowing speech on behalf of the risen Lord Jesus produced such a violent reaction that he was stoned to death. After his death, his garments were laid at the feet of the still-unrepentant Saul of Tarsus. Psychologists have often pointed out that this act broke Saul's resistance and ultimately made it possible for him to become St. Paul. Saul must have remembered how, even while he was being killed, Stephen expressed concern for the members of the murderous crowd and, finally, joy at the sight of Jesus in heaven. The arms assigned to Stephen show the martyr's palm between three stones (FIG. 119).*

FIG. 119

PAUL was, for his contemporaries, one of the most difficult people in all human history; he had both extraordinary power and an insistence on taking in Gentiles—those uncircumcised folk who had eaten all sorts of foods they never should have touched. The difficulties led to the Church's first knock-down-drag-out fight, the Council of Jerusalem. One must not wax too sentimental about the unity of the Church—in terms of uniformity, it has never existed. As long as there are human beings who care, there are going to be arguments, and there is nothing wrong with them. That is the way things

*One of the reasons martyrs may be so popular is that recognizing the pain of other people always makes life more endurable. We can stand whatever we may have to because the saints have been through something far worse. The phrase "the patience of a saint" was fundamentally a reference to a person's ability to stand up against pain.

grow and happen. After all, the only city in which St. Paul did not have a fight is the only one in which he did not found a church. In every other place he had a knock-down-drag-out fight and founded a first-class church.

St. Paul is symbolized by a sword, due to the fact that after he made his appeal to Caesar, he was ultimately condemned and beheaded. Beheading was considered a noble, even merciful, death. Had Paul not been a Roman citizen, he would have been crucified or killed in some other horrible way, but as a citizen he had a right to be beheaded.

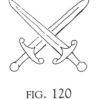

FIG. 120

In some cases, a saint's symbol is doubled or trebled in order to fill out a shield or design. For example, the sword symbolic of St. Paul is too plain, too thin, when shown alone on a shield. Double it, and make the swords short, stumpy, and broad, and they fill the space even more effectively (FIG. 120).*

While many symbols, such as St. Stephen's, are based on historical events in the saint's life, others are based on the saint's life taken as a whole. ST. AUGUSTINE's symbol is one of these—a heart with flames emerging from its top, pierced by two arrows. In many ways, this conveys a clear picture of St. Augustine—his thinking, the kind of devotion that characterized his life. Thus the heart topped with flames and pierced per saltire (in an X-shape) is the symbol for ST. AUGUSTINE OF HIPPO (FIG. 121).

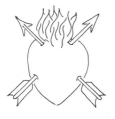

FIG. 121

One will often find the characteristics of two or three different people combined into the symbol of one person, as is the case with MARY MAG-DALENE. There is nothing in Scripture that designates Mary Magdalene as the woman taken in adultery, but that has become part of her image. Mary Magdalene has also been identified as the woman from whom evil spirits and infirmities were banished, as the woman who poured the ointment on the Lord's feet, kissed them, and dried them with her hair, and as the sister of Martha. The actions of three different women have simply been combined.

Yet this composite saint has a definite character. In French, *madeleine* meant a repentant demimondaine. So the Madeleine, an elegant, classic church in Paris, had this concept in mind in its dedication. A considerable group of noble and royal mistresses once entered convents as *madeleines*, whereas the poor, wretched peasant women in the same situation were transported to Louisiana, as in *Manon*. In any case, thanks to these combina-

*If you think that Paul's swords, for example, do not look much like real swords, remember that good symbolism is not intended to be naturalistic. In fact, excessive naturalism can create the kind of triviality that characterizes much heraldry done in the late eighteenth and nineteenth centuries. Heraldry is not designed to display steam engines or ocean liners. The kind of ship that is put on a shield (see the emblem of St. Jude) should look just enough like a ship that one can tell what it is from a distance, and no more.

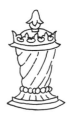

tions, the alabaster ointment pot has come to be identified with St. Mary Magdalene (FIG. 122).

FIG. 122

There are certain agreed-upon symbols and fixed colors—and many exceptions. One of the rules is that, if the symbol is that of a martyr, the shield or background will be red, as in blood, whereas the background of a confessor will be white or blue. One of the exceptions is the blue shield of ST. ANDREW, which has nothing to do with his death at all. St. Andrew is reputed to have been crucified on an X-shaped cross—technically called a *saltire*—and so he is a martyr. But he is represented by a white cross on a blue field or a blue cross on a white field.*

St. Andrew is also the patron saint of the Ecumenical Patriarchate of Constantinople, the city now called Istanbul. That is why the Patriarchal Order is the Order of St. Andrew. There is also a tradition that St. Andrew converted the first-century inhabitants of Russia. The Imperial Order of St. Andrew was the foremost order of Imperial Russia, more important than all the other orders put together.

The tower and lightning bolt symbolizing ST. BARBARA (FIG. 123) are based on a seventh-century story recorded in the popular medieval *Golden Legend*. Barbara, a beautiful young woman, was shut up in a tower by her father for security reasons. She converted to Christianity while still in the tower, and when her father heard of it, he set out to change her mind. After she refused under torture to renounce her faith, her father ordered her killed and was himself immediately struck by lightning. For obvious reasons, St. Barbara became the patron saint of artillerymen.

FIG. 123

ST. BARNABAS is represented by alternating red and white roses. No one knows how he came to have this symbol, but we do know that in medieval days the clerks and singing boys of many English parishes decked themselves out with roses on his name day.

ST. SWITHIN is symbolized by three green apples and, at the top of the shield, a blue section sprinkled with silver raindrops. This preserves the popular legend that rain on his day, July 15, predicts a fixed period of rain. The other half preserves the legend that wetting the green apples on St. Swithin's Day guarantees a plentiful harvest.

SEBASTIAN is one of the most familiar saints, thanks to the endless

*These symbols also represent Scotland, since Andrew is the patron saint of that country. On the Royal Arms of Scotland, the unicorn symbolizing Scotland carries a flag with the blue, X-shaped cross of St. Andrew atop a lance.

FIG. 124

FIG. 125

illustrations of his martyrdom. According to Ambrose, Sebastian was already known as a martyr by the end of the fourth century. Legend has it that he was an army officer and favorite of the emperor Diocletian, but when he became a Christian, Sebastian was made a living archery target. The arrows failed to kill him—he was finally beaten to death—but arrows remain his symbol to this day (FIG. 124).

ST. LAWRENCE, the beloved archdeacon of Rome, was roasted on a gridiron in A.D. 258 for refusing to cooperate with the emperor Valerian after the martyrdom of Pope Sixtus II. Following his death, the emperor could not find the treasures of the church—Lawrence having already distributed them among the poor. The great palace-monastery of the Spanish royal family is dedicated to him and therefore is called the *Escorial,* which means "gridiron" (FIG. 125).

The symbol for ST. BARTHOLOMEW—who was believed to have been flayed, or skinned alive, for his faith—is the flaying knife. In the Duomo in Milan, among a superb series of statues, is one that is truly startling in a way Renaissance people loved. It depicts St. Bartholomew holding his skin in his hand, with every vein, every muscle, and every nerve visible, like an illustration in an anatomy textbook. Anyone startled by this bloodthirsty turn of the medieval and Renaissance mind need only think of modern children enjoying the violence on television to grasp the mind-set.

ST. JUDE is known chiefly for his missionary efforts, and so his emblem is a ship. Once again, this symbol is not an essay in realism. There is usually no attempt to make St. Jude's ship look like a perfect galleon or even like it's at sea. Symbolists are quite sensible about such matters.

There is a legend that when ST. PETER was sentenced to die by crucifixion, he insisted on being crucified upside down, so as not to rival his Lord. He is thus symbolized by an inverted Latin cross (FIG. 126). Another symbol for Peter, from the reference in Matthew, is the Keys of the Kingdom, two colossal keys crossed on a background of martyr's red (FIG. 129).

FIG. 126

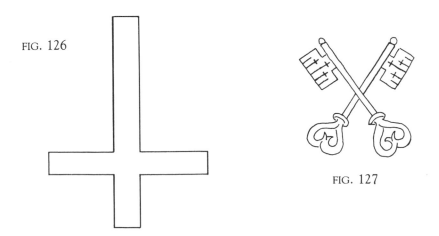

FIG. 127

The crossed swords of St. Paul are reminiscent of Peter's crossed keys. One or the other appears in the seal or coat of arms of fourteen of the Episcopal dioceses in the United States and eight of the dioceses of the Church of England. The Archdiocese of York is dedicated to St. Peter, and its arms display the crossed keys. Nowadays there is a crown above them, but this crown was originally a Byzantine mitre. The Diocese of London is dedicated to St. Paul—hence, we have St. Paul's Cathedral—and so has the crossed swords in its arms. The crossed swords also appear in the arms of the Episcopal Diocese of New York, because it was under the jurisdiction of the Bishop of London in colonial days.

ST. JAMES THE GREATER, or St. James Major in classical terms, was the brother of John and the first of the disciples to go on a missionary journey. St. James also became the patron saint of Spain when he supposedly saved the Spanish army by appearing on the field of battle at a critical moment. (This sort of thing, by the way, is not unique to St. James. One hears of appearances by Joan of Arc in the First World War.) Santiago de Compostela, which has a relic of St. James, is the great pilgrimage site in Spain, and the pilgrim's symbol, the scallop shell, has become the symbol of St. James.* In heraldry we find not a single shell but three, two above and one below. The one below is larger than the other two, to balance the design (FIG. 128).

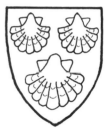

FIG. 128

ST. JAMES THE LESS, or St. James Minor, was supposedly sawn asunder and is appropriately symbolized by the saw. Again, the least effective sort of symbolic representation would be a saw that looks as though it were designed for an ordinary job of carpentry. One must think in terms of broad, two-handled saws with great jagged teeth to capture properly the spirit of martyrdom.

ST. BLAISE is represented by a hideous carding instrument, a wooden paddle with a handle and spikes standing out from it, which was used to prepare wool for weaving. Traditionally, Blaise was killed by being carded to death. Not surprisingly, St. Blaise is the patron saint of people dealing in cloth. He is also the patron saint of people with sore throats, which is why, on St. Blaise's Day, candles are moved down the sides of the throats of the faithful who have presented themselves for this preventive medicine.

ST. BONIFACE, the patron saint of Germany and the Archbishop of

*Unlike clams, which dig into their sandy bedding and remain there, scallops actually move from place to place, and so are an appropriate symbol for our own journeying.

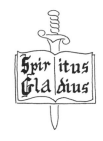

FIG. 129

FIG. 130

Mainz in the eighth century, was responsible for the conversion of a group of tree-worshippers. Eventually, he ran into a group of tree-worshippers tougher than he was whom he didn't convert, and they killed him by one of their trees. His emblem is his missionary's Bible with a sword plunged right through it (FIG. 129).

ST. CATHARINE OF ALEXANDRIA was threatened with being broken on the wheel and, although she was delivered by angelic intervention and later killed by the sword, the wheel remains her symbol. This association of St. Catharine with the instrument of her torture has produced the "Catharine Wheel" (FIG. 130), the revolving object that throws off sparks and smoke as it spins, which is familiar to anyone who has ever seen fireworks.

The other great Catherine is ST. CATHERINE OF SIENA, one of the most important women in the history of the Western Church. This Catherine made and unmade popes, emperors, bishops, archbishops, and cardinals—she seems to have run the whole Church at one point. When we think of the controversy over women in the Church, of people agitated by the thought of women in Holy orders, we should remember that St. Catherine ran Europe and that St. Hilda ran Britain in the same way. St. Catherine of Siena's symbol is a heart with a cross on it, rather like the heart and cross symbolizing Martin Luther.

ST. CECILIA is the patron saint of music, thanks to a legend that tells of beautiful angelic music surrounding her wherever she went. Her symbol is not a harp, as might be expected, but rather a primitive organ with three pipes of different lengths.

ST. BEDE, or the Venerable Bede as he is generally known, was the first historian of the English Church and an extraordinarily good preacher, as we know from the wealth of material that has come down to us. One of the medieval symbols for him was a pitcher with a sun seeming to radiate into it. Pitchers were popular symbols of preaching in medieval heraldry; they were things one poured from, which quenched the thirst of others by pouring forth the abundant material of salvation. Everyone understood what was intended. This is in marked contrast to the pitcher and bowl (FIG. 131) used to indicate Pilate's washing of his hands as a symbol of his renouncing any responsibility in the death of Jesus.

We go from St. Bede to ST. BENEDICT, and what we might call "high brow" heraldry. St. Benedict, who came from a very great fifth-century Italian family, gave up the life of a hermit, took a number of veterans from the collapsing Roman army, and set up a religious house for them. The Rule of St. Benedict is one of the two principal rules of the Western Church, the

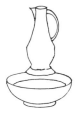

FIG. 131

other being that of St. Augustine. It is impossible to overestimate the effect of St. Benedict's Rule on Western monastic life. It combined simplicity, devotion, and a vast amount of horse sense. Most of the Western rules are derived from it in one way or another, either by amplification or change in emphasis. The discipline of Benedict's house was highly intelligent, with the monastic offices consisting primarily of the singing of Psalms. It was only later that Scripture readings were added, and not until the Franciscans came along—very late indeed—were such things as the Apostles' Creed added. The symbol for the Benedictines consisted of a sword and a legend, *Crux Sancti Patris Benediciti,* meaning "the cross of the Holy Father of blessing," which is also a play on Benedict's name.

The legend of ST. CHRISTOPHER tells us that, as he was crossing a stream, he was accosted by a child who wanted to be carried across. Christopher lifted the child to his shoulder and waded in. As he crossed, the child grew heavier and heavier, exhausting the burden-bearer by the time he reached the other shore. The child (really the Child Jesus) then said, "You have borne the weight of the world on your shoulders." St. Christopher's symbol is the lantern signifying Christ as the light of the world, with the walking staff appropriate to a traveler.*

One of the most imaginative heraldic constructions is Dorling's suggested arms for ST. MATTHIAS. Matthias was chosen to take the place of Judas in the Twelve, a group that constituted a synagogue congregation that worshipped, took religious meals, and received instruction as a private synagogue with the Lord as the rabbi. When Judas hanged himself, the Twelve (now eleven) came together to elect a replacement. They required that any candidate have walked with the Lord Jesus and be able to witness to his Resurrection. After narrowing the field to two candidates, they chose Matthias by throwing dice. His arms represent this choice—a shield divided into six segments with the upper left, the upper right, and the bottom center containing one die (FIG. 132). The requirements for Matthias are still used today in the examinations and consecrations of bishops: has this man walked with the Lord Jesus, and can he stand up and witness to the Resurrection? The thinking is still valid.

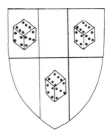

FIG. 132

Christopher is a theological name meaning "Christ-carrier," and the problem with theological names is that we are never certain whether they represent actual historical people or simply ideas. Mary Magdalene, as we have seen, stands for what is basically the consolidation of various persons and ideas. Then there are St. Faith, St. Hope, and St. Charity, and in the Eastern church, St. Lent. Although these names may seem absurd to us, they are perfectly sound theologically.

FIG. 133

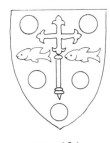

FIG. 134

ST. EDMUND, as his symbol (FIG. 133) shows, was both king and martyr. King of the East Angles when the Danes invaded in 870, defeating him and his army, Edmund was martyred with the Lord's name on his lips. Bury St. Edmunds, the shrine built for him by King Canute in 1020, achieved a prominent place in English history when, in 1214, the barons met there to draft the Magna Carta and swear they would force King John to approve it.

ST. ASAPH's symbol, dating from the sixth century, employs the keys as in St. Peter's symbol. One key is gold, the other silver; both are mounted on a black shield. As with other, very early symbols, no one has the slightest idea why this one is associated with St. Asaph. Asaph himself was the first Welsh Bishop of Llanelwy, which after his death was renamed the Diocese of St. Asaph. His monastery had in it nearly a thousand monks.

ST. ANTHONY OF PADUA was one of the most appealing of the Franciscans, noted for his extraordinary gentleness and goodness. He is often depicted in sentimental statuary holding the Child Jesus on his shoulder, or perhaps on a book. His extraordinary purity is represented by the book and the lily.

ST. PHILIP is symbolized by a bishop's cross set amid loaves and fishes (FIG. 134), commemorating the feeding of the five thousand. Philip, like any good parish treasurer, asked, "Where are we going to get the money to feed these people?" Andrew replied, "Well, there is this youngster with loaves and fishes," and the miracle followed.

ST. SIMON, the companion of St. Jude of the missionary journeys, is represented by a fish on top of a book. The book refers to his missionary journeys, and the fish is a primitive suggestion of his power as a fisher of men. Books, frequently opened to appropriate texts, are very popular in heraldic art. They are even more important in Orthodox icons.

ST. CLEMENT OF ROME, who is mentioned in the New Testament, became the Bishop of Rome after Peter's death. For historic reasons now lost to us, his symbol is and always has been the anchor. Whether this has to do with his nature or his commitment we cannot know, but it is one of the oldest symbols we have.

ST. COLUMBA is represented by a Celtic cross because he was the founder of the great monastic establishment on the Isle of Iona. His formative years had been spent in Ireland, where he had founded two monasteries, Durrow and Derry. He brought Celtic Christianity to Scotland. The Celts are always quick to point out that he completed his great work and died in the year 597, the very year when St. Augustine of Canterbury first arrived in

Kent. The Celtic cross owes its unusual shape to the fact that such crosses were originally carved from a single piece of stone. Stone crosses will not tolerate long arms, so the cross arms will generally be shorter than the top, and a circle is frequently added to the crossing for additional support. These crosses, although they are called Celtic, originated in Denmark and were brought to Ireland when Ireland was ruled by the Danes. One hears tales that St. Patrick himself designed the Celtic cross, but these tales have no basis in fact (FIG. 135).

FIG. 135

People's symbolic memory is not always the best, and there have been occasional lapses in communication. A good example of this pertains to ST. NICHOLAS. An old French Christmas carol tells the "Legende de Saint Nicholas," which goes on for nearly thirty stanzas about three children who were boiled by a wicked innkeeper. When St. Nicholas stopped at the inn and was served boiled child, he recognized that something was wrong and, being a saint, did a marvelous thing. He remade the children, brought them to life, then killed the wicked innkeeper and his wife—a typically medieval Christian tale with enough gore to keep any child interested.

This tale arises from a curious misreading of early depictions of St. Nicholas. The medieval Church had forgotten that baptism involved total immersion in ancient times, so when they saw old icons of St. Nicholas with three young men waist-deep in a font awaiting baptism, they turned the baptismal font into an iron pot of water full of babies' arms and legs. The same transition took place in the Eastern church as total immersion was gradually abandoned and medieval artists lost the concept of the original font.

The true story of St. Nicholas is much better served in his symbol, three coins (FIG. 136). According to this beautiful story, Nicholas saved three girls from prostitution by throwing three bags of gold through their window at night. According to Donald Atwater, pictorial representations of this act may have confused the bags with children's heads and may be the real basis of the other, more grisly, legend of St. Nicholas.

FIG. 136

ST. JOHN CHRYSOSTOM, although generally associated with gold, does not have a specific symbol because he is an Eastern saint, and the Eastern church doesn't think in terms of specific symbols for specific saints. Had he been a Western saint, we would undoubtedly have all sorts of elegant symbols devoted to him. But John Chrysostom is a very great saint who deserves to be remembered even if he isn't symbolized. He was a simply superb preacher. He preached a set of sermons once to the people of a town about to be destroyed by the emperor because they had thrown down the statues of him and the

empress. John Chrysostom's Sermons on the Statues were taken very seriously, given the fear of impending doom. Like all the great early preachers, he preached sitting down, and in those days the congregation would not only talk back but also react verbally to the sermon as it went along. When we read his sermos, we see notes, such as "Ah, you applaud that" or "You booed that? You're missing the point." When his enemies spread rumors that his quiet and disciplined life was really nothing other than a cover for his overeating and drinking, "he showed himself half naked, gaunt rib bones showing through the starved and ravaged flesh."* The empress eventually prevailed upon the emperor to exile him, and John was quite literally walked to death by guards who kept him at it until he dropped dead. When his body came back to Constantinople, every single window in that great and glorious city had a lamp in it. A golden lamp would provide an elegant and appropriate symbol for St. John Chrysostom.

ST. THOMAS, the patron saint of India, seems actually to have visited India at one time. In any case, there is a Mar Thoma ("Lord Thomas") Church in India today. Every Indian prelate, whether Syrian or Mar Thoma, will have the Mar Thoma in his name. Thomas, a carpenter, was ultimately speared to death, so his standard symbol is a carpenter's square on the top of a spear.

Judas, naturally enough, is symbolized by thirty pieces of silver. We must be very careful concerning our understanding of Judas Iscariot, for his case is not nearly as simple as it sounds. Was he the monster he is portrayed to be, or was he doing nothing other than forcing our Lord's hand? In any case, the sheer horror of what he did drove him to go off and hang himself. Traditionally, Judas went to hell immediately, which made him the latest arrival until the Lord came. Thus, it may be that the poor wretch was one of the first souls freed.

ST. DAVID was the principal builder of the Church in Wales. There is a charming legend to the effect that when he had to be raised up in order for a congregation to hear him, the ground itself rose as a mountain under his feet. A white dove sat on David's shoulder, and the preaching could be heard by all.

ST. AGATHA, the famous Catanian martyr, had her breasts torn off with red-hot pincers. Thus, with its usual sanguine turn of mind, the medieval church represented her with pincers.

*Robert Payne, *The Holy Fire*, p. 217. New York: Harper and Row, 1957.

ST. AGNES, a thirteen-year-old martyr, was beheaded after a period at the stake. She is represented by an *agnus* (lamb) on a sealed book.

ST. AIDAN, who was Bishop of Lindisfarne, had as his symbol an ancient form of torch. Another charming symbol for him is a stag, for he is said to have once made a hunted deer invisible to the huntsmen.

EDWARD THE CONFESSOR (a "confessor" is one who witnesses nobly to Christ but is not a martyr) was a popular figure in twelfth-century England, and the last reigning king of the old line. He had two nephews: Harold, who took over the throne, and William, the Duke of Normandy. After the Battle of Hastings, in which Harold died and William became king, it was to everyone's advantage to build up the interest in Edward the Confessor: William was extremely anxious that Edward's mantle should fall on him.

FIG. 137

Edward's arms (FIG. 137) are a cross paty (see p. 110) with five martlets placed in the usual heraldic order, one in each quarter of the cross and the fifth below. Dorling notes that the martlets may have derived from designs on Edward's coinage, which in turn were derived from the dove at the top of the royal scepter. Note that the martlets are shown without legs, heraldic birds being rarely shown *with* legs—one thinks of little birds as being basically in flight. The cross paty is, of course, a tribute to Edward as a Christian, the one who founded Westminster Abbey.

Some of the symbols for saints are visual plays on words, or what is technically known as *canting*.* ST. DOMINIC, for instance, is represented by a dog holding a torch (FIG. 138), from the phrase *domini canes*, meaning the "dogs of the Lord." The Dominican order's involvement with the Inquisition should not blind us to what a great saint Dominic was. Remember, the Inquisition was forced on the Dominicans in Spain and southern France. Dominic had originally set up his order of preachers to *persuade* heretics by love, so that there would be no force or coercion involved. Indeed, it is a supreme irony that one of his own order would end up presiding over the torture of heretics. St. Dominic is highly regarded in all monastic institutions, and deservedly so—he was a very great man.

FIG. 138

AMBROSE, military governor of northern Italy, was presiding over a church council during a crisis over the election of a new bishop, with the Arians on one side and the Orthodox on the other. The legend is that, as the debate reached its height, a little child cried, "Ambrose for bishop!" The rest of the delegates took up the cry, and Ambrose was elected by acclamation.

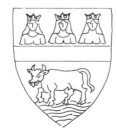

FIG. 139

*This is true for ecclesiastical heraldry as well, such as the Arms of Oxford (FIG. 139), in which the lower portion of the shield is occupied by an ox passing a ford.

Curiously, he was consecrated bishop without being made a deacon or priest beforehand—indeed, he was a catechumen at the time, not yet baptized. The ancient Church permitted this; technically, it is called consecration *per saltum,* Latin for "skipping."

Ambrose proved to be one of the Church's great bishops, mostly through his work on the liturgy. The Ambrosian rite, like the modern Roman, Anglican, and Lutheran eucharistic prayers, has laypeople present the alms and oblations. The collect used at the commingling of the water and the wine is a summation of the Christian religion in one sentence: "O God, who didst wonderfully create and still more marvelously renew the dignity of human nature, grant that by the mystery shown forth in the mixing of this water and this wine, we may become partakers of the divinity of him who for our sakes partook of humanity." This is the whole Gospel. It is no wonder that Ambrose was made bishop as a catechumen.

Another story about St. Ambrose involves the same emperor whose threat of dire punishment ultimately caused St. John Chrysostom's Sermons on the Statues. The emperor had statues of himself and his wife put up in one town, and again the locals got out of hand and destroyed them. This time the emperor had the entire town put in the circus and killed—thousands of people—after which Ambrose refused to allow the emperor to make his communion. To the emperor's credit, he did the penance required of him. Ambrose is patron saint of industry and of the sweetness of learning, and his arms (FIG. 140) is a beehive with two disciplines crossed behind it. *

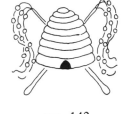

FIG. 140

The obvious association of particular flora and fauna with individual saints can frequently produce duplication. For example, the beehive is a symbol of St. Ambrose, St. Bernard of Clairvaux, and also, in the West, of St. John Chrysostom. In the former instance spiritual energy was implied; in the latter two, extraordinary preaching.

There is nothing in the New Testament that gives us the name of the Blessed Virgin's mother, and the only Anne mentioned is Anna the Prophetess. The references to Joachim and Anna are from two apocryphal books, *The Protoevangelion of James* and *The Gospel of the Nativity of Mary,* which the Church turned down as Scripture but kept as legend.† Anne's symbol (FIG.

*Disciplines, three-thronged whips with small knots of lead in the cords, were used for penance during the Middle Ages. Theoretically, they were still in use by some Orders until Vatican II.

†The pious upbringing of Mary, her being chosen to be weaver of the Temple Veil (the purple and scarlet portion), her being fed by an angel while she was one of the temple virgins—all scenes popular in later art—are derived from one or the other of these books. The account of Anna is very similar to the biblical account of Hannah (both names, of course, are the same in Hebrew).

141) is a lily on a blue background, all within a masonry border that refers to the raising of the Blessed Virgin in a pious, protected environment.

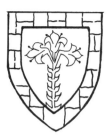

FIG. 141

Another symbol derived from motherhood is that of ST. ELIZABETH, the mother of St. John the Baptist (FIG. 142). A Maltese cross, the symbol of St. John, grows out of a vine, the lower leaves of which are withered. This is a memorial of Elizabeth's years without childbearing. When shown in color the cross is white, the vine is gold, and the shield is black.

JOHN THE BAPTIST is difficult to portray symbolically. The staff, the locusts and wild honey on which he lived, the animal skins he wore, don't lend themselves to portrayal. The eight-pointed cross was the symbol of Amalfi, the Italian republic of which John the Baptist was the traditional patron saint. Amalfi's cross as St. John's symbol was arbitrarily chosen because that republic provided money to rebuild the pilgrims' hospital in Jerusalem around A.D. 1050.*

FIG. 142

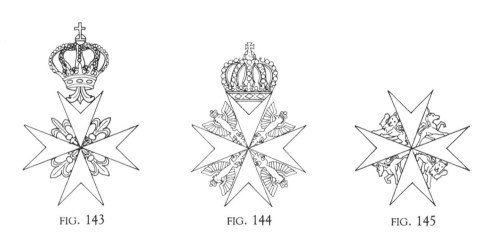

FIG. 143 FIG. 144 FIG. 145

*The work originally endowed by Amalfi still continues. Of the ancient serving orders of Western Christendom, the most distinguished one extant is the Sovereign Military and Hospitaller Order of St. John of Jerusalem, of Rhodes and Malta—the "Knights of Malta," the great and exclusively Roman Catholic body that is acknowledged by the Holy See. The Order's red flag with the white cross running throughout and its red flag bearing a white Maltese cross are recognized the world over (FIG. 143).

There are four other orders of St. John of Jerusalem that are orders of chivalry in the accepted sense and recognized as such by the Federal Republic of Germany and by the crowns of the United Kingdom, Sweden, and the Netherlands. They are associated with the Order of Malta (with whom they have a concordat) and with one another by history, traditions, sentiments, Christian devotion, and active collaboration in works of charity.

These orders of St. John include the Cross of the Knightly Order of St. John of the Hospital of Jerusalem, the *Johanniterorden*, headquartered in Bonn and distinguished by the Prussian eagles between the arms of the cross (FIG. 144).

The Cross of the Grand Priory of the Most Venerable Order of the Hospital of St. John of Jerusalem, headquartered in London, has lions and unicorns between the arms (FIG. 145); its flag is exactly like that of the Sovereign Military Order, save that in the first quarter created by the cross, the British Crown Royal is represented.

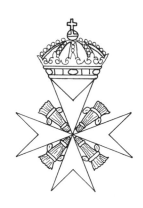

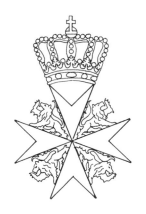

FIG. 146 FIG. 147

ST. ANTONY OF EGYPT, one of the greatest of the desert fathers, is represented by the tau cross, a cross shaped like the letter *T*. As was mentioned, the tau cross is like the actual cross of crucifixion, but nobody knows why it was associated with Antony. It was an ancient Egyptian symbol long before his time, and he may have picked it up simply because of his locality.*

ST. HELENA, the emperor Constantine's mother, is associated with the discovery or "invention" of the True Cross. Because of this association, the Western church long ago assigned her a golden cross on a purple field. She takes top credit for her insistence on Orthodoxy—probably with greater reason than we might think, since Constantine wasn't all that firm in his convictions. He knew Christianity would be the cement that would bind his empire together, but he was somewhat ambivalent about Orthodoxy.

ST. AUGUSTINE OF CANTERBURY arrived in Kent in 597, to learn that from the remnants of the ancient British church, St. Patrick, St. Columba, and St. Cuthbert had built the Celtic church, which had already established some fourteen hundred monasteries in Britain before Augustine's

The Cross of the *Johanniterorder i Sverige*, headquartered in Stockholm, has the sheaves of wheat, the symbol of the Royal Family, between the arms (FIG. 146). The Cross of the *Johanniter Order in Nederland*, headquartered in the Hague, has the lions of the House of Orange Nassau between the arms of the cross (FIG. 147).

Of the other ancient religiously oriented orders, one of the most important is the Equestrian Order of the Holy Sepulchre of Jerusalem, founded under Godfrey de Bouillon at the end of the eleventh century. The ceremonial dress of this order is a long white mantle with the scarlet cross of Jerusalem on its left shoulder.

The Orthodox Patriarch of Jerusalem confers the Orthodox Order of the Holy Sepulchre, which the Orthodox regard as having been founded by the emperor Constantine.

The Teutonic Order was founded in Jerusalem in 1190 and was attached to the German Church of St. Mary. It became an order of knighthood in 1198. After the Crusades it continued with enormous power in the Hanseatic League, virtually disintegrated in the early nineteenth century, and was revived under the Hapsburg dynasty. Its distinguished cross of black and silver was the original basis for the design of the Iron Cross, the famous German decoration.

*Crosses, in any case, are not unique to Christianity. They have shown up in nearly every kind of religion. One of the most powerful crucifixes ever designed is an ancient Assyrian one made centuries before Christ. The cross is all part of a continuing mass of symbolic recognition, a point constantly made clear in Jungian psychology.

arrival. Indeed, it was as a member of the ancient British church that Restitutus was Bishop of London in the year 314, and it was in this same church that St. Patrick's father had served as a deacon. Kent, however, had been overrun by the Danes, and the Celtic church had been pushed west into Wales, Cornwall, and Ireland, and north into Scotland. Augustine of Canterbury's genius lay in establishing law and order in a church made up mostly of peasants rather than in establishing good relations with another existing church. (His refusal to do so did nothing to improve relations between the Latins and the Celts.)* Dorling has suggested an arms symbolically appropriate for St. Augustine of Canterbury: A black shield with a white cross running throughout; in the first quarter, a gold pall surmounting a white archiepiscopal cross; and in the second quarter, a white lily. The black is an obvious reference to the Benedictine order, the archbishop's regalia to his rank, and the lily to the fact that he died in May, which is the month of the Blessed Virgin.

ST. ALPHEGE, Archbishop of Canterbury, was killed by the Danes. While defending the cathedral, he was captured and held for ransom. He refused to have his people pay it, and so was stoned to death and put to the sword. His symbol is a great Danish battle-ax in silver and gold on a red field.

ST. ANSELM is one of the great Christian scholars. *Why Did God Become Man? (Cur Deus Homo)* is one of his most famous theological works. The thirty-fourth Archbishop of Canterbury, he had a great deal of trouble with the kings of his time, thanks to his insistence on the freedom of the Church. This situation led to the adoption of a symbol for the Church—a *nava* (ship), as in the nave of a cathedral, with pennants having little crosses on them—as Anselm's symbol. Note that the heraldic waves, alternately blue and white, are properly symbolic and not at all naturalistic.

*Important to this conflict are its rival and competing mentalities. The Celts were mystically disposed and passionately expressive of their devotion; the Latins were efficient, highly organized, and restrained. Both temperaments have left their mark on the current religious world, whether it be the Anglican world of the Church of England and those in communion with it, or the Presbyterian world of the Church of Scotland, or the Wesleyan world, or the world of the Quakers. The continental Catholic church, like its American offspring, is powerfully divided in its sympathies for one side or the other. Once one forgets the local loyalties or labels, the mental processes of St. Thomas Aquinas and John Calvin seem strangely alike. The discipline and devotion of John Wesley is a later century's and a different country's expression of the pastoral ideas of Ignatius Loyola. Thus, the temperament of Patrick made it possible for him to evoke the warm response of Celtic people (his conversion of the Irish brought into being the Celtic church); but on the other side, St. Augustine's formal sense of hierarchical mission won the loyal response of Englishmen devoted to things "being done decently and in order." The two kinds of temperament are both right, and are evidenced by the tensions within all of the bodies mentioned. This tension at its most absurd has shown up in arguments about the correct date of Easter and the correct style of monastic tonsure.

ST. FRANCIS OF ASSISI presents a difficulty in the symbolic handling of the stigmata, the wounds of Christ that marked his hands, his feet, and his side as a result of his intense devotion to his suffering Lord. The brethren of St. Francis's order knew nothing of his stigmata, for Francis himself took great pains to keep them hidden. This suggests that Francis was an incredibly tough man, nothing like the American image of him as a soft, sentimental patron saint of birdbaths. The symbol for Francis and the stigmata is five drops of blood in positions as though on a body: hand, hand, heart, and feet. When these blood drops are mounted on a cross with the Franciscan colors, one has a particularly effective symbol for St. Francis.

ST. GILES is the patron saint of hunters, which is curious since he protected animals from being killed by them. The legend tells that St. Giles sheltered a doe from hunters, and the king in recognition built a hermitage for him. His symbol is a golden doe pierced by a silver arrow, the whole on a green field.

FIG. 148

In medieval piety, one often comes across tales of hunters who, as they take aim at a stag, say, will suddenly see a crucifix between its horns. The point of these stories is that if one hurts an animal one is hurting Christ. Some symbols preserve the legend of the way in which an individual saint was converted. The white stag with a cross between its horns (FIG. 148) refers to ST. HUBERT, who went out as a hunter but was converted by this vision.

JOAN OF ARC is naturally represented by the fleur-de-lis for having saved the French kingdom. She is also symbolized by the sword, and, at some point, the martyr's crown.

ST. JOSEPH OF ARIMATHEA is represented by a tomb that "has never been used." Tombs in the Holy Land were cavelike chambers with a great stone door that could be rolled into place. This is terribly difficult to portray without resorting to naturalism. Two stylized lilies on the edge of the round stone tomb-cover would suffice, and, since he was a confessor, Joseph's shield would be blue.

ATHANASIUS's symbols, and there are a number of them, all have to do with his effect on the doctrine of the Trinity. One of the standard symbols is the pallium, an heraldic Y-shaped yoke. (This yoke is seen in the arms of the archbishop of Canterbury, on a blue field in white.) But the use of a Western pallium for Athanasius is not really fair, because he was an Eastern doctor. St. Athanasius should be represented by a symbol of the Trinity itself, either a triangle or a trefoil, and a proper Orthodox pallium.

A discussion of symbols used to represent saints is probably the appropriate

place to mention saints who were used as symbols of other things. The most familiar of these, of course, is ST. NICHOLAS, who became the Santa Claus of German and Scandinavian countries, where gifts are still given on his feast day, December 6. Father Christmas in England still carries some of the trappings of Saint Nicholas, but in the United States, thanks to the Dutch background of New York, he has retained only his concern for children and a fondness for reindeer. It may be that the increasing sophistication of American youth will lead them back once again to the traditional figure of St. Nicholas.

ST. ELMO'S FIRE is the visible electricity seen at the tops of ships' masts. St. Elmo, or more classically, St. Erasmus, was a fourth-century confessor who later became one of the patron saints of sailors. The halo effects seen around the metal bands of mainmasts during a storm were assumed to be the patron saint appearing to protect the faithful.

ST. ANTHONY'S FIRE was fire of a totally different sort. In the eleventh century, relics of St. Anthony were instrumental in curing an outbreak of erysipelas, a disease characterized by inflammation and violent itching. Since that time, the disease has been known as St. Anthony's Fire.

The last warm spell before winter, called Indian summer in America, is known by the saints in Europe, with different saints for different climates. ST. LUKE'S SUMMER starts on October 18, ALL SAINTS SUMMER on November 1, and ST. MARTIN'S SUMMER on November 11.

Of course, the place where people are most likely to encounter the saints is in the Church calendar. The calendar was originally designed to divide and measure the year for the purposes of agriculture. The summer lectionary still has a lot to do with the ripening of crops or the planting of vines.

Eventually, the calendar grew out of all proportion, until every day was named for several saints. I saw one result of this when I visited the monastery of San Anselmo in Rome. After the lection ended, wine was served. I asked one of the senior brothers about this and was told that the day was Brother So-and-So's name day. I remarked that the saint wasn't very well known and asked how the brother had come to choose his name. "Do you think he had any choice?" my companion said. "We have it so worked out that the only days of the year we don't have an available name day are Ash Wednesday and Good Friday, and they move from year to year."

An important part of the calendar are the several feasts dedicated to the Blessed Virgin. The largest of these is known to Roman Catholics as the Feast of the Assumption, to Eastern Orthodox as the Feast of the Dormition (the falling asleep of the Virgin), to Anglicans as the Feast of St. Mary the Virgin,

and to everyone else as August 15. The bodily assumption insisted on by Roman Catholic piety has some precedent in the Old Testament—both Enoch and Elijah were received bodily into heaven.

The Feast of the Conception (December 8) is technically the Immaculate Conception for the Roman church, which maintains as an article of faith that Mary was born without the taint of Original Sin.

The Feast of the Visitation marks the visitation of Elizabeth by the Blessed Virgin and her recognition of the divinity of the child that Mary carried.

The Feast of the Nativity (September 8) marks the birthday of the Blessed Virgin. The emphasis is on the preparation of both body and soul for the task that was to be hers.

The symbols of the saints are most effective when they either remind us of something we already know or invite us to question what we thought we knew. When a child asks, "What does this *mean?*" it is often best to reply, "What do *you* think it means?" and to seriously listen to the answer. For, in a child's eyes, believing is seeing. Most adults could well be reminded of that from time to time.

NINE

The Symbol of the Cross and Some of Its Myriad Variations

THE PRIMARY SYMBOL for Christianity is, without question, the cross. Yet the cross referred to in the New Testament was not the model for the cross we know today. The form of the cross first used as a symbol for Christianity was derived from the first letter of Christ's name in Greek—the *chi*, an X-shaped letter. This instantly recognizable symbol was used by early Christians to "sign" everything—food, cups, plates, furniture, clothing. The *chi* was placed anywhere it would go. The X is, of course, still used as a universal sign in modern society. The legal signature of an illiterate person is an X, followed by the statement of a witness giving the person's name and marking the X as his or her sign.

Variations on the *chi*, particularly geometric variations, were quick to arise. The earliest of these was simply the division of a *chi* to form something like the rays of a star sapphire. The vision of Constantine before the Battle of the Milvian Bridge involved just exactly this sort of symbol (FIG. 149).

But it was the combination of the *chi* with the *rho* (the second letter of Christ's name in Greek) and elaborations on this combination that produced the first of what would be recognized as modern crosses. The combination of these two simple letters has given rise to hundreds of permutations—some scholars have said there are over four hundred forms of the cross, fifty or sixty of which are in common use.

Crosses are most frequently used in heraldry. Indeed, the heraldic use of crosses has become something of a science, with highly technical rules and regulations. (For example, when a cross is shown on a shield, it extends the

FIG. 149

FIG. 150

full height and width of the shield, unless it is what is technically described as "couped," cut squarely at the ends to stand free of the outer rim of the shield.) Many saints are represented in heraldry by a single, simple cross, with the various saints distinguished by the color of the cross. Elaborately enriched crosses were popular in Byzantine times, and a common pattern, such as FIG. 150 from Mount Athos, clearly inspired several important patterns adopted by groups like the Armenians and the Nestorians. Possibly the best way to approach all of these variations is to do so alphabetically.

The most popular cross in Victorian times was the CROSS ADORNED, a simple cross shape with elaborate surface enrichment. These crosses, considerably less popular now, in many instances have been retired or made into processional crosses. A richer form has floraled extensions added to the ends, creating the fleur-de-lis (FIG. 151). Many examples of this handsome form, popular in Victorian ecclesiastical furniture, are still around.

The ADVENT CROSS (FIGS. 152 and 153), also known as the tau cross or *crux commissa,* is actually shaped like the cross of crucifixion itself, although it was not thought of in those terms until much later. In ancient Christian thinking, this was the shape of the cross held up by Moses in the wilderness. A white tau cross on a black field is the symbol of St. Antony, since an ancient Egyptian symbol recalled the establishment of Antony's hermitage in the Egyptian desert. In the Middle Ages, when paintings of the Crucifixion started to become popular, the good thief and the bad thief were shown hanging on tau crosses. This was an unconscious reference to the fact that the top portion of the cross of crucifixion was really the placard containing the legal charge against the criminal. This placard was attached to the top of the spike that went through the crossbar.

FIG. 151 FIG. 152 FIG. 153

FIG. 154

FIG. 155

The CROSS AIGUISY (FIG. 154) is an heraldic development based on the Greek cross—a cross with all four arms of equal length, as distinct from the Latin cross with its longer lower member. To the Greek cross have been added half-diamond points, which stand free of the cross. This is a highly decorative design, and because the points can be thought of as nails, it is also a symbol of the Passion.

The CROSS ALISY PATY (FIG. 155), with four arms curving outward and a circular outline, is one of the most popular of all crosses. It has been used by quite a few religious sodalities and is still one of the most popular forms for ceremonial wear, particularly in vestments.

The ANCHOR CROSS (FIGS. 156–158) is an extraordinarily old variety, dating back to earliest Christian history. Many of these crosses can be seen in the Roman catacombs, the burial places of early Christians. The anchor, of course, is an ancient symbol of hope, representing stability in an unstable sea or security in an insecure world. It was easy to elaborate on the top part of the anchor to form a combination of the flukes of an anchor and the cross itself. When all four arms of a Greek cross end in these flukes (FIG. 159), you have what is technically an ANCHORED CROSS.

FIG. 156

FIG. 157

FIG. 158

FIG. 159

The ANKH (FIG. 160), or *crux ansata,* is also known as the Egyptian cross. This form existed in pre-Christian days as a symbol of life after death, the Egyptian religion being more conscious of life after death than any other ancient religion. When Egyptian Christians read into the ankh their larger view of the spiritual world, the earthly provisions that Egyptian piety required to be buried with the dead were no longer needed. Moral and spiritual possessions took the place of earthly goods in the world of spirit, life, and light.

The CROSS ANULETY (FIG. 161) is an interesting heraldic design made from four rings, or anulets. The cross is usually Greek in shape, as other proportions tend not to work so well.

The CROSS AVELLAINE (FIG. 162) is so named because it seems to consist of four filberts. It has become famous as a result of a remarkable picture taken of St. Paul's Cathedral during the World War II blitz of London, showing this cross still standing at the top of the dome with all the world collapsing and burning around it.

The CROSS BARBY (FIG. 163) is, in theory, made up of the barbs of fishhooks (actually, fish spears). This refers back to the popular fish design—and the references to fish—in Resurrection appearances and the early Church. F. R. Webber has suggested that the cross barby was also a missionary symbol referring to the Christians' obligation to be "fishers of men."

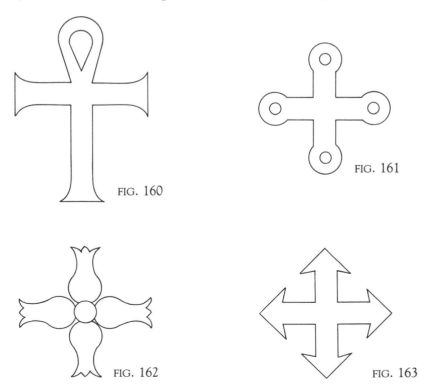

FIG. 160

FIG. 161

FIG. 162

FIG. 163

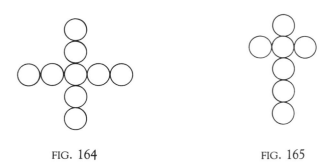

FIG. 164 FIG. 165

The CROSS BEZANT (FIGS. 164, 165) is made up of golden disks or balls, which in heraldic terms derive from the Byzantine word for gold coins, *bezant.* (The three bezants of the Florentine bankers are with us today as the sign for a pawnshop.) The term is used to describe any cross, Latin or Greek, composed of five, seven, or nine golden disks. The Greek form of this cross, with five golden disks, is best known for its use in the Vatican State as a decoration of the Papal Lateran Cross.

The BLUNTED CROSS (FIG. 166), also known as the *cross moussue,* is simply a Greek cross whose arms terminate in semicircles. It often lends itself to building or structural usage as the plate anchoring a tie rod to a wall.

The BORDERED CROSS (FIG. 167), also known as the FIMBRIATED CROSS (FIG. 168), is a cross in which the center has been voided. One of the more famous examples is the cross of St. George in the Union Jack.

The CROSS BOTTONY (FIG. 169), more technically known as *bourbony* or *treffly,* is a Latin or Greek cross whose arms terminate in trefoils. One of the most popular of all cross designs, it is used widely to decorate corporals, stoles, or exteriors of buildings, being an easily executed architectural form.

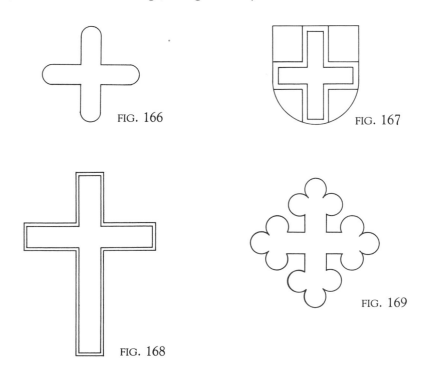

FIG. 166

FIG. 167

FIG. 168

FIG. 169

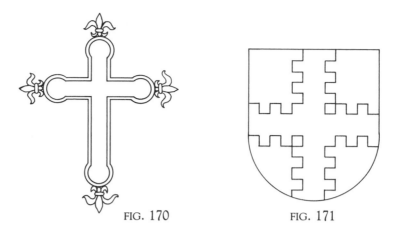

FIG. 170 FIG. 171

A CROSS BOURDONY (FIG. 170) is basically a cross with spherical knots at the ends of the arms. Some scholars insist that the spherical knots are fleur-de-lis, but in most instances it is actually impossible to tell.

The BRETESSED CROSS (FIG. 171) is a cross with the crenellations of a castle running down the sides of each arm and offset from one another. This form was popular in the late medieval days, when the armies and navies of Europe were involved in what was regarded as the defense of Christianity. Castellated thinking, if you will, became representative of what they were pleased to call the Church Militant.

The CROSS CABLEY (FIG. 172) gained its name from the simplest form of embroidery stitch. This pattern has no real ecclesiastical association beyond its cross shape.

The CALVARY CROSS (FIG. 173), or graded cross, is a Latin cross on a three-stepped base. From the early nineteenth century on, it has been one of the most common symbols used in American churches. Popular piety has associated the bottom step with *caritas,* or "charity"; the second step with *spes,* or "hope"; and the top step with *fides,* or "faith." Hope without charity avails nothing, and faith is the gift of Christ.

FIG. 172 FIG. 173

FIG. 174

FIG. 175

The CROSS CANELLY (FIG. 174) is a cross that is "invected," the heraldic term for a series of nearly semicircular designs added to the sides and ends of the arms of a cross. The cross canelly may be either Greek or Latin in shape.

An unusual popular cross is the CANTERBURY CROSS (FIG. 175), whose hammerlike arms radiate from a fimbriated, or voided, square in the center. The most common form is the rather heavily decorated Victorian version. A simpler, more elegant form appears on the archbishops' tombs in Canterbury Cathedral.

The CROSS CANTONNY (FIG. 176) is a straightforward, widely popular symbol. It consists of a large central cross, Greek in shape and form, with four smaller crosses in the four corners. The smaller crosses do not go beyond the border margins of the large, central cross. For many people, this cross recalls the Lord as the Master of the Four Gospels. The word "cantonny" derives from the heraldic word "canton," meaning the corner of a shield, generally the upper left corner. "Cantonny" refers to a design in all four corners.

The CROSS CAPITEAU, or CAPITAL CROSS (FIG. 177), is an heraldic structure, actually referring to an architectural form derived from the meeting of four capitals, or columns. This elegant, balanced design is equally effective with a Latin cross.

FIG. 176

FIG. 177

FIG. 178 FIG. 179

The CROSS CERCELY (FIG. 178) has ram's-horn ends, harking back to the Old Testament. When the shofar sounded forth at the start of the Jewish New Year, it was, in Christian terms, a joyous sound, signifying constant renewal—all the time, in every direction, for all people everywhere.

The CHAIN CROSS (FIG. 179) is an heraldic construction that has, through the years, come to mean different things. At one point it represented the fetters of sin destroyed by the cross of Calvary. Later, it represented the suffering of Christians. In more recent times—in the concentration camps and in the memorials to them—the chain cross has represented the horror and brutality of the victims' oppression.

The CHECKY (also ECHIQUETY) CROSS (FIG. 180) is an heraldic enrichment made up of rows of squares alternating in colors and metals. Given the number of prime colors and the metals, the number of permutations of this design is extraordinary.

The CHRISTUS REX (FIG. 181). The vested figure of Christ crucified recalls the ancient practice discussed in Chapter 3. Some churches still use this cross to observe the Feast of Christ the King on the last Sunday after Pentecost.

The CROSS CLECHY (FIG. 182) is a fimbriated cross with spearlike ends. Note the design in outline, and an inner cross defined by the outer one. This is an extremely handsome and effective design for pectoral crosses—ceremonial crosses worn midchest.

FIG. 181 FIG. 180 FIG. 182

CROSSES SYMBOLIC OF INDIVIDUAL COMMUNIONS are organized here chronologically. Each has its own historic background, but each has come to represent a particular loyalty—a loyalty for which someone in some place has suffered or died.

FIG. 183

The GREEK CROSS (FIG. 183) is one of the most widely used versions of the cross. Its origin from the *chi rho* has been mentioned. In theory, the four arms are of equal length; in actual practice, the lower arm is imperceptibly longer. This is an important design element, because in its absence the human eye will see the lower arm as shorter.

The LATIN CROSS (FIG. 184) is technically eight squares high and five squares broad, with the crucial point being the third square down from the top.

FIG. 184

The ARMENIAN CROSS (FIG. 185) is still found in surviving churches in Turkey and in Holy Etchmiadzin, the seat of the Catholicos of All Armenians. A beautiful design, it is extraordinarily similar to the cross of the Nestorians—the group with which the Armenians disagreed the most theologically.

The PERSIAN CROSS (FIG. 186). One of India's treasures is the remarkably ancient Persian Cross of Kottayam. The ancient Persian church, the Syrian Jacobites, had long enjoyed metropolitan authority over Indian Christians, an influence that can still be seen in the adjective "Parsi." The Persian cross form is similar to Byzantine crosses of the same period.

FIG. 185

FIG. 186

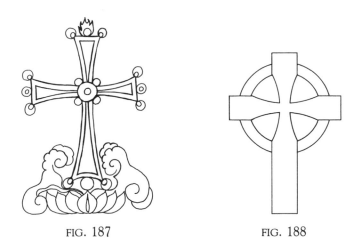

FIG. 187 FIG. 188

The NESTORIAN CROSS (FIG. 187), still found in China, is an ancient relic of early missionary efforts there by the Nestorians, also originally from Persia.

The CELTIC CROSS, or CROSS OF IONA (FIG. 188), has by long historic association come to be known as the Irish cross. Many of the ancient crosses found in Ireland are covered with rich, symbolic bas-relief. There are at least ten Irish crosses so well known that each has its own name, generally after its location. This cross is also dear to the Church of Scotland, and therefore to Presbyterians everywhere.

The large central cross of the deservedly popular JERUSALEM CROSS (FIG. 189) is made up of four tau crosses joined together at the bottoms, set between four crosses "couped cantonny." This cross, part of the armorial trappings of the Kingdom of Jerusalem, is one of only two instances in heraldry in which metal is used on metal. A Jerusalem cross is normally gold on a silver field. Now popular in every part of the Western church, it has also been used by the Eastern church.

The RUSSIAN ORTHODOX CROSS (FIG. 190) originated as a reference to the cross of crucifixion. The cross was T- or *tau*-shaped, the *stipes* (upright) being permanently set up at the place of crucifixion,

FIG. 189

FIG. 190

and the *patibulum* (crossbar) carried there by the prisoner. The crossbar was held in place by a vertical spike that went through a hole and on which the accusation or charge was displayed. A saddle in the middle of the upright was used to increase tension above and below the pelvis, making crucifixion a death by slow strangulation.

The spike eventually became an upright extension, with the accusation or charge taking permanent form. There being no easy way to accurately portray the saddle, it came to be shown as a horizontal *supedaneum* (footrest). Perspective of the footrest was indicated by angling the ends. Eventually, the entire footrest came to be angled, and there are Byzantine examples with it angled in either direction (see FIG. 34).

The Russian church eventually made a uniform choice, and now the footrest runs from upper left to lower right. Pious legends soon arose assigning historic and divine justification to the choice.

The LUTHERAN CROSS (FIG. 191), the personal symbol of Martin Luther, became, for obvious reasons, a popular symbol of the Evangelical Reformed churches of Germany and Scandinavia. The design is handsome and understandably popular.

FIG. 191

The HUGUENOT CROSS (FIG. 192), the Languedoc cross with the dependent dove of the Holy Spirit, became the sixteenth-century symbol of the Reformed Church in France. It is still the official symbol of a Huguenot chaplain in the French armed forces.

The CROSS OF LORRAINE (FIG. 193) picked up its earliest, somewhat unfortunate association as symbol of the Holy League. The Wars of Religion left a bitter taste, and the Revocation of the Edict of Nantes perpetuated this bitterness. The Cross of Lorraine was not restored to its full splendor and ancient dignity until it became the symbol of the Free French under General Charles de Gaulle.

FIG. 192

FIG. 193

FIG. 194

The COMPASS ROSE (FIG. 194), the emblem for the Anglican communion, centers on the cross of St. George, with the points of the compass radiating from it to illustrate the worldwide spread of its apostolic and evangelical faith. In place of the usual decoration marking north, a mitre has been substituted as the time-honored symbol of the Apostolic Order essential to the churches that constitute the Anglican communion. The inscription encircling the shield ("The Truth shall make you free," the words of Jesus in John 8:32) is in the original New Testament Greek, which, unlike Latin or English, is the only language studied in common by scholars throughout the Anglican communion. Designed for the 1954 Anglican Congress at Minneapolis, the Compass Rose has been used by all subsequent Congresses, and at the latest Lambeth Conference, this symbol in bronze was inlaid in the pavement of Canterbury Cathedral. It has been adopted as the emblem for the London headquarters of the Anglican Executive Office, inspiring the cable address "Compasrose."*

The CROSS COMPONY (FIG. 195) or GARBONY is made up of alternating rows of small squares of contrasting colors. This fixed pattern does not run into the innumerable permutations that the checky cross does. The CROSS COUNTER COMPONY (FIG. 196) is made up of two rows of squares arranged so that color is opposite metal and metal opposite color.

FIG. 195 FIG. 196

*Editor's note: The Compass Rose was designed by the author.

FIG. 197 FIG. 198

The CROSS CORDY (FIG. 197) memorializes Christ's Passion, featuring the ropes that were used to bind him. It is an artificial construction but still a very useful one, being appropriate for the Lenten array used in that most solemn season of the Church's year. Note its difference from the cross cabley.

The CROSS COTISED (FIG. 198) has a scroll-like addition to the end of each arm and is generally edged or fimbriated. It is heraldic in form but has come to be extremely important in Georgian churches, where both silver and gold surround a black cross.

It may be best to note at this point that black is not a mourning color but a color of solemnity. The mourning color of the Church is violet, basically because purple was the royal mourning color. The medieval Church did not, by and large, use violet—it was only after the Council of Trent that its use became popular throughout continental Europe.

The CROSS COUPED or HUMETY (FIG. 199) is a cross with the ends cut perfectly square. A saltire (X-shaped) cross with square-cut arms (FIG. 200) is also described as "couped."

FIG. 199

FIG. 200

FIG. 201

FIG. 202

The CROSS CRAMPONY (FIG. 201) is a *hackenkreutz* (broken cross) similar to the swastika except that the "broken" section of each arm is shorter than the unbroken section. Since World War II, the swastika has picked up horrendous associations, but it is actually an ancient and honorable symbol. Indeed, the hackenkreutz appears on one of the principal decorations given by one of the most trusted and beloved countries of the world—Finland. A variant form consits of four *crampons,* tools used in mountain climbing for icy terrain or in raising blocks of stone—anywhere a tight, nonslip grip is needed. This cross is popular as an ornament both with mountain climbers and stoneworkers.

The CROSS CRENELLY (FIG. 202), or CROSS INVECTED, is exactly like the cross bretessed, except that its crenellations are placed opposite one another: each indentation is opposite the indentation on the other side of the arm of the cross.

In the CROSS CROSSLET (FIG. 203), four Latin crosses are arranged so that all four meet together in the center to form a Greek cross. This cross has come to have enormous importance in the Episcopal Church, appearing on both the Church's flag and the Arms of the Primate.

The CROSS CRESCENTED (FIG. 204) is a relic of the Crusades in which the ultimate conquest of the cross over the crescent is made evident. It is also possible, as some have stated, that this cross is a relic of a particular religious body once under the control of Islam.

FIG. 203 FIG. 204

FIG. 205

The CROSS CROSSLET FITCHED (FIG. 205) is a variation of the cross crosslet with the upper three Latin crosses unchanged but the bottom one replaced by a swordlike point. This form was extremely popular with the Crusaders, who could drive the point into the earth and have their complete devotional background wherever they went. This cross appears very frequently in crusading arms as well as in a number of ecclesiastical arms.

The CRUCIFIX (FIG. 206). The actual cross of crucifixion has been discussed in some detail elsewhere. The version used privately and in churches consists of the upright, known as the *stipes*, and the transverse beam, known as the *patibulum*. Until the fifteenth century, the popular version of the corpus had no crown of thorns and the feet were separated—both details still characteristic of Eastern Orthodox usage.

FIG. 206

FIG. 207 FIG. 208

Another cross crosslet variation is the CROSS CRUSILLY (FIG. 207), a series of crossed crosslets covering an entire shield's field in symmetrical pattern.

The CROSS DANCETTY (FIG. 208) is generally a Greek cross in which the edges are outlined with a regular array of jagged points, like sharks' teeth or a saw blade.

The CROSS OF DANNEBROG (FIG. 209) belongs to the Order of the Dannebrog, one of the most distinguished orders of knighthood in the world, dating originally from the first part of the thirteenth century, revived in the seventeenth, and given its present status at the start of the nineteenth. The banner of this order is a red flag (*brog* means "cloth") with a white cross like the one in the example. According to legend, this banner led the Danes, who were Christian, to victory over the Livonians and the Estonians, who were pagan.

The DEGRADED CROSS, CROSS DEGRADED, or CROSS PER-RONY (FIG. 210) is actually four graded or Calvary crosses joined at the crucial point.

The CROSS DEMI-SARCELLED (FIG. 211) is basically a cross paty (see p. 110) with regular indentations at its outer four edges. It has become popular recently in some of the Orthodox jurisdictions.

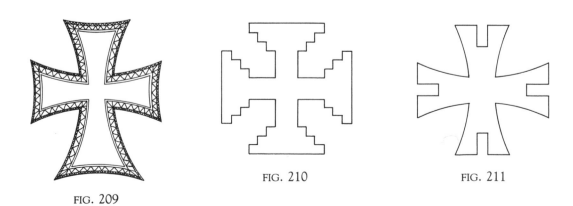

FIG. 209 FIG. 210 FIG. 211

FIG. 212 FIG. 213 FIG. 214 FIG. 215

The CROSS DISMEMBERED or TRONONY (FIG. 212), a cross cut in five pieces, is a decorative item appropriate to mosaics and enamels or, possibly, vestments and banners. As a structural item, of course, it will not work.

The DOUBLE-PARTED CROSS (FIG. 213) is made up of two interlacings blended to form a single unit. With the FRETTY CROSS (FIG. 214), a variant, the interlacings remain separate.

The CROSS DOVETAILED (FIG. 215) is not unlike a crenellated one, except that instead of the rectangular crenellations it features a dovetailed design like the one used in fine cabinetmaking.

The EASTER CROSS (FIG. 216) exists in two forms. A popular but rather sentimental form has a Latin cross twined with Easter lilies (also called the

FIG. 216

FIG. 217 FIG. 218 FIG. 219

cross adorned). The more formal and ancient form is the CROSS RAYONNY, or CROSS IN GLORY (FIG. 217), a Latin cross with rays coming out from the crucial point. It was from its inception a symbol of the Resurrection.

The CROSS ENGRAILED (FIG. 218) is almost exactly like the cross clechy, except that the arms are ornamented beyond the spear-ends with small loops rather than knobs.

The CROSS ERMINY (FIG. 219) is composed of four heraldic ermine tails conjoined by the unification of their spots into five roundels in cross. It is a handsome design, but by its nature must be either imposed or embossed.

The CROSS ETOILE (FIG. 220) is simply a four-pointed star. It is a difficult design to use by itself because of its lack of body at the ends.

The FELLOED CROSS (FIG. 221) is a Greek cross couped with the top arm expanding into a "felly," a segment of the rim of a wheel. It is still occasionally seen on the gables of churches.

The CROSS FER-DE-FOURCHETTE (FIG. 222) is an heraldic invention using the iron rods with forked ends on which soldiers rested their guns in order to aim as accurately as old-fashioned muskets permitted. The form was used most frequently in the seventeenth and eighteenth centuries.

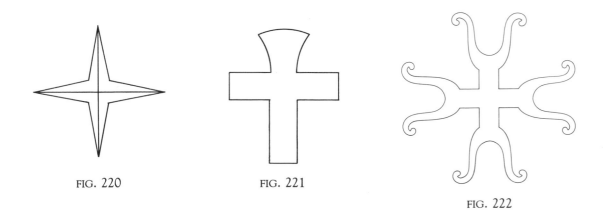

FIG. 220 FIG. 221

FIG. 222

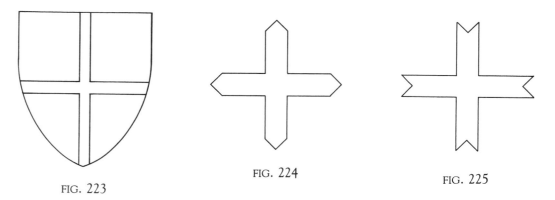

FIG. 223

FIG. 224

FIG. 225

The FILLET CROSS (FIG. 223) is an extremely slender cross that is—from the aesthetic standpoint—often used to provide divisions for other decorations on a shield or flag.

The FITCHED CROSS (FIG. 224), or CROSS FITCHY, is a Greek cross with pointed ends that provides a clear reminder of the sharpness and horror of the cross. The DOUBLE FITCHY CROSS (FIG. 225) has the four spear-points that distinguish the cross fitchy doubled to form eight separate points. As with the Maltese cross, the eight points recall the eight Beatitudes. The CROSS FITCHED AT THE FOOT (FIG. 226) describes any cross with a point instead of a bottom arm. This design dates from the Crusades and in theory provided a cross that could be thrust into the ground when a fixed object of devotion was required (see the description of the cross crosslet fitched). A CROSS PATY FITCHED AT THE FOOT (FIG. 227) indicates that the point is added to the bottom arm rather than replacing it.

The CROSS FLAMMANT (FIG. 228) refers either to a cross whose edges are bursting into flames, or one whose flames come forth from the center in saltire fashion. It is surprising that this unusual, exciting design has not been used more frequently. It does present certain problems of execution, but it could be extraordinarily effective either in embroidery or very fine metalwork.

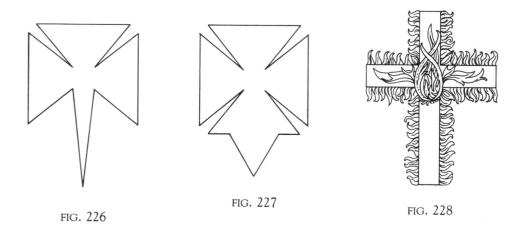

FIG. 226

FIG. 227

FIG. 228

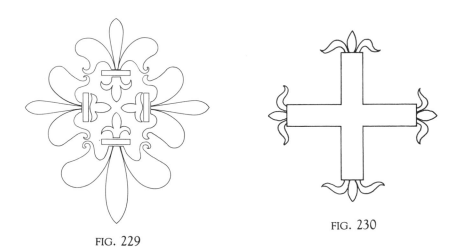

FIG. 229

FIG. 230

The FOUR FLEUR-DE-LIS IN CROSS (FIG. 229) comprises, as might be expected, four fleur-de-lis joined together at the bottoms to form a cross. A symbol of the Holy Trinity, the fleur-de-lis also has a long-standing association with the Blessed Virgin.

The CROSS FLORETTY (FIG. 230) is similar, except that the lower portions of the fleur-de-lis have been cut off and the truncated tops added to the ends of a cross couped.

The CROSS FLEURIE or FLORIE (FIG. 231) is another familiar variety, being seen more often on stoles than is any other type. This Latin or Greek cross has three floral petals added to the end of each arm.

The CROSS FORMY (FIG. 232) is a cross paty (see p. 110) whose edges have been couped so that it does not follow in shield structure but stands independently.

In the CROSS FOURCHY (FIG. 233), the ends of the arms are divided and spread, like the opening petals of a flower. This design is unusually handsome and well balanced—it reproduces well and is particularly effective when realized in wrought iron.

FIG. 231

FIG. 232

FIG. 233

FIG. 234 FIG. 235

The CROSS FRETTY (FIG. 234) is simply a latticework cross of continuous design, neither beginning nor ending at any particular point.

The CROSS FUSILY (FIG. 235) is composed of four diamond-shaped lozenges all of the same substance—or color, as the case might be. These designs allow for considerable interweaving to produce a structural form dear to Celtic and Byzantine designers, as in the *Book of Kells*.

The CROSS GIRONY has its center cut to resemble a pinwheel. There are a number of variations on this design, most notably the CROSS GIRONY OF EIGHT (FIG. 236) and the CROSS GIRONY OF SIXTEEN (FIG. 237). With different possible color combinations, the possible number of permutations on this design is simply staggering.

FIG. 236 FIG. 237

The CROSS GRINGOLDY (FIG. 238) is a cross whose arms end in two serpents' heads. The double serpents' heads, which may seem odd to the Western mind, frequently appear on the scepters and pastoral staffs of Orthodox and Celtic clergy.

FIG. 238

FIG. 239

The IBERIAN CROSS (FIG. 239), or the cross of St. James of Compostela, is the singularly graceful design appropriate to the distinguished Spanish Military Order of Santiago. Its use has increased along with the popularity of Compostela as a pilgrimage site.

The CROSS INDENTED (FIG. 240) is basically the same as the cross dancetty. Its teeth, however, are much smaller and even more like the teeth of a saw.

The CROSS INTERLACED (FIG. 241) is a variation on the cross double-parted, with ends joined together to form a consistent and unbroken whole.

The JEWELED CROSS (FIG. 242) is a plain Latin cross studded with five red jewels, symbolic of the five wounds of Christ. It should be noted that the stones are placed in strict formation and are not intended to suggest a particular area of a crucified body.

FIG. 240

FIG. 241

FIG. 242

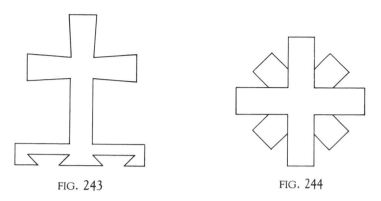

FIG. 243

FIG. 244

The CROSS LAMBEAU (FIG. 243) is a cross paty (see p. 110) resting on what, in heraldic terms, is known as a "label." The arms of various royal children and royal dukes are distinguished from one another by their labels, which bear designs appropriate to each person.

The LOTHRINGIAN CROSS (FIG. 244) is a cross couped surmounting a saltire couped, a happy combination that originally became famous as the cross of Alsace-Lorraine.

LOZENGES IN CROSS (FIG. 245) simply describes a cross constructed of diamond-shaped lozenges. In strict heraldry, the number of lozenges involved must be stipulated. With the variation called CROSSED LOZENGI (FIG. 246), the actual field of the cross is divided into lozenges but remains continuous.

The MALTESE CROSS (FIG. 247), originally the badge of the Republic of Amalfi, was adopted at the beginning of the ninth century by Benedictine monks stationed at a hospital founded in Jerusalem on land purchased by the Republic. But it is most easily recognized as the symbol of the Sovereign Military Order of Malta, of the *Johanniterorden,* and of the Most Venerable Order of the Hospital of St. John of Jerusalem. Again, the eight points refer to the eight Beatitudes.

FIG. 245

FIG. 246

FIG. 247

FIG. 248

The CROSS OF MARRIAGE (FIG. 248) symbolizes the Church's conviction that Christian marriage is the Church's blessing that rests upon a natural function common to all people. This is indicated by the cross resting upon interlaced wedding rings.

The CROSS MASCLY (FIG. 249) derives its name from the Latin word *mascula,* meaning "spots." The cross mascly is so named because it is made up of five spots defined by their edges, or, more technically, five voided meshes whose points touch.

The CROSS MASCLY POMETTY (FIG. 250), a variation in which twelve knobs have been added to the external points of the cross, has become a popular design in religious jewelry sold in the Holy Land.

FIG. 249 FIG. 250

The CROSS MILLRINE (FIG. 251) is another instance of a common tool's use in religious design, the arms of the cross being derived from the clamps that hold an upper millstone in place. This design gained particular ecclesiastical significance during the religious wars of the seventeenth century.

FIG. 251

FIG. 252

FIG. 253

FIG. 254

The CROSS MOLINE (FIG. 252), an heraldic invention in which two flower petals terminate each arm of the cross, is a popular design in ecclesiastical embroidery.

The CROSS NEBULLY (FIG. 253) takes advantage of an heraldic dividing line made up of a continuous series of interlocking semicircles.

The CROSS NOWY (FIG. 254) refers to any form of cross with a circle or round disk at the meeting of the four arms.

The ORB, or CROSS TRIUMPHANT (FIG. 255), is a globe girdled by a band and topped by a small, freestanding cross. The orb symbolizes the sovereignty of Christ. Orbs were regular parts of the royal regalia of France, Britain, Spain, and the Holy Roman Empire.

The PALL CROSS (FIG. 256), occasionally called the "forked" cross, is derived from the pallium worn by archbishops in the Western church as a symbol of their office. The most famous examples would be the armorial bearings of the archbishop of Canterbury and the archbishop of Armagh.

FIG. 255 FIG. 256

FIG. 257 FIG. 258

The PATER NOSTER CROSS (FIG. 257) is a Greek cross entirely composed of small roundels that give the appearance of beads. Each arm contains five beads with a single bead at the center, the number "5" referring to the five letters of PATER.

The CROSS PATONCE (FIG. 258) is a simpler form of the cross paty patonce (see following entry) in that the arms are straighter and more slender. This cross can easily take either Latin or Greek form, whereas the cross paty patonce is best realized in Greek form.

The CROSS PATY (FIG. 259), one of the most famous crosses in history, is apparently the original form used by the Knights Templar. The four arms curve outward, and the ends of the arms are straight. The CROSS PATY INDENTED (FIG. 260) is a variation of this classic cross with the ends indented to form five points at the end of each arm. When the arms do not curve, the form is known technically as PATY FORMY (FIG. 261), and a regular cross paty with a spear-end added to the end of each arm is PATY FITCHED (FIG. 262). Another graceful and popular derivation is the PATY PATONCE (FIG. 263), in which the arms end in a three-part floral pattern.

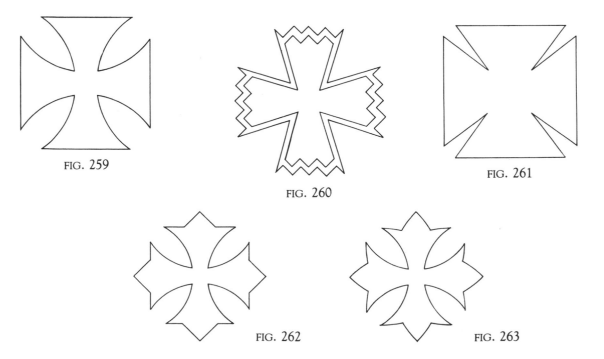

FIG. 259 FIG. 260 FIG. 261

FIG. 262 FIG. 263

FIG. 264 FIG. 265 FIG. 266

FIG. 267

The CROSS PER FESS COUNTERCHANGED (FIG. 264), the CROSS PALE COUNTERCHANGED (FIG. 265), and the CROSS QUARTERED COUNTERCHANGED (FIG. 266) give a slight notion of the endless possibilities in the heraldic division of a shield. "Counterchange" means that what is metal on one side is color on the other, whether horizontally (FIG. 264), vertically (FIG. 265), or quartered (FIG. 266).

The CROSS PHEON (FIG. 267) is composed of four pheons—barbed heads of arrows—meeting point to point. This cross has been associated with St. Sebastian because of the form of his martyrdom.

The CROSS PIERCED (FIG. 268) is either a Latin or Greek cross with a hole at the crucial point. The CROSS QUARTERLY PIERCED (FIG. 269) has the junction of the four arms hollowed out, providing a large, empty square at the center. The CROSS QUARTER PIERCED (FIG. 270) is identical, except that the penetration at the crucial point is much smaller than the square created by the full expanse of the crossing arms.

FIG. 268

FIG. 269

FIG. 270

FIG. 271 FIG. 272

The CROSS POMMELLY consists of one to three freestanding bezants added to the ends of a couped Greek cross. Sometimes the bezants are joined to the cross by a small base (FIG. 271). The variety with three bezants at the ends of the arms was popular in Victorian days (FIG. 272).

The CROSS POMMY (FIG. 273) is similar to the cross bezant except that the fifth circular disk is not present at the crucial point. This cross is important as the symbol of St. Michael the Archangel (see p. 000).

The CROSS PORTATE (FIG. 274), obviously intended to convey the angle at which it would be carried (note the adjective "portate"), is a simple but effective symbol of the Via Crucis.

In the CROSS POTENT (FIG. 275), the central cross in the pattern comprising the Jerusalem cross mentioned earlier, four tau crosses are joined together. The four taus, however, are associated not with the cross but with the T-shaped form of crutch that was used until the start of this century. The cross potent was regarded as symbolic of the New Testament healing miracles.

FIG. 274

FIG. 273

FIG. 275

FIG. 276 FIG. 277 FIG. 278

PROCESSIONAL CROSSES: According to that august authority, Bruno Bernard Heim, the so-called PAPAL CROSS (FIG. 276) with its three traverse beams was developed without any heraldic approval by the Holy See. In strict heraldic terms, the papal cross carried immediately before the pope in procession must have a single traverse beam. The PATRIARCHAL CROSS (FIG. 277) is a fifteenth-century creation. Heralds have assigned it to the armorial bearings of the several patriarchs since the seventeenth century, and it is now in general use by primates and currently by archbishops as well. Bishops whose heraldry is controlled by the Holy See adorn their arms with a single barred cross, the LATIN CROSS (FIG. 278). The proportions of the Latin cross, the *crux immissa,* are constant, but the terminations may have augmented designs.

The CROSS QUADRATE (FIG. 279) is a couped Greek cross with a larger square added at the crucial point. This design has on occasion been used on a Latin cross—a tricky undertaking in which the side arms should be shortened to maintain pleasing proportions.

The CROSS RAGULY (FIG. 280), occasionally referred to as a "knotted" cross, uses an heraldic form of tree branches in alternating positions on the sides of each arm.

FIG. 279 FIG. 280

FIG. 281

FIG. 282

The CROSS RECERCELY (FIG. 281) is reminiscent of the cross moline, but the ends of the arms are rounded rather than pointed.

The CROSS OF REGENERATION (FIG. 282) is a form similar to the Maltese cross but with the angulation at the points only half as sharp. The eight points are again reminders of the Beatitudes. In historic religious thinking, eight is also the number symbolic of rebirth in Christ.

The CROSS RUSTRE (FIG. 283) is made up of five voided meshes, as in the cross mascly, but the voids are circular instead of rectangular in shape.

The CROSSES OF ST. ALBAN, ST. ANDREW, ST. OSMUND, and ST. PATRICK (FIG. 284) are identical, comprising in each instance a saltire on a shield. They are distinguished by the assigned colors. St. Alban has a gold saltire on a blue field, St. Andrew white on a blue field, St. Osmund black on a gold field, and St. Patrick red on a white field.

The CROSS OF ST. CHAD (FIG. 285) is a cross potent quadrate (four sided) between four crosses formy (see p. 107), the whole divided per pale red and white and all counterchanged.

FIG. 283

FIG. 284

FIG. 285

FIG. 286

FIG. 287

The CROSS OF ST. CONSTANTINE (FIG. 286) is naturally the *chi rho* of Constantine's vision, with the Latin letters IHSV standing for *In hoc signo vinces,* or "In this sign conquer."

The CROSS OF ST. CUTHBERT (FIG. 287) is a representation of the pectoral cross found on Cuthbert's breast when his tomb was opened in 1827.

The CROSS OF ST. ELIZABETH (FIG. 288), mother of St. John the Baptist, employs an interesting piece of symbolism. The fruit of her vine, so to speak, is St. John Baptist, represented here by a Maltese cross. When shown in color, the cross is white, the leaves and stem are gold, and the background is black.

The CROSSES OF ST. GEORGE and ST. HELENA (FIG. 289) are identical except for color. St. George is patron saint of both England and Greece and is represented by a red cross on a white field, while St. Helena, mother of the emperor Constantine, is represented by a gold cross on a purple field.

The CROSS OF ST. JAMES (FIG. 290) is different from the Iberian cross in that its base is shaped like a dagger.

FIG. 288

FIG. 289

FIG. 290

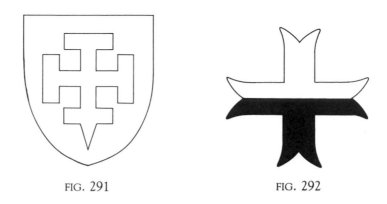

FIG. 291 FIG. 292

The CROSS OF ST. JEROME (FIG. 291) is technically a cross potent, fitched (pointed) at the foot, red on a white field.

The CROSS OF ST. JOHN OF THE CROSS (FIG. 292) represents an interesting heraldic division of a shield. The color of the shield was determined by those characteristic of two religious orders: the black of the Jesuits who trained him and the white and brown of the Carmelites. In technical language it is "per fess, in base party per pale, argent and brown." This means that the top half of the background is black and the lower half divided, with the left half of the shield as you look at it being white and the right half brown. Over this is set a cross moline "party per fess, argent and sable," which means that the moline cross is divided horizontally, the upper half being white and the lower half black.

The design of the CROSS OF ST. JUDE (FIG. 293), identical with that of ST. PETER, shows a Latin cross inverted (upside down). According to accounts of their deaths, each saint wished to be crucified upside down, since neither felt he was worthy to have the same position as our Lord had on the cross. The only distinction is in the colors used. St. Jude's cross has a gold shield with the cross done in red; St. Peter, a red shield with the cross appearing in gold.

The CROSS OF ST. JULIA OF CORSICA (FIG. 294) derives from the legend of a Christian slave girl who refused to land voluntarily in Corsica. The local chief had her hanged from a cross for refusing to renounce her faith. When shown as arms, the cross is gold, the rope natural, and the field red.

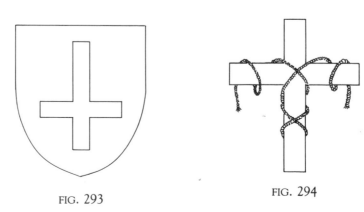

FIG. 293 FIG. 294

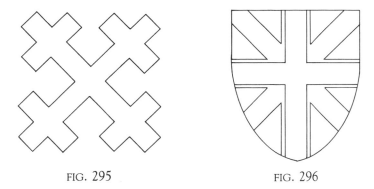

FIG. 295 FIG. 296

The CROSS OF ST. JULIEN LeMANS (FIG. 295) is a regular cross crosslet, but in the saltire position. Although Julien was extremely popular in England, the reason he is associated with the cross crosslet is lost.

The CROSS OF ST. MARGARET OF SCOTLAND (FIG. 296) is as effective a handling of a combination of crosses as is the Union Jack of the United Kingdom. In technical terms, this cross appears on a shield azure. The charge reads: "A cross sable, fimbriated argent over a saltire of the third." In ordinary language, this means a blue shield on which there is a black cross with white edges on top of a white saltire, the standard symbol of St. Andrew of Scotland.

The CROSS OF ST. MICHAEL (FIG. 297) is a cross pommy; when shown on a shield, the cross is red and the shield itself is white. Michael was extremely popular with the Normans, both before and after they came to the British Isles. The use of this particular cross as a symbol for him cannot be definitely traced but may have arisen because of the four powerful war maces of the mighty warrior Michael.

The CROSS OF ST. SYLVESTER (FIG. 298) is strictly a patriarchal cross. When shown in heraldry, the cross is white on a blue field. Sylvester, an important figure in the history of the early Church, was famous for the introduction of patriarchal discipline.

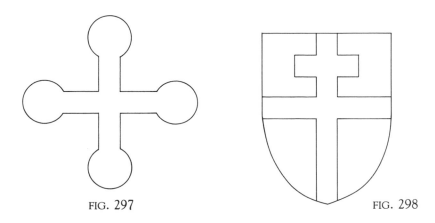

FIG. 297 FIG. 298

FIG. 299 FIG. 300

The SALTIRE (FIG. 299) is an X or *chi*-shaped cross. It is the technical name for the crosses listed for St. Alban, St. Andrew, etc.

The SHIELD OF FAITH (FIG. 300) is actually a simple Latin cross displayed on a shield. The coloring should be carefully chosen to prevent confusion with combinations already preempted by arms assigned to or suggested for particular saints.

The SIXTEEN-POINTED CROSS (FIG. 301), a variation on the eight-pointed cross, was developed in heraldry at a time when virtually every other form had been used.

The CRUX STELLATA (FIG. 302) is a cross, either Greek or Latin, whose arms terminate in eight-pointed stars, only seven of which are visible. The Hebrew religion found stars to be a marvellous expression of the glory of God and, on occasion, a guiding light for those following some vocation God had sent. Also, a curious mistranslation of one phrase referring to the Blessed Virgin produced *stella maris* (star of the sea), a symbol that became increasingly popular through the late Middle Ages. All of this symbolism is reflected in the *crux stellata*.

FIG. 301 FIG. 302

FIG. 303

FIG. 304

The SWASTIKA (FIG. 303), also known as the CROSS REBATED, the FYLFOT (FIG. 304), or the CROSS GAMMADIAN, is pre-Christian in origin and was part of the formal decoration of clerical clothing right into Christian times. It has become unpopular, of course, since its adoption by the Nazis.

The THORNY CROWNED CROSS (FIG. 305) is a striking symbol of the Passion and, in churches using *antependia,* a common sight during Passiontide.

The CROSS OF THUNDER (FIG. 306) is a singularly effective adaptation of Old Testament readings on the power of God, echoing both the hymn of the thunderstorm recounted in Psalm 29 and the famous hymn "St. Patrick's Breastplate."

The CROSS OF TOULOUSE (FIG. 307) is a gold cross clechy on a red field.

FIG. 306

FIG. 305

FIG. 307

FIG. 308 FIG. 309

The CROSS TRI-PARTED FLORY (FIG. 308) is an extremely ornamental form in which each arm is divided so that the fleur-de-lis endings carry through to the crucial point. The crucial point itself is solid, but the interstices leading up to it are sufficiently open to reveal the tripartite relationship of the arm portions. This highly satisfactory form is used effectively on stoles.

The CROSS TRI-PARTED AND FRETTY (FIG. 309) is a complex but easily understood symbol. It has three vertical and three horizontal members, all of equal length, interwoven at their junctures. This handsome design is, naturally enough, popular in ecclesiastical needlework.

The CROSS URDY (FIG. 310) is basically a cross with spear-ends added onto it. It shows up frequently in all heraldry involving forms of martyrdom, especially death by spear. The cross urdy depicted as rising out of a chalice is a symbolic reference to the Lord's agony in the Garden of Gethsemane (FIG. 311).

The CROSS VAIR (FIG. 312) is based on the heraldic "vair" used to indicate fur. The four arms are thus the symbols of vair, but the figures themselves seem almost bell-like in structure. This does not differ greatly from the cross capital.

FIG. 310

FIG. 312

FIG. 311

FIG. 313 FIG. 314

CROSS VOIDED (FIG. 313) describes any form in which the whole center is removed. When you have a cross voided at the center, it means that there is a hole at the crucial point of the cross.

The CROSS WAVY (FIG. 314) is one in which the arms undulate in the heraldic convention representing waves of the sea. This is an excellent example of the herald's facility and imagination in creating symbols that speak to a particular situation.

TEN

Symbolism as Expressed in Flags, Banners, and Crowns

THE VIRTUES AND strengths of nations have long been represented by the virtues and strengths of creatures. Earliest standards, or flaglike symbols, tended to perpetuate a warlike heritage by including bloodstained cloths or leather and skulls. By classical times, the Roman legions were using a spear bearing the symbols of a unit's history and allegiance as their standard, or *signum.*

In 104 B.C., the eagle became the sole standard of the Roman legions. The spears now also carried a portrait of the current emperor below the *vexillum,* the small flag suspended below the fixed metal portion of a ceremonial mace. Napoleon had the Roman eagle in mind when he ordered that eagles be used as the finials of all French flags. The eagle remained as Rome's national symbol until Constantine's day, when it was replaced by the *chi rho* (FIG. 315), the symbol of a theoretically Christian empire. Since that time, symbols for Christ have been found in the standards of many nations, if not in the nations themselves.

Before we consider the symbolism of flags, we should explain some of the technical language involved. The end of the flag attached to the pole or staff is called the "hoist." The other end of the flag, which in most instances is free, is the "fly." The pole or staff always appears on the observer's left in descriptions or illustrations. The face of the flag shown is called the "obverse";

FIG. 315

the other side, the "reverse." The "canton" is a small rectangular division at the upper left side of the flag as one faces it. Thus, the blue section of the American flag with its fifty white stars is technically a canton. "Livery" meant, and still means, the colors used habitually by any particular organization or serving group. Thus the servants at Windsor Castle wear a particular combination of colors known as the Windsor livery. When used in flags or banners, the livery colors are ordinarily presented as horizontal or vertical stripes of equal width and numbered according to purpose.

Where most flags with crosses have the cross throughout (FIG. 316), the flags of Scandinavia and Finland have the cross offset to the hoist side (FIG. 317). This design is identical for all the Scandinavian countries and Finland, the only distinction being that of color; Denmark's flag is a white cross on red, Finland's a blue cross on white, Iceland's a red cross fimbriated white on blue, Norway's a blue cross fimbriated white on red, and Sweden's a yellow cross on blue.

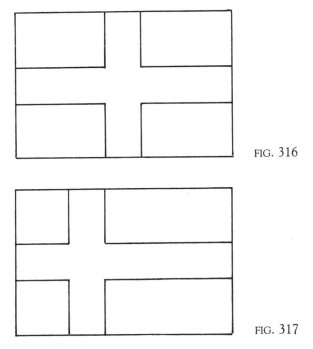

FIG. 316

FIG. 317

The flag of Greece is a blue canton with a white cross and, in livery fashion, five horizontal blue stripes and four white ones. The canton runs from the top of the flag to the bottom of the third blue stripe.

One of the most famous flags in the world is the union flag of the United Kingdom (FIG. 318). This design combines the ancient white flag of England with the red cross of St. George running throughout, the blue flag of Scotland (bearing the white cross of St. Andrew), and the white flag of Ireland (bearing the red cross of St. Patrick). It developed from an earlier combination of the

FIG. 318

flags of England and Scotland, which was made when James VI of Scotland became James I of England. The cross of St. George was fimbriated in white to preserve the memory of the original white flag, and the cross of St. Andrew stayed as it was. Then, at the union with Ireland at the start of the nineteenth century, the cross of St. Patrick (also fimbriated in white) came to divide half of the space of the cross of St. Andrew. When this combined pattern appears in the first quarter of the ancient white English flag, the result is known as the White Ensign. When it appears in the first quarter of a completely blue flag, it is called the Blue Ensign. Until recently, the union flag pattern formed a part of the flags of fifty-eight members of the British Commonwealth. The British Union flag set in a red field (the Red Ensign) was familiar to the American colonists, though it was not as popular as the livery flag of the Honorable East India Company, which had seven horizontal red stripes and

FIG. 319

six white (FIG. 319). This flag had a canton of "Great Britain" in the upper left corner; it was, in fact, the flag in use by the Continental troops from 1775 to 1777. Later, the British Union pattern was replaced with a circle of thirteen stars on a blue field (the "Betsy Ross" flag), combining Washington's command flag with the thirteen white stars "representing a new constellation."

The shield of the Great Seal of the United States (FIG. 320) has seven vertical white stripes and six red, the reverse of the colors on the flag (FIG. 321). In both cases, the color scheme was designed so that the colors at the edges would not "bleed off" because of the lack of definition. With the flag,

FIG. 320

FIG. 321

FIG. 322

seen against the sky, white edges would bleed. With the shield, seen against a colored background, colored edges would bleed. The "chief" (the top third of the shield) in the Great Seal (FIG. 322) is plain blue. The stars appear in a crest position within a circular cloud, poised above the head of the American eagle, which supports the shield.

The tricolor is a widely popular flag design, not only because of its excellent visibility, but also because of the great number of possible color combinations. These various color combinations have often had strong historic and ideological connections, and it is fair to say that every tricolor combination without exception has had religious overtones.

Among the more famous tricolors is France's blue, white, and red (the colors read from the "hoist," or from the pole side to the free side). The traditional colors of Royalist France, dating back to Henry IV of Navarre, were the blue of ancient France and the white of the Bourbons. Red was at one time the exclusive symbol of revolutionary France, and it was Napoleon who brought all three together in the flag we know today. The Legitimist candidate for the throne of France would have indeed become king had he been willing to include the red in France's flag, and France would have returned to monarchy instead of becoming the Third Republic. Other famous tricolors are Belgium's black, yellow, and red; Ireland's green, white, and orange; and Italy's green, white, and red. Mexico's green, white, and red flag is distinguished by the eagle and cactus symbol in its center.

Tricolors that are divided horizontally, or "tierced per fess," include the Federal Republic of Germany's black, red, and yellow (read from the top down); the Netherlands' red, white, and blue; and Argentina's blue, white, and blue. Austria and Peru have identical colors, but Austria is horizontally red, white, and red, while Peru is vertically red, white, and red.

Some flags use symbols with local associations as well. One of the most effective of these is Canada's, which is divided into three parts vertically—red, white, and red. The central white section is double the width of the red sections and is charged with a large red maple leaf.

The religious loyalty of many non-Christian nations is evident in their flags. For example, the crescent of Islam—generally with a star added—is seen in the flags of the Republic of the Maldives, Algeria, the Federation of Malaysia, Mauritania, Pakistan, Singapore, Tunisia, and Turkey. The blue Star of David between two blue bars on white identifies the flag of Israel.

The hammer and sickle of communism has also become an important symbol for much of the world. The flag of the U.S.S.R. uses a five-pointed star above the hammer and sickle. That star also appears in the flags of all the Eastern bloc countries, including China, Albania, Vietnam, Yugoslavia, and North Korea. The state arms of Austria show the sickle in the eagle's dexter claw and the hammer in the sinister claw.

In addition to all of these national banners, there are several important international flags. The Red Cross and the Red Crescent have already been mentioned, and in addition there are the flags of the United Nations (FIG. 323), Nuclear Physics (FIG. 324), and the Olympic Games (FIG. 325), all of which have been assigned the commonly agreed-upon symbols.

FIG. 323

FIG. 324

FIG. 325

In addition to the flags of nations, there are also flags of houses and even individuals, and there is no field in which pedantry is more pedantic than that of flags. The first thing to learn is that the royal standard that flies over Buckingham Palace when the sovereign is in residence isn't really a standard at all but rather the royal banner, the sovereign's armorial flag (FIG. 326). St.

FIG. 326

Joan of Arc's banner is a famous instance of a moral generalization on a spiritual particular. She herself described it as a white field "sprinkled with lilies; the world was painted there, with an angel on each side; . . . there was written above it, I believe, *Jhesus Maria*; it was fringed with silk." It displayed a representation of God giving his blessing to a fleur-de-lis and two angels. According to Dr. Whitney Smith, it was a white St. Joan's banner that "would serve as the principal French national color from shortly after her death in 1431 until the French Revolution almost three hundred and fifty years later."*

The statements made by flags and banners are of prime importance; they are statements of loyalty. On the towers of English churches one may often see flying the red cross of St. George on a white flag, the symbol of the Anglican communion. The papal flag—as seen, for example, in front of St. Patrick's Cathedral in New York—displays the papal tiara and crossed keys. This is not just heraldic decoration: it is a statement of loyalty. As is mentioned elsewhere, the various flags of the orders of St. John are all statements of religious commitment.

*Whitney Smith, *Flags Through the Ages*, p. 66. New York: McGraw Hill, 1975.

FIG. 327

A personal banner is a rectangular flag without any other accompaniment, such as a crest or badge. A standard (FIG. 327), on the other hand, is a long, wedge-shaped flag ending in a single- or double-rounded end at the fly. In early times the first section of a standard bore the symbol of one's nation—cross, fleur-de-lis, or whatever—and in later times, this section came to hold the arms of the bearer. The horizontal sections held one's livery colors, badges, and mottoes of the family. The many forms of banners are known by a confusing number of names, and frequently they have interchangeable shapes.

The *pennon*, or *pennoncelle* (FIG. 328), was a small pointed banner carried at the top of a lance, which generally bore a reproduction of the bearer's badge. There is also a larger form of pennon that was often double-pointed

FIG. 328 FIG. 329

rather than single-pointed at the fly. A curious German form of armorial banner known as a *schwenkel* (FIG. 329) is a rectangular flag with a continuing pennantlike tail at the top of the fly. These tails originally held a horizontal rod that stiffened the banner so that the display or arms would be complete.

Livery banners were rectangles divided either per fess or per pale in the livery colors of the owner.

Scottish practice allows for an *ensign banner*, fundamentally a rectangular flag with a full *achievement* of arms on it—exactly what a standard or banner is not supposed to be.

The military *guidon* (FIG. 330), originally a large, wedge-shaped banner ending in a semicircle at the fly, was used primarily as a guide in cavalry maneuvers. The modern small guidon of infantry troops is swallow-tailed and displays the company's colors.

FIG. 330

Processional flags used by civil and ecclesiastical institutions were suspended from crossed staffs and read vertically rather than horizontally. They are called *gonfallons* (FIG. 331).

Ships of war carried extremely long, swallow-tailed pennants devised either from the livery colors of the country's national symbols or from its arms. These were often simply extensions of the national banners.

FIG. 331

There are many crowns that have played as important a part in the history of their nations as have flags and banners. Indeed, many such crowns, recognizable by their outlines, have become symbols of the nations to which they belong. Nearly all of these crowns have specific religious associations and have at some point been involved in coronation ceremonies, which were, of course, primarily religious. In modern times, with the notable exception of Great Britain's full ecclesiastical coronation, the accession of a new monarch is still effected within a religious context, even though there may be no anointing. The crown itself is present because it is the symbol of the loyalty required of both the head of state and the state's citizenry.

St. Edward's crown (FIG. 332) is the official crown of the United Kingdom, but it is used only at the coronation. On other state occasions, the sovereign wears the Imperial State Crown (FIG. 333). Both crowns have the orb and cross at their top.

The Imperial Crown of Russia (FIG. 334), which was made for Catherine II, has the same form as Eastern Orthodox mitres and the crowns of Byzantine emperors. The crown of St. Stephen of Hungary (FIG. 335) is valued enormously by all Hungarians. Its cross, bent during an attempted theft, has never been straightened.

FIG. 332

FIG. 333

FIG. 334

FIG. 335

Austria, when it ceased to be termed the Holy Roman Empire, adopted its own regalia, including the Austrian Imperial Crown, an interesting cross between East and West (FIG. 336). This form of imperial crown was not adopted until 1804, although the crown itself was made in 1602.

The crown of the emperor Charlemagne, kept in the treasury of the Cathedral of Aachen, is quite ancient, but it doesn't actually date to the time of Charlemagne. The eight golden plates that form the crown are surmounted by the "imperial arch" (FIG. 337).

FIG. 336

FIG. 337

The crown of St. Wenceslas (FIG. 338) is a splendid example of medieval goldsmithery at its best.

The crown made for Louis XV (FIG. 339) once contained several of the most precious stones in the world, a 55-carat diamond and a 140.5-carat diamond. The cap on the interior, made of cloth of gold rather than the usual velvet, must be unique among Western crowns.

FIG. 338

FIG. 339

ELEVEN

Symbolism in Liturgy

DESPITE THE COMMON assumption, liturgy does not mean optional and external bits of form and ceremony reflecting the preference or taste of its participants. Liturgy is, rather, the presentation of a religious body's convictions in terms that make those convictions clear to all its users—quite without regard to whether they agree or disagree with those terms. Liturgy means nothing less than the public work of the people of God. Why do we sing hymns? Because they are one of our forms of praise. Why do we say Amen? Because something has just been said or proclaimed with which all of us agree. Why do we bow to the cross? Because it is the symbol of our common loyalty, just as the national flag is the symbol of a particular country.

Liturgy, then, informs all of its attending servants: architecture, art, vestments, and styles of decoration. The first question then must be: What are the people of God in aid of? What do they think they are doing? The word *worship* itself, of course, is a contraction of the phrase "worth ship." In ordinary use the word's history and practice differ not greatly from the word *gossip,* which is a contraction of "God ship" and originally was applied to godparents; thus, the title "Your Worship" as used in the United Kingdom is the ascription of public worth to a particular person. The Christian concept of appropriate liturgy, then, was determined by Christian convictions about worship—worship being simply the public ascription of worth, the recognition of the sacred. Creation itself is sacred because the Creator is sacred and holy—his handprints are visible in his world. A holy building exists to call attention both to the holiness of the Lord *and* to the holiness of all that he has made: light and darkness, the heavens, the earth, the waters, the green things, the beasts of the field, the birds of the air—and men and women!

The Christian experience in liturgy arose from several sources: the splendor of the Temple in Jerusalem where God had caused his Name to rest, the simple synagogue that served the instructional and social needs of a community, and the meal held in an upper room, with its mystical quality of continuation—the Eucharist. (The word *eucharist* itself means "the giving of thanks," but of the fifteen times the word is used in the Greek New Testament, each time is directly or indirectly connected to the breaking of bread and communion with the risen Lord.) To these three sources the early Church constantly looked for the means to convey its religion and way of thinking. This is why the emperor Justinian likened the great church he had built to the Temple of the Old Testament. Indeed, the Temple left two permanent marks on Christian religious architecture: the splendor of space and the Holy of Holies.

The services at the Temple in Jerusalem must have been a magnificent spectacle. Herod's Temple (Solomon's had been destroyed) had taken fifty or sixty years to build and was considered one of the wonders of the ancient world. There were great open courtyards, one of which was the Court of Men, or the Court of the Faithful. Only Jews were allowed in it, and after his *bar mitzvah*, a boy came here to be recognized as a man in Israel. There was also a Court of the Gentiles, which was for people called "God-fearers." God-fearers recognized that the God worshipped by the Jews was the one and only God, but they were neither circumcised nor of a mind to become Jews. There were a fair number of them, but if one of the Gentiles entered into the Court of the Faithful on a high feast day, or any other day for that matter, he would most likely be seriously harassed. Feelings ran very high.

A great flight of steps ascended to the Holy of Holies in the Great Temple. The songs in the Book of Psalms described as Psalms of Ascent were sung as the temple clergy moved up the ceremonial stairs. Punctuating the steps were an altar of incense and an altar of burnt sacrifice.

The altar of incense (FIG. 340) originally was a fumigatory intended to counteract the otherwise dominant odor of burning flesh, but incense has other advantages besides its odor. It is superbly beautiful to look at, it creates a mystique as the smoke rises and disperses, and its effect indeed illuminates the ancient prayer "Let my prayer be set forth in thy sight as the incense . . ." If one could possibly visualize prayer, incense comes closest to the concept: this great, powerful whitish cloud billowing up and thinning out, thinning out, thinning out. Prayer, like incense, not only travels up, it travels out.

Upon reaching the Holy of Holies in this very tall temple (the back half of it reached heights of eighty or ninety feet) set on Mount Moriah, a tall hill itself, the worshipper encountered two great leathern curtains through which

the high priest entered. The curtains were fastened one to each side wall, but they hung one in front of the other, providing passage of about a cubit, or twenty-four inches, between them. Thus the high priest entered at one side, moved through the passage, and emerged at the other end, whether arriving or leaving the Holy of Holies. There was no light in the Holy of Holies whatsoever, except light taken in by the high priest.

Originally, in theory, the Holy of Holies was where the Ark of the Covenant (FIG. 341) rested. Nobody really knows just what this looked like. The "Mercy Seat," as the Ark was also called, was said to have cherubim sitting on either side of it, but these probably weren't the cute little cherubs we imagine today. Rather, it is quite likely that they were tremendous, otherworldly winged creatures, not unlike the great Babylonian figures of Baalbek. (Another reference, in Genesis, to the cherubim is a connection with a flaming sword "which turned every way, to keep the way of the tree of life." This is known as the Sword of Expulsion (FIG. 342) and seems to have been in the charge of the cherubim.) In the Ark itself were the Tables of the Law and Aaron's Rod. When the Ark ceased to rest in the great Temple, we do not know; it is likely that it was destroyed before the Israelites went into exile.

FIG. 341

But the *Shekinah*, the presence of God, was still in the Temple. Of course, God is everywhere, but sometimes he sets his Name in a particular place and sanctifies that place, as in this quote from Genesis: "God caused his Name to rest in the temple." Yet when the people were forced into exile, the *Shekinah* went with them. Symbolic of the relationship of God with his people, it moved with them wherever they went. When the Romans attacked and burned the Great Temple in the year A.D. 70, they were quite shaken to find nothing except solemn beauty within the Holy of Holies. (The Romans fundamentally had no religion, they were just supremely superstitious. After they conquered Egypt, for example, the first thing they did was erect a temple to an Egyptian god in Rome to keep that god quiet—a prime example of their bureaucratic, imperialistic thinking.)

FIG. 342

The interior space of the Holy of Holies was richly decorated—with fine carving, gold, and jewels—but no one ever saw it. It is important to remember this fact when offering anything to the glory of God. It is also important for St. Luke to note that the veils of the Great Temple split at the moment the Lord died. There must have been a kind of internal explosion in the Holy of Holies at that moment.

One must never assume it necessary to have "things" in a place for the place to have a concentration of spirit. If God has set his Name there, look

out. St. Cuthbert, for example, dominates Durham Cathedral. He is one of the few saints whose living spirit is well known. During World War II, when the Nazi planes came over and began bombing Durham, a great mist, terribly out of season, rose from the River Wear and covered the cathedral completely. All the locals—including the Roman Catholics, Church and Chapel, and village atheists—knew the significance of the mist. It was Cuthbert, protecting his place.

One can, of course, find the curious power of holy places in settings that are not subject to the ordinary rules of Christian liturgy, from Sri Lanka (a Buddhist monastery there is obviously, powerfully holy) to the starkest and simplest of Quaker meeting houses. And Orthodox Judaism today, of course, is quite removed from the splendor of the Temple. During worship in a synagogue, it sometimes seems that everyone is doing something different— all praying, but each man at his own pace. Jewish liturgy, as we understand the term, disappeared with the Temple, nor is liturgy used in the synagogue. Indeed, the Orthodox Jewish synagogue has no touch of sanctity in and of itself. The only holy things in a synagogue are the scrolls containing the Law and the Prophets—the Torah.

The concept of an upper room modeled on the room of the Last Supper gave Christians their attachment to the common table. The original table of the Last Supper was U-shaped and low, but worship of a risen Lord promptly ruled out lying down at the reception of the bread and the wine. Indeed, although the origins of the Eucharist lie in a Jewish communal religious meal, it wasn't long before the meal itself disappeared and came to be the "breakfast" following communion.

Modern liturgies tend to restore the ancient Church's sense that its thanksgiving, the Eucharist, means not only communion with God but also communion with one another. Hence, the Church is less and less concerned with such questions as "When is the exact moment of consecration?" and is much more concerned with the fullness of the Body of Christ. The Christian understanding of the memorial of the Eucharist is as an *anamnesis* (memory), whereby, in the mystic memory of the Church, we become a part of the original action and thus part of the original sacrifice of Christ. More simply, in anamnesis one realizes that the answer to the question posed by the spiritual "Were You There When They Crucified My Lord?" is simply, "Yes."

Symbolism is based on a maximal rather than a minimal understanding of the mighty acts of God. Whether one believes a lot or believes only a little, the language of belief is constant. Thus, for example, a lily is one of the

representations of the Blessed Virgin and refers to her whether one thinks of the Immaculate Conception, the Assumption, the simplest evangelical concept of her function, or a straight out-and-out Unitarian concept of her ministry. The lily simply says "Mary." In the same way, the word *table*, *trapeza* in Greek, always refers to the piece of ecclesiastical furniture that supports the elements used in Holy Communion.

The *trapeza* is shaped differently in Eastern and Western churches, the difference arising from the different forms of martyrdom common to each place. When Christians began to erect their own buildings, they wanted to recognize the role martyrs had played in preserving the faith, to show that someone's life had been spent to make it possible for later followers to be there. With this in mind, they placed a martyr's remains at the building's center and designed their altars accordingly. In the East, where martyrs were generally burned to death, the *trapeza* took on the square shape of a funerary urn. In the West, the usual form of death was by arrows, spears, or swords, and the altars generally measured six feet by twenty-one inches, the size of a coffin.

As time passed, various additions were made to the altars, additions that developed into symbols in their own right. The West generally used stone for their *mensa* (altar table), with five *stipes* (legs) situated at the corners and the center to support the brittle stone. The relic was placed in a niche in the center leg. When the altar was consecrated, the bishop took *chrism* (consecrated oil) and made the sign of the cross over each one of the stipes. Eventually, these crosses came to be carved into the altar at the corners and center, and the linen altar cover picked up embroidered crosses reflecting the carved ones underneath. These five crosses came to represent the five wounds of Christ.

Westerners have traditionally thought of the altar as God's body; the Orthodox view the altar as God's throne. Thus, Western altars are vested, as a body can be vested, and Eastern altars have hangings recalling an imperial throne. Western altars are also washed with wine and water on Maundy Thursday, as Jesus was washed to prepare his body for burial. Clearly, the altar, not the cross, is the center of worship in a church, the symbol of God's body. Indeed, many medieval churches did not even have crosses. The altar was the holy thing, vested in scarlet in honor of God's martyrs, vested in gold in honor of his mysteries, and naked on the one day of the year he was naked, Good Friday.

The Western church is basically "low church" compared to the Eastern church, having a simpler, sparer liturgy. The Roman collect, for example, is

a relatively tight, truncated little prayer: "We beseech thee, O Lord, pour thy grace into our hearts; that as we have known the incarnation of thy Son, Jesus Christ, by the message of an angel, so by his Cross and Passion we may be brought unto the glory of his Resurrection; for the same Jesus Christ our Lord. Amen." It says all that it needs to say, but sparingly. An Eastern church prayer saying the same thing would be much longer.

Worship in the Western church is oriented to the ears. St. Benedict is largely responsible for this, in that the offices we have now were largely composed by him. (It is fairer to say that St. Benedict composed the offices than it is to say that he wrote them. They were so heavily taken from Scripture that it was a matter of arrangement and sequence rather than imaginative construction.) These offices, and the music added later, are central to worship in the West. Art, worship through sight, came very late to the Western church and then came mostly from the East. And when visual arts arrived in the West, they were simple and severe, not unlike the Roman collect. The precise, brief, and sharp approach may have been the result of the Western legalistic mind.

The Orthodox church, on the other hand, thinks visually, as a result of its Greek and Eastern background. Icons are central to their worship and to their symbolism, as they think things through very thoroughly. One very important aspect of the Orthodox celebration of the Eucharist is the "Little Entrance," in which the Gospel is welcomed into the service. In the Little Entrance, the Gospel is carried in a candlelit procession and then sung in the front middle of the church, more or less. *

The "Great Entrance," in one pious tradition, represents the funeral procession of Christ. All of the appurtenances of the Eucharist and the symbols of Christ's Passion make their entrance here. When the bishop or priest is preparing the bread for the Eucharist, he uses a little spear about six inches long to cut portions of the eucharistic bread for the Blessed Virgin, for the great Forerunner John the Baptist, for the apostles, martyrs, various other saints, and for the ordinary people. In addition to the spear, there are a sponge and a cross as emblems of the Passion. The Passion symbolism is clearly well thought through. †

The chalice is brought in at the Great Entrance in a glorious procession

*All lections, incidentally, are sung in the Eastern church, with the exception of those on Great and Holy Saturday, when the principal laymen read through the entire Acts of the Apostles in a loud voice while the clergy prepare for the midnight mass.

†The paten, called a *diskos*, a silver plate on a pedestal used for the bread, has an *aster* (star) arching over its top to keep the covering cloth from resting on the bread itself.

while the "Cherubicon" is sung, the anthem that praises "our Lord invisibly uplifted upon the spears of the angels." The Orthodox consecration harks back to early Hebrew thinking, which saw the body as death and the blood as life. Kosher rules still prohibit the taking of an animal's blood, and to understand how seriously the Hebrews took this tenet is to understand why they were so shocked when Jesus told them to drink *his* blood. To a Jew, this was simply unthinkable. Thus, with the bread symbolizing the body (or death) and the wine symbolizing the blood (or life), the Orthodox consecration symbolizes the Resurrection. All in all, this is a typical example of how the Eastern mind works.

This mystical symbolism was definitely not part of the first thinking on the matter. It is certainly not present in the *Didache,* a book of the teachings of the Twelve Apostles believed to have been put together as early as the year 130. The *Didache* was written for country parishes that didn't have regular access to the elegant urban preachers who traveled around the countryside. These preachers would lead the congregations in holy—and nearly endless— readings from the Old Testament, as was the custom in evangelical American churches in this century. But the local *episcopos* wasn't learned enough to lead the people in this sort of scholarly prayer, so he used the *Didache,* which was beautifully simple and not mystically obscure. Many of the most elegant items in modern hymnals come from the *Didache.* This division of labor between the resident clergy and the visiting prophets was the beginning of the forms that later came to be agreed upon and formalized.

Just as relatively few people in the early Church knew of the *Didache,* St. Paul himself never heard the whole of Holy Scripture as we know it.[*] Religion for the early Christian meant not the teachings of the apostles or Scripture, but the continuation of Israel's religious pattern. The Christians in Jerusalem were faithful Jews, going to the Temple every day as usual. Then, following the great bursting forth of the Spirit at Pentecost, the early Christians began to withdraw from the Temple after the *synaxis,* the ordinary Jewish service, and reconvene in their own upper room to have their own mystery, knowing the risen Lord in the breaking of bread. The presiding officer, originally one of the Twelve, later was invariably the *episcopos* (bishop). He didn't necessarily say anything at these early services but he was always there, presiding.

In the synaxis, the lectern faced an ark that contained the scrolls of the

[*]Holy Scripture to Paul was the Old Testament plus the Apocrypha. Paul didn't know he was writing Scripture; he would perhaps have written it somewhat differently had he realized that people were going to argue about it forever. (He certainly might have thought twice about some passages in Romans!)

Law. The person reading the Scripture would take the scroll, roll it back and forth until he found what he wanted, and read. If the ruler of the synagogue asked, he would preach,* a practice similar to that of the Quakers of today. In the apse of the synagogue with the ark containing the Scripture, there was a single chair, called in Greek a *cathedra*. When bishops started to use this chair, it came to be regarded as a throne. The bishop would sit in the *cathedra* while he preached, hence the phrase *ex cathedra*. When the bishop spoke ex cathedra, he was to be taken seriously, whether preaching or administering to the needs of his congregation. Because the great fathers preached while seated, the outdoor pulpit found in most great cathedrals and parish churches in France is called a *chaire*. (One can say things sitting down that one can't say standing up.)

As time passed, the Christians were no longer welcomed at the *synaxis*, so they had to come up with their own meeting places. Their favorite sort of building was called a *basilica*, which might be a very large building like a city hall, but also was often a small, domestic building. A domestic basilica would have a courtyard and fountain in the middle, living accommodations along the sides, and a raised area at the far end. It is this raised section that gave us the word *altar*, from *altus*, or "high place." As has been noted, the technical name for what we call the altar is *sacra mensa* or *trapeza*, both of which mean "table."

When Christians were at last able to go public, during the reign of Constantine, the Eastern church was faced with the question of how to convey to a pagan, eye-minded world the history behind it. These newcomers, who developed a keen interest in the Church when they learned that the emperor was to be baptized, knew nothing of the mighty acts of God. So the Eastern church began to put up pictures in the main body of the church, or *nave*, a word that derived from the Latin word for "ship" and that evoked the Ark of Salvation. These pictures in the nave helped educate the people about God and his mighty acts, but they did not address the issue of worship.

And in addition to the bishop and the clergy, pictures were used in worship. There were pictures of the most holy Birthgiver, the great Forerunner, the archangels, the cherubim, the seraphim, Peter, Paul, and all the disciples, the great bishops, even the great doctors. To the Western mind, the

*In the author's opinion, the Polish National Catholic Church is probably right in counting preaching as a sacrament. If more of the clergy regarded preaching as a sacrament, the product might well be less trivial and far better.

preface "Therefore with angels and archangels and all the company of heaven" makes the same point, but to get this information across to an Eastern eye-minded people required visual aids.

Then as now, worship was sharply influenced by the world in which people worshipped. The emperors being all-powerful and treated with great pomp and circumstance, the question naturally arose: if you do this for the emperor, how much more do you do for the King of Kings? As a result, in Byzantium there were two identical thrones, one for the emperor, the other for the Holy Gospel. Imperial mandates were rolled-up scrolls, and much of the ceremony surrounding the reading of the Gospel comes from the image of a mandate from the King of Kings.

The *trapeza* eventually came to be thought of as a reflection of the throne of God, so anything done for the emperor's throne had to be done better for God's throne. Above the emperor's throne was a *ciborium*, a dome supported by columns, so the Church began building domes over the *trapeza*. The emperor had curtains around his throne—originally used when he dealt with foreigners from lands having no treaties with him—and so the *trapeza* picked up curtains. The deacon, who moved back and forth between the congregation and the *trapeza*, came to be called the *angelos*, or "ambassador," of the congregation. In simple terms, he would tell God what the congregation wanted, and the congregation what God wanted.

Imperial custom also had its effect on the physical behavior of the people in church. Members of the imperial court stood in the presence of the emperor, so the members of God's family stood in the presence of the King of Kings. The standard taught to old-fashioned churchmen—one sits to listen, stands to praise, and kneels to pray—is a much later development. After all, no one ever knelt at baptism, only the bride and groom kneel for the nuptial blessing, and prayers go on all the time without kneeling. Monastic offices that are virtually nothing but praises are largely read sitting down. The collect, too, was never the summing up of the epistle and the gospel for the day that it is now thought to be. Originally, it was simply the conclusion of the previous litany, a short prayer that followed the prayers of the people.

Of course, neither the Eastern nor Western tradition should be taken as the final word. Both need a certain adaptability to traditions outside their own. For instance, Christians got themselves in an awful mess in Japan and China because they used white vestments. In the Orient, white is the color for mourning. The Orientals have a totally different mentality, and the Church has had to adapt.

Another area in which the Church has had to adapt itself is that of communion food. Bread and wine are simply not appropriate everywhere in the world. If a person does not eat bread every day and only comes across it at communion, "our daily bread" will mean something totally different to him than it does to us. An Eskimo's "daily bread" is fish. And what does wine mean in India, where there is a very small tolerance for alcohol physically and none mentally? Bombay, one of the principal cities of the world, is totally prohibitionist, so what is a church there to do? I am the last person to believe that we can improve on Jesus Christ, and I do not particularly approve of grape juice for the Sacrament. But where there is a built-in local problem, I suspect God is able to use fruit juice or anything else if he so wishes. We must go with people, not against them and their customs. We must not let the symbols stand in the way of him whom they represent, Christ.

Another aspect to consider regarding the material for consecration is the question of what kind of bread to use. Pita bread is appropriately scriptural but presents some practical difficulties. It cannot be reserved because it dries out to the point of inedibility, so one must have wafers for reserve, no matter what one does in the regular service. But there is a problem with wafers, too. The new Episcopal prayer books call for the communication of babies. In the medieval Church, babies received only the chalice (as did the rest of the congregation) because the wine was swallowed easily. Administering a wafer to a baby could cause its death. After all, wafers can be confusing enough to an adult who has never seen one before, so we can imagine how perplexing they are to an infant who has never eaten anything but pabulum. The question is not which bread one uses, the question is which bread is appropriate at which time.

Symbolism has from the very beginning been the most effective medium for conveying essential truth. We still learn more from what we see than from any other method of acquiring information. To oversimplify, symbolism does not work because "seeing is believing," but because "believing is seeing."

TWELVE

Symbolism in Vestments

VESTMENTS, LIKE MOST other symbols of Christianity, arose only after the Church was established—strictly speaking, the only vestment with recognized New Testament authority is a towel, or just possibly the stole, if it is regarded as an item derived from the Jewish prayer shawl. Since fashion in clothing in general, and vestments in particular, tends to rise from the ranks rather than being adopted at the top and moving down—the recent popularity of Italian workers' clothes as a style for affluent Americans being a good example—it is not surprising that most vestments had their beginnings in the ordinary clothes of ordinary people. The early Church took the clothes of the pagan world, generally the working clothes of the peasants, simplified them, and adapted them to its own use.

The *casula* of the farmer, which ultimately became the *chasuble* of the early Church, was a form of poncho that allowed a farmer to work in his fields even when it was raining, because he could see down inside the front of his cloak to watch what he was doing. It had one seam in the front and a hood for working in bad weather (FIG. 343).

Since the Romans hated long clothing (their army was entirely equipped with kilts), it was not until after the Church had adopted the garment that the upper classes also took on the casula of the farmer. It is interesting to note that in the Church, the chasuble was not used exclusively by the priests. As was mentioned elsewhere, an ancient illustration depicts St. Augustine and his parents all clothed in chasubles.

One emperor, to the vast annoyance of the half-clad Roman upper classes, introduced in Rome a type of tunic that had been popular in his court in Dalmatia. These dalmatic tunics—long, nearly white robes with oxblood-

FIG. 343

colored bands running from the shoulders to the hem (FIG. 344)—eventually caught on in the West and became part of the imperial trappings. When the collapse of the empire left the pope as the only stable force in the principal city of the Western world, he adopted many of the trappings of the imperial court. These included dalmatics for his deacons and albs (from *tunica alba,* or "white tunic") for his priests. These garments were also adopted in the East as the Eastern emperor recognized the power of the clergy by dressing them as officials of the empire.

The *pallium,* the great shoulder scarf used as a sign of episcopal office (FIG. 345), was inherited from the philosophers of Greece after being run through the splendor of the Byzantine Empire. In the West, the pallium, or *pall,* became the symbol of an archbishop, and even today it is given to him by the pope on the theory that it is still an imperial gift. The Western pall very soon became a single Y-shaped yoke hanging down both the back and front of the archbishop (FIG. 346), but its antique form can still be seen on the arms of the archbishop of Canterbury and of the cardinal archbishop of Westminster.

FIG. 344 FIG. 345

FIG. 346

FIG. 347

FIG. 348

FIG. 349

The headgear of the Western church also arose from peasant's clothing. The mitre (in Greek, *mitros*) was a cord or band that went around the head and tied in a bowknot in back, rather like today's sweatband (FIGS. 347 and 348). In fact, it was originally worn by Greek athletes at the Olympics to keep the sweat out of their eyes as they performed their athletic feats. Gradually, the Western bishops adopted the *amictium,* a rectangular piece of linen thirty or forty inches in length worn by the Romans as a scarf and held in place with the mitros (FIG. 349). The combination was similar to the Arabs' kefeyeh. The *infulae,* or *lappets,* were simply the long streamers that hung down from the back, where the mitros was tied (FIG. 350). These infulae are still to be seen on the backs of bishops' mitres (FIG. 351).

FIG. 350

FIG. 351

The staff of the bishop was originally the staff of a ruler, the *ferula,* or straight scepter, being considered a symbol of rule. It is not known whether these staffs evolved in the Church from policemen's rods, from devices used to divide the heavens astrologically, or simply from walking sticks used for support before the introduction of seats in churches.

Pope Celestine's letter to the bishops of Narbonne and Vienna, containing the earliest reference to the episcopal use of the pastoral staff, dates from the early part of the fifth century. The staff in its final form was a rod of wood with a head of a precious metal, which was either "crooked" or "crutched," suggesting that the symbolism of the shepherd had great appeal to the early Church.

Staffs in the Eastern church are not as large as those in the West. The head features serpents facing the central cross—a mystical handling of Moses' experience in the wilderness. The Celtic church's staffs are similar but much shorter. Given the fact that the Celts thought of bishops in terms of being grandfathers in God rather than fathers in God, the staffs appear to have served as canes.

The shape of vestments has generally been determined by the liturgics of the period. When everyone stood, there was no reason to have the hands free, so conical vestments presented no problem (FIG. 352). When people started kneeling to receive communion, the officiant needed his hands free, and thus the sides of the chasuble (FIG. 353) were cut shorter to ultimately form the almost straight-sided Renaissance chasuble (FIG. 354). Changes in secular styles in the late seventeenth and eighteenth centuries—which included high heels, wigs, and balloon sleeves—changed the male topography, and the "fiddleback" chasuble (FIG. 355) was developed to reflect these changes.

FIG. 352 FIG. 353 FIG. 354 FIG. 355

There were no liturgical colors in the ancient Church. As far as Clement of Alexandria was concerned, there was only one possible color for Christians, and that was white. The first mention of colored vestments is a fourth-century description of Palm Sunday rites at the Church in Jerusalem, in an account called the *Pilgrimage of Etheria*. According to this document, the regular Church liturgy was performed inside, after which the clergy processed in black vestments to the Mount of Olives, where they had a reading of the Passion according to Matthew. *

We also have early references to the light oxblood-adorned dalmatic worn by the deacon. Deacons also carried a maniple, or *mappula*, a long white towel-like cloth used while administering the sacrament in the hot climate where the Church began. In ancient times the chalices, called *amahs*, had two handles—from which we get "loving cups." The deacon would take hold of one handle, and the communicant would use the other to guide the chalice to his or her lips. As he approached the communicant, the deacon would wipe the sweat from the communicant's brow with the maniple. In the northern countries, where more moderate temperatures eliminated the need for it, the Church kept the maniple anyway. Gradually, it evolved into a small forearm stole (FIG. 356), serving no purpose whatever, and it was finally dropped by Vatican II. (Such is the vast conservatism of the Church: when faced with any two alternatives, it chooses all three.)

FIG. 356

In more modern times, color for vestments seems to be determined by the prevalent weather of the area involved. Violet, for example, and kelly green do very well in Florida or Puerto Rico but very badly in New England. In France, the favorite ecclesiastical color is blue, a preference that quite likely influenced the choice of blue as the field for the French Royal Arms, rather than the other way around. French bishops wore blue, never purple.

The ecclesiastical reference to colors, it should be noted, can be most confusing. In ecclesiastical terms, there is a profound difference between purple and violet. Violet is fundamentally bluish in cast, whereas purple runs from reddish to red. Technically, in the Roman church, when one is "raised to the purple" one wears bright, flaming scarlet.

The English color scheme is tied to climate. England's brief summers are lovely; the autumns, long. But English winters are reliably depressing, espe-

*Matthew's Gospel, as the early Church's favorite, was invariably read on Palm Sunday. Actually, the order of the Gospels in the New Testament is not by chronology but by accessibility, starting with the most popular and ending with the most mystical.

cially in the appallingly dismal month of February. The liturgical colors are chosen to compensate somewhat, to inject some color into gray times. Sundays in Advent call for blue, the great feasts call for gold, the three Sundays before Lent call for blue again. At Epiphany and Trinitytide the clergy generally wear what suits them best, and traditionally it has been rose-colored.

One of the old English color schemes still in complete use is the Sarum color scheme of the Church of England. (*Sarum* is the ancient name for the Diocese of Salisbury.)

A TABLE OF LITURGICAL COLORS according to the ancient USE OF THE CHURCH OF ENGLAND (SARUM)

Season or Day	*Colors*
Advent	Blue
Christmas	The Best (regardless of color), or White
St. Stephen	Red
St. John the Evangelist	White
Holy Innocents	Red
Octave of Christmas	White
Circumcision	White
Epiphany	The Best, or Red
Octave of Epiphany	Red
Sundays after Epiphany	Red
Septuagesima to Lent	Blue
Ash Wednesday	Red (oxblood)
Other days in Lent until Passion Sunday	Unbleached linen
Passiontide	Red (oxblood)
Maundy Thursday	Red (oxblood)
Good Friday (Ante-Communion)	Red (oxblood)
Easter Even (Ante-Communion)	Red (oxblood)
Easter Day	The Best, or White
Eastertide through Trinity Sunday	White (Whitsuntide, in a few places, Red)
Sundays after Trinity	Red
Dedication Festival	The Best, or White

St. Andrew	Red
St. Thomas	Red
Conversion of St. Paul	White
Purification	White
St. Matthias	Red
Annunciation	White
St. Mark	Red
St. Philip and St. James	Red (if in Eastertide—then White)
St. Barnabas	Red
St. John Baptist	White
St. Peter	Red
St. James	Red
The Transfiguration	White
St. Bartholomew	Red
St. Michael and All Angels	White
St. Luke	Red
St. Simon and St. Jude	Red
All Saints' Day	The Best, or Red and White together
All Souls' Day	Black
Funerals	Black
Baptisms	Red
Confirmation	The Bishop alone wears a Stole, and that is Red.
A Saint's Day	
If a Martyr	Red
Virgins	White
Confessors	Yellow or Blue
Holy Women	Yellow
Holy Cross Day	Red (even in Eastertide)

A few notes are in order. As vestments became richer, there developed the hierarchy of best, second-best, and ordinary. Today, for example, when you see an Armenian bishop at a great festival service vested in the deepest blue, purple, or black velvet with sumptuous embroidery, these vestments are the "best." It has nothing to do with color at all. Also, the "red" mentioned in the preceding scheme is actually a pale rose. Several beautiful seventeenth-century examples of vestments with this color still exist today.

While the early Church's vestments were simple and dignified, the Middle Ages added a number of complications—primarily, again, because of the climate. The surplice derived from the *super pelliceum* (in Middle French, *surpelisse*, referring to something worn over a fur coat). Ordinary cassocks were lined with sheeps' wool, and the surplice was an additional garment conceived for warmth, not beauty. The hoods and scarves that were also used with vestments eventually became the tippet of English academia. Incidentally, the absurdity of an outgrown tradition becomes evident in Japan in July—where, in heat that surpasses belief, priests still wear vestments that are neither apostolic nor patristic but were designed for the climate of medieval Europe.

Medieval bishops, then, wore a vast number of vestments, a number that generally increased as Christianity moved north into colder and colder climates. Thus, a medieval archbishop would be vested with a cassock, amice, white alb *(tunica alba)*, girdle, stole, tunicle, dalmatic, chasuble, pallium, maniple, gloves, mitre, and special stockings and shoes. He would also wear a ring that fitted over his gloved fourth finger on the right hand and would carry the archiepiscopal crossed staff. These vestments have been somewhat simplified in recent years. The *capa magna* (long train) with its fur overcape is seen no longer. The pope no longer wears a three-crowned tiara, and cardinals are now given scarlet berettas rather than the multitasseled hats that used to signify their position.

The medieval theory of clerical rank, unlike the ancient Church's theory, was expressed by putting on additional vestments for each additional Holy Order. The early Church operated not on this basis but on ordination *per saltum*—one started with the bishop, who in turn delegated any particular phase of his ministry that seemed to be needed. Some people became pastors, some social service workers—which is what deacons were—and some liturgical officers. The Church ended up with a tunicle worn by the subdeacons, a dalmatic and stole worn (over the left shoulder) by the deacons, and a chasuble worn by the priests. Ultimately, in the West, a bishop put on all these garments before consecration, implying that the ranks were added on to lower ones rather than derived from the top and ordered as needed. Some newer prayer books do not expect the ordinands—whether for the rank of bishop, priest, or deacon—to be presented wearing any vestments other than cassock and surplice, or cassock and alb.

The evolution of headgear in the Church has been one of gradual elaboration. The simple *pileus* of classical days, a round brimless felt hat, gradually acquired more and more dignity until it became a rather splendid

cylindrical structure with raised ridges running from front to back and side to side. This ultimately led to both the beretta and the mortar board. Stiffening and extending the vertical seams produced ridges on the top of the hat, which eventually gathered a significance of their own. The three-horned beretta (the left horn being eliminated) was used by the clergy in general, the color being determined by hierarchical rank. The four-horned beretta has been reserved for "doctors," becoming the mortar board of eighteenth-century clergy and of seventeenth-century English academics.

The most easily recognized clerical vestment, the clerical collar, has its origins in the "bands" of the seventeenth century. The top of the shirt worn beneath the cassock began to be decorated in the Middle Ages and, by the time of Cromwell, had become a large, ornate affair flowing out of the cassock at the neck and shoulders. These bands were simplified again, until by the end of the eighteenth century they had become two decorated strips of cloth at the neck held together by a stock. Bands of this sort are still seen on the full choir or academic habit of many churches. The clerical collar (the dog collar) developed from the stock.

The vestments of the Orthodox and Eastern churches are in many ways similar to those of the West, although their authority has a slightly different source, as we have seen. The chasuble, or *phelonian* in Greek (FIG. 357), still derives from the working poncho of the farmer. The fundamental undergarment or cassock, *podriasnik* and *andheri* (FIG. 358), is still an all-purpose undergarment. The deacon wears an alb, or *sticharion* (FIG. 359), over the

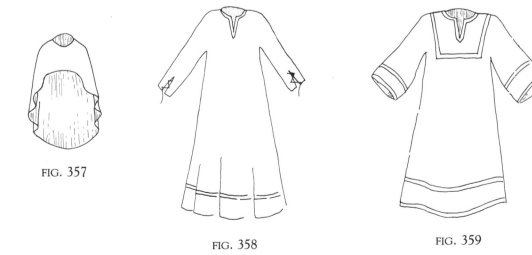

FIG. 357

FIG. 358

FIG. 359

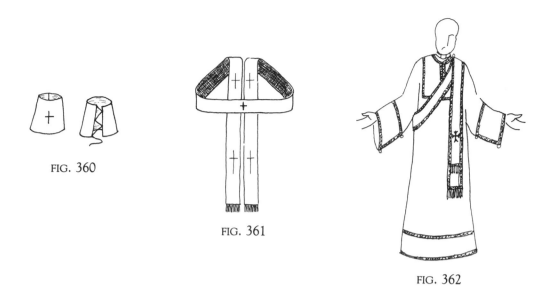

FIG. 360

FIG. 361

FIG. 362

cassock and binds the cassock's sleeves with liturgical cuffs, or *epimanakia* (FIG. 360). The deacon's stole, or *orarion* (FIG. 361), is simply a long ornamented band of material worn over the left shoulder (FIG. 362), but the priestly stole is appropriately enough in yoke form, joined all the way down the front (FIG. 363). In addition, a priest wears a belt, or *zone* (FIG. 364), to hold the stole in place. Subdeacons and acolytes wear just the alb (FIG. 365). The Eastern church insists that the priest wear his stole at every office of the Church, whether public or private.

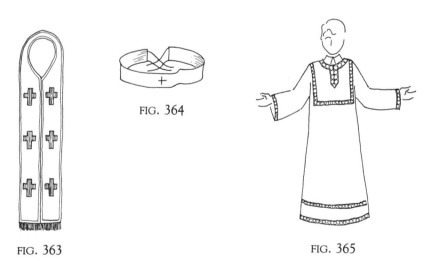

FIG. 364

FIG. 363

FIG. 365

FIG. 366

FIG. 367

FIG. 368

In addition to these more-or-less familiar vestments, a fully vested priest in the Eastern church (FIG. 366) wears a diamond-shaped cloth pendant suspended on his right hip. These *palitzas* (FIG. 367), now awards of honor, were originally used, like the burse of the Western church, to carry the corporal, or *antimas*—regarded in both East and West as one of the essential items for the celebration of the Eucharist. Another decoration of honor, the *epigonation*, is a rectangular case like the palitza but is worn on the left hip (FIG. 368). It was originally a case for carrying the sacred texts.

In place of the priestly *phelonion,* an Orthodox bishop wears a dalmatic-like vestment called a *sakkos,* and at appropriate moments, either of two pontifical stoles: the great *omophorion,* (omofor) (FIG. 369), similar to the Western pall, or the short *omo* (FIG. 370). The bishop also wears a pectoral image called the *panagia* (FIG. 371) on his breast.

FIG. 369

FIG. 370

FIG. 371

FIG. 372 FIG. 373 FIG. 374 FIG. 375

In full pontifical vestments, an Orthodox bishop wears a mitre (*mitra*, (FIG. 372), which developed in the East from amice and wreath, ultimately to become a crown. The everyday headgear of the clergy is either the *scoufia*, a soft cap (FIG. 373), or the *kamilavka*, a stiff cylindrical form of hat (FIG. 374). The material and color of these caps vary with local use, and in the Greek church, the *kamilavka*, or *kamalavkion*, has a projecting lip at the top (FIG. 375).

The black kamilavka used by monks (and all Orthodox bishops must be monks) is worn under the monastic hood, or *klobuk*. Archbishops and metropolitans also have "crosses of brilliance" attached to the top front of the klobuk. FIG. 376 shows a monk wearing the kamilavka with its klobuk and the loose overcassock—Greek *exoraso*, Russian *riasa*. Another part of the monastic habit is the *mantiya* or mantle, a loose, trained cape joined at the bottom front and at the neck opening. There must always be folds in the mantle, to symbolize the all-embracing power of God.

The bishop's mantle (FIG. 377) is colored and, unlike the monk's mantle, has horizontal stripes, usually of red and white, representing the streams of teaching. The four panels on the front at the top and bottom are called the "tables" and may display either crosses or iconic designs. The pastoral staff, or *posokh* (FIG. 378), borne by bishops may take either the tau form or the serpents form mentioned earlier.

FIG. 376 FIG. 377

FIG. 378

FIG. 379 FIG. 380

Armenian vestments are in many ways, and for historic reasons, a combination of East and West. The overcassock, or *verargu,* is similar to the Greek *exoraso;* the *velar,* a conical hat over which the monastic veil is placed, is the Armenian version of the *klobuk* (FIG. 379). The priest's and bishop's vestments are essentially identical with the Greeks', except that the *phelonion* is replaced by a rich cope fastened only at the neck. The Armenian mitre is a tall, baroque version with the *infulae* (the remains of the original *mitra*) attached below the collar rather than to the mitre itself (FIG. 380). The pastoral staff is of a late Western design.

The mixture of Eastern and Western practice can be seen most clearly in the matter of rings. Eastern bishops do not wear rings, Western bishops wear them on the fourth finger of the right hand, and Armenians on the little finger of the left hand.

In addition to vestments that are actually worn, there are those vestments, generally headgear, whose only job is to appear in heraldry. For all clerical ranks below the pope in the Roman church and below bishops in the Anglican church, heraldic headgear consists of a soft, wide-brimmed hat of a type once worn by cardinals. These hats appear above the crest and are ornamented on each side with a number of tassels. Clerical ranks and special offices are indicated by the number and color of the tassels. The clerical hat of a cardinal or patriarch has fifteen tassels on either side (FIG. 381); an archbishop's has ten on either side (FIG. 382); a bishop's has six on either side (FIG. 383); and in all three cases the hat and tassels are green. An abbot has a black hat with six black tassels on either side (FIG. 384). A protonotary apostolic uses a violet hat with six red tassels on either side. A prelate of honor has a violet

FIG. 381

FIG. 382

FIG. 383

FIG. 384

hat, violet cords, and six violet tassels on either side. A chaplain to the pope has a black hat, and the cords and six tassels on either side are violet. A canon has a black hat with three black tassels on either side (FIG. 385); a dean has a black hat with two black tassels on either side (FIG. 386); and an ordinary priest has a black hat and one black tassel on either side (FIG. 387). The College of Heralds, by order of the earl marshall, the duke of Norfolk, makes available the following structural pattern for the clergy of the Church of England: deans, archdeacons, canons, honorary canons, and prebendaries all have hats assigned to them three tassels on either side. The distinctions are made by the designated colors (FIG. 388). The dean has three red tassels on either side suspended from purple cords; archdeacons have three purple

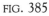

FIG. 385

FIG. 386

FIG. 387

FIG. 388

tassels on either side hanging from purple cords; canons, honorary canons, and prebendaries have three red tassels hanging from black cords on either side. Ordinary priests have one black tassel on either side hanging from black and white cords (FIG. 389). Deacons may use the black hat above their arms (FIG. 390). Certain additional distinctions are possible: members of the ecclesiastical household of the queen may have the hat with their degree charged with a Tudor Rose (FIG. 391). Doctors of divinity have a skein of red interlaced with the cord of their degree (FIG. 392).

FIG. 389

FIG. 390

FIG. 391

FIG. 392

Bishops of the Church of England have continued the ancient practice of ensigning their arms with the mitre rather than with the clerical hat (FIG. 393). Armenian priests wear crowns surrounding the round imperial tiara (FIG. 394). The Greek Melchite uses a mitre much like the Orthodox one (FIG. 395), as do the Byzantine-rite bishops (FIG. 396). One of the most famous pieces of ecclesiastical headgear is, of course, the papal tiara. The use of the tiara dates from the end of the thirteenth century. The three crowns have come to symbolize the Church Militant, Penitent, and Triumphant, comprising the pope's several functions as priest, pastor, and teacher (FIG. 397).

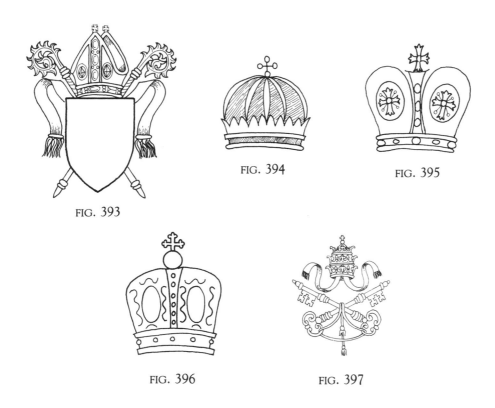

FIG. 393

FIG. 394

FIG. 395

FIG. 396

FIG. 397

One final note on vestments is in order. Vestments have developed as part of the traditions of the Church, and although these traditions enrich the lives of the worshippers by bringing them in touch with their past, they are not graven in stone—nor should they be. For instance, Liverpool Cathedral, while architecturally magnificent, is made of brownstone and provides a poor background for most modern vestments. Dean Dwelly recognized this when he arrived and threw out all the usual vestments to create a new set designed specifically for that building. His results, in saffrons and pale gray-greens, blend with the cathedral perfectly.

In the long run, as Percy Dearmer observed years ago, vestments ought to look like clothing. Any elaboration that interferes with their straightforward usefulness should not be maintained simply to keep up a tradition.

THIRTEEN

Symbolism in Architecture

WINSTON CHURCHILL, IN discussing his plans for rebuilding the House of Commons, insisted on retaining the crowded intimacy so apparent in the Commons when any critical matter is under consideration. In the course of the discussions, he observed that we form our buildings, and then our buildings form us. In the same way, liturgy needs to express itself in buildings, and the buildings, in turn, affect the liturgy.

From the ancient Holy of Holies to the sanctuary of a modern liturgical church, the gathering place for the people of God is still in the nave—the Ark of Salvation. And so the design of the nave is the center of church architecture. Since the late seventeenth century, architects have come to understand that the sphere of attention within a building is fundamentally egg-shaped. In a church, the wide end of the egg would be at the altar, and the bottom (thinner) end would extend to the back of the nave. As soon as people are seated or stand outside the space so defined, their attention drops markedly. The Basilica of St. Peter in Rome is a prime example of space designed with this approach in mind.

Considering the sphere of attention to be egg-shaped has led architects to start designing churches in the shape of a Greek cross once again. The necessity of this approach becomes clear when you consider that enlarging a rectangular church simply moves more people outside of the egg-shaped sphere of attention. The easiest way to accommodate more people without losing them in the four corners of the nave is to design your churches with four "eggs" radiating out from the altar—a Greek cross. The principal Russian churches are so built, and in many other large churches in Christendom, central altars have come to be common practice. Such a design calls for

changes in thinking about the position of choirs, clergy seating, visibility, and, of course, acoustics to make it all work.

The idea that attention is egg-shaped is quite ancient, and this awareness of the body's responses is still preserved in the East, where we see a marked Persian influence in architecture. Ancient Armenian architecture holds many examples of this great heritage, buildings basically circular in shape. Yet the use of circular buildings was more than a matter of practical architecture for the ancient Eastern church—it also had theological significance.

Eastern and Western theologies eventually developed along different lines, with many of the Eastern convictions arising from the writings of Origen. A remarkably free thinker along pre-Freudian and -Jungian lines, Origen believed thought to be limitless, infinite—if you could imagine something, you could think about it. His philosophy exerted a tremendous influence on St. Gregory of Nyssa and Duns Scotus.

Westerners begin with earth and move upward to divinity; Easterners begin with the divine and come down. Recall the Eastern belief that the great columns of Hagia Sophia, the Church of the Holy Wisdom, are not there to hold the great dome up but to attach it to the earth, to keep it from floating away. To the East, the mind of the Father is Love, the expression of that Love is the Son, and the Holy Spirit lifts the congregation up into the life of the Trinity. Eastern liturgy thus puts the worshipper in the middle of Love, and so Eastern churches are predominantly circular or domical, placing the people in the center of the house of God. The Hagia Sophia is an extraordinary example. Despite centuries of Moslem occupation, it still conveys the great theological concepts behind its structure, creating a marvelous sense of intimacy despite its vast size. This idea that the worshipper should be surrounded by the Love of God is also why so many ancient churches contained dioramas, circular vertical structures. Since dioramas are not constrained to centrality, they are infinitely malleable and thus capable of expressing the Eastern understanding of vision unlimited. The absence of corners and confining spaces allows the diorama to meet this need perfectly.

As churches in the West increased in size, they lost their sense of intimacy. Buildings, whether domical or not, can only grow so large before the ceiling or the dome collapses. St. Peter's is enormous, but its vast dome is held in place by a gigantic metal girdle around the base. In large rectangular buildings, the supports must lean against one another. As the pressure at the top of a vast building seeks an outlet, buttresses are needed to support the side walls, and then pinnacles on top of the buttresses. Gothic structure, its architecture

tied to Western thought, destroyed the dioramic effect. The top of a great Gothic building is pointed, and so is Gothic theology. That is why, in some ways, the Norman buildings—Durham Cathedral, for instance—are more effective than the Gothic ones. St. Paul's in London is a striking example; it is magnificently adapted to its liturgy and its climate. Its domical structure is expressive of the enlarged and enlarging nature of the theology it represents.

Differences between Eastern and Western thought appeared at altars as well. In the West the altar was in the open on a raised platform with three flights of steps, two leading up from the nave and one down to the martyry, the depository of a martyr's relics. In the Orthodox churches the altar is surrounded by a great screen of icons, technically called an *iconostasis*. There are three sets of doors in the screen: the royal doors in the center, ordinarily shut except in certain seasons and periods such as Pascha, and two ceremonial doors, one on either side. On the screen are icons of our Lord, the most holy Birthgiver, and the great Forerunner, all placed according to strict rule. While these *iconostases* were originally very simple (St. Vladimir's in Crestwood, New York, is a good example), some of the *iconostases* in the Balkans reached almost unbelievable heights of elaborate decoration. This approach to altar decoration—surrounding the altar with a beautiful screen—represents a different view of the altar. Heaven symbolically exists inside the *iconostasis*, and heaven ought not to be made too easily or casually approachable.

A case could be made that, for the ear-oriented Anglican communion, language serves as the *iconostasis*. If the language is high-flown and stately and secure, Anglicans feel as much in the presence of God as the Orthodox do in the *iconostasis*. It is interesting to note that in moments of supreme triumph and of devastating defeat, Anglicans sing the same hymn, "O God Our Help in Ages Past."

Theology as had its effects on church furniture within the Western tradition as well, as is the case with altar rails. In the days when the Puritans first began to become powerful, it was alleged that Archbishop Laud called for rails in churches to "keep dogs and puritans away from the altar." People discovered that the rails made kneeling very convenient, and so they were retained even after opinions of puritanism changed—not as altar rails but as communion rails. The former were to keep people out, the latter to assist their participation in the Eucharist.

Fixed rails, however, caused difficulties of their own. They preempted space, and were always too short to accommodate many people, and generally they were located at the top of too many steps. The position of these rails

caused endless numbers of people to mill about, which all but destroyed any sense of flow in a service. The upshot of all this is that many churches now use movable communion rails placed below the choir, at the foot of the steps.

John Wesley, an important influence on church design, maintained that the altar should be freestanding with a rail around three sides—thus ensuring that people took the sacraments with each other as well as with the priest. This idea has some merit—the so-called communion stations may be more efficient, but efficiency always exacts a price. Communion means not only communion with God, but also communion with one's fellow worshippers, and too much efficiency can make us miss this very important point.

One of the more recent cases of theology's influencing architecture is the Gothic Revival, which was rooted in the Cambridge Ecclesiological movement in the early nineteenth century. (While Oxford generally produces theology, Cambridge produces philosophy and its aesthetic derivatives, architecture and music.) The most famous example of a Gothic Revival church is the first one ever built, the Leeds Parish Church. This church, a magnificent creation in a wonderful setting, has one fundamental problem—it was built on the High Church theory that every parish church should be a miniature cathedral.

The great cathedrals were designed with monastic choirs, areas where two groups of monks could face each other and sing antiphonally. Additional choirs of men and boys were put in the galleries, as in Canterbury or Westminster Abbey. But transferring this arrangement to parish churches will only work if the parish has endless supplies of money and space. If a parish doesn't have both, and most parishes don't, you end up with what has been rudely described as "one and a half tenors divided firmly between two sides."

The ordinary parish church in England in 1830 would have had a string quartet and possibly a couple of wind instruments up in the gallery with eight voices singing in the choir. This arrangement made for stunning and elegant music—a properly directed quartet could make churches of this period ring with the sound of a forty-voice choir. Much of this effect was lost during the Gothic Revival.

On top of that, people will sing better if supported by voices behind them, and they sing less effectively when the music comes from the front. Music in the front is, also, inevitably associated with entertainment. By moving our choirs and eliminating the gallery, we have weakened the effect of the polyphonic music written for the Church, and it has taken enormous effort and time to get part of this elegant music back. But it is still true that where one has a superb choir, the congregational singing is generally not very soul-stirring.

Another result of the Cambridge movement is that choirs now go in, fully vested, in procession. In the old days, the members of a parish choir did not do anything but sing—they simply went up to the gallery as they were and performed. The more modern practice of marching up to the choir in robes has its architectural implications. The first of these is that a choir in procession should never disappear, visually or audibly, by going up back stairs or separate aisles. (St. Patrick's, New York, has its choir in the West Gallery, and they are audibly nonexistent when en route.) The second result is that all churches must have ceremonial steps—wide enough to take two people, fully vested, walking side by side, and shallow enough that these people won't have to hoist up their vestments to avoid stumbling. These steps should also have a rail.

The day has passed when the liturgies of the several churches were so diverse in their demands that one could immediately recognize a denomination by its building. As it stands now, there are in New York City three parish churches that were apparently designed to meet the same liturgical requirements, yet one is Lutheran, one is Roman Catholic, and one is Episcopal. The working ground plans for St. Patrick's Cathedral and Trinity Church, Wall Street, are now identical, and both are the result of liturgical changes that have come about in the last twenty years.

The frieze above the great bronze doors of the Cathedral of St. John the Divine in New York shows a procession of men and women of all races and nations, and points up the staggering difference between ours and other ages. A medieval cathedral would have "all peoples" include Europeans and Africans. We have to think not only of them but also of Eskimos, Indians, Fijians, Chinese, Japanese, and Lapps, among others. Yet if our knowledge of the totality of our world has increased this much, it is nothing compared to the *cultural* impact of that knowledge.

It must be recognized, however, that since the Christian Passover, no physical space can be consecrated in the *absolute* sense as was the ancient Temple, for Christ himself has become the Temple and his Body has become the Temple of the Holy Spirit. Strictly speaking, this means that no *space* can now be *set apart*. ("The hour cometh, when ye shall neither in this mountain, nor yet at Jerusalem, worship the Father" [John 4:21]).

Ultimately, therefore, the decision about what may be done in a consecrated building cannot depend on whether a thing is holy or unholy, but rather upon its *appropriateness*. Folk dancing is fascinating to watch and certainly most enjoyable for the dancers, but would Notre Dame in Paris,

Lourdes, or Westminster Abbey be the appropriate place in which to perform it?

But there is and always has been such stuff as religious dancing. Indeed, the balletic qualities of the old-fashioned High Mass have long been remarked on. However, some more exuberant forms of rock music may do much to release the energies of the young, but would St. Patrick's in New York or the Trinity–St. Sergius Monastery at Zagorsk be the place for them?

The instinct of the ordinary layman is probably more trustworthy in its assessment of what is appropriate than the reasoning of the library apologist, who may find himself trapped by answers to questions which no one has asked.

FOURTEEN

Symbolism in a Life: Bishop Nicholai Velimirovich

JONATHAN SWIFT, ALTHOUGH known for his brilliance, wit, and social concern, should, in religious terms, probably be best known for his statement "Vision is the art of seeing things invisible." Such vision is characteristic of the Eastern church, and was characteristic too of the late and very holy Bishop Nicholai Velimirovich, bishop of Zica and Ochrid, ancient dioceses of the Serbian church.

Serbian piety has had a long history of martyrdom. In the Middle Ages it had been bled white by the Battle of Kossovo—Britain's experience in World War I, only writ larger. Loving as a captive people under an alien power—alien both ethnically and religiously—the Serbs had come to know that triumphs of the spirit are achieved through such tribulations rather than as a reward after they are over. The cross and the crown are not separate; the emptying of hell is the first scene of the Resurrection.

In one of their glorious hymns of Easter, the Orthodox church sings:

In the grave with the body, but in hell with the soul, in that thou art God;
in Paradise with the thief, and on the throne with the Father and the Spirit,
wast thou, O Christ, filling all things, in that thou art infinite.

It is spiritual genius that recognizes that one can be in hell and in heaven at the same time.

Nicholai, at great personal physical cost, made this point absolutely clear when he was imprisoned in Dachau. He told a young Nazi officer that he didn't *believe* there was a God—he *knew* there was, and Dachau confirmed it more every day. Such, of course, was not the Nazi intention, and along with conviction came triple hernia. The ultimate result was the wondering and awed response of the American troops who liberated him for the first time (and for some others, possibly for the last time). These liberating soldiers also had vision: they saw the invisible and transparent holiness of this aged saint.

Any consideration of Christian symbolism must remain superficial unless it acknowledges the contributions of the Eastern Orthodox mind. These contributions are beautifully exemplified in Bishop Nicolai's small, superb book entitled *The Universe as Symbols and Signs*. Bishop Nicholai made his philosophy clear with his opening quotation from St. Maxim the Confessor:

> "To those who have eyes to see, all the invisible (spiritual) world is mysteriously presented in symbols of the visible world; and all the natural world depends on the supernatural world." This can be understood by those whose spiritual sight is opened to such a degree that they are apt to see by the spirit the spiritual meaning of everything, but not by those who see by physical eyes only the physical being of things.

The only true sight for Bishop Nicholai was spiritual insight, which enables thoughtful Christians to see the hand of God in all that surrounds them. Nicholai started with Adam's naming of the animals, which he viewed not as merely attaching a label but as seeing in each animal a unique relationship to the rest of creation. In some ways Adam's naming may have enabled the very creatures themselves to find their established place in the kingdom of God. Patristic thought holds that the heavens mentioned in "God created the heavens and earth" represent a sovereignty of spiritual or bodiless reality over physical reality. "The earth is meant as the universal amount [the totality] of the bodily and visible symbols of those realities. That is to say, the earth, or the Universe generally, is nothing but a symbolic picture of the heaven," Nicholai stated. He quoted St. Gregory the Theologian: "What the sun is to the natural man, God is to the spiritual." But Nicholai had a prophetic concern that the visible symbol not be worshipped. God and Truth are one and the same; and since God is spirit, Truth has to be spiritual.

For Nicholai, faith was the foundation of life on earth, but the knowledge of God goes beyond faith because it contemplates God face to face, as in heaven. The physical symbols may help our faith by hinting at the facts about

God, the symbolized, but true knowledge of God is based on direct dealings with a person rather than impersonal beliefs about actions or attributes involving the object of belief.

Bishop Nicholai found the message of God symbolically expressed in every aspect of nature. Stone is the symbol of faith in Christ, as in the Petrine confession. Gold, frankincense, and myrrh, according to St. John Chrysostom, are truth, obedience, and love. Salt symbolizes the Christian who is beyond corruption, Nicholai's interpretation of the "salt of the earth." As trees require water and light to grow, so the human soul must be nurtured by the grace of God. Lilies, in Scripture, are symbols of purity and lack of earthly concern; olive trees, symbols of the people elected to do God's work. The seed that dies to come to life again is a figure "of the death of the old and of the birth of the new man in every one of us." Grapes and thorns are figures of the good and the evil of mankind.

The vine is the symbol of Christ—we live and serve only insofar as we are willing to be branches of that vine. The vast movement of God is known best from the symbol of the mustard seed, which starts infinitesimally small but quickly grows to be enormous in size and capable of serving the birds of the air.

The bishop was at his most intense when he likened the soul of a righteous man to a flower that becomes ever more pleasant as it dries out. To understand old age in these terms requires a deeply spiritual perspective. Nicholai also quoted Dionysius the Areopagite as saying that the horse signifies obedience, and he noted that the Orthodox service book calls the apostles swift horses "because they swiftly and faithfully spread all over the world the good news of salvation."

This little book, written decades ago, expresses an understanding of ecology more sensitive than any in vogue today:

> When the Creator of the world created our first ancestors, He said to them, "Have dominion over the fish of the sea, over the fowl of the air, and over every living thing that moveth upon the earth." What does all this mean? Certainly not "to conquer nature" in the modern sense, namely, to exploit it and, at the same time, to worship it. No, the cited words have quite a different meaning. Essentially they mean: "O man, have dominion over all these symbols, and allow them not to have dominion over thee!"

Nicholai saw a city set on a hill as representing the unavoidable visibility of true Christians, just as the candle in a candlestick is visible to all. The

closet of private prayer and the room in the house in which treasure is hidden are symbols of the heart of man, Christ himself being the door to that place as he is also the Way, the Truth, and the Life. New wine *is* new life and requires new containers.

Nicholai wrote passionately of the mistaken charity that would "give a morsel of bread to the prodigal son instead of turning him back to his father's house." A yoke is either a ghastly burden of servitude or a reason for exhilaration, because it means taking on the burden of others. Hence, Christ's yoke, unlike Hercules', is easy and his burden is light. Bags "which wax not old" are the symbols of inner riches. The many mansions of the Father's house symbolized for Nicholai individual human bodies rather than the spiritual rewards they represent in the West. Natural birth was not only a symbol of spiritual birth, but also a reminder that the pains of our childbearing are a symbol of the growth of a spiritual man with the natural man. Water into wine symbolizes the "transformation of the earthly man into the heavenly man."

The great Bishop's most touching statements center, naturally, on Christ:

> The symbols of Christ are: a farmer, a builder, a potter, a carpenter, a hammersmith, an artist, or any other man or woman who, out of rough material, makes something good, useful, and beautiful. Therefore, whenever you see a person of any honest and useful occupation, who by his labor transforms the ugly into the beautiful, and the unclean into the clean, and the abandoned into the useful, and the mean into the noble, and the diseased into the healthy, and the dying into the living, think then of the Christ and his labor upon your soul.

One observation, taken from St. John Chrysostom, sounds curiously modern: "Disrobed, physical athletes are a symbol of spiritual fighters, who are willingly disrobed of the riches and the worries of this world." To Bishop Nicholai, as in the latest theological readings, gender had simply nothing to do with God. "The bride of Christ is every Christian soul, but his bride also is the Church as a whole."

The nonsentimental quality of patristic piety is nowhere more evident than in Nicholai's recollection of the desert fathers' advice about the keeping of a Holy Lent: if, at the conclusion of a highly disciplined and single-minded keeping of Lent, one is no worse than at the beginning, then this should be regarded as a highly successful endeavor.

Nicholai treated dreams as signals rather than symbols, summarizing the

signals in the Old Testament from Abimelech to Daniel; in the New Testament, from Joseph, through the Wise Men, to Pilate's wife. Part of his own deep pastoral experience emerges in this observation: "It is not a rare case that a signal of approaching death is given in dreams to some persons. Not only to the great saints, but also to ordinary persons; and not only in the ancient times, but also in our own." He also noted that dreams can be false and meaningless.

Nicholai's understanding of events as signs provided in itself a remarkably complete essay on the hand of God in human history. Whether or not the unrighteous themselves perish—and they all will, ultimately—the important thing is that their works are doomed. This is true at every level of life, from the history of empires to the history of individuals. But this observation is not, by its nature, necessarily negative. Nicholai wrote:

> Some time when heavy clouds of worries are hanging over our soul, we are unexpectedly visited by some person who helps us to solve our troublesome problem. Or we hear a word, or receive a letter, with the same effect. Entangled in the web of a complicated life, we sometimes despair, not knowing how to disentangle ourselves by our own efforts. Then, suddenly, something happens which does for us more than all our personal efforts. If we are only able to understand all those things as God's signals, either as a warning, or for enlightenment, or instruction, or encouragement!

Peter was warned by the crowing of the cock, Baalam by the observations of an ass. Nicholai, through his own experiences in a concentration camp, came to know the power of the Holy Spirit when oppression was all around him. He knew what it was to have death at hand, but he also learned at one point that the *Phos Hilaron,* or "Gladsome Radiance," was not ready for him yet on that other, wider shore.

Like all mystics of East and West, Nicholai had no patience with "coincidences" but wished people to understand that God is always good, whether to the just or the unjust:

> It is as if a father had two sons, the one obedient and the other disobedient; the one healthy and the other sick, and he gives equal gifts to both. You may protest, "That is not just!" Don't be angry O man! God is not like man. He is not only the God of justice, but also of wisdom and love. By His mercy He makes the strong child stronger and the sick one healthy. He strengthens the one and He heals the other by the same means. To both sons His mercy is a signal; to the one a signal of approval, and to the other a signal for repentance.

Bishop Nicholai also understood natural phenomena to be signs of God's concern, whether the constellation that guided the Wise Men, or the three-hour darkness on Good Friday, or the explosion that rent the veil of the Temple, or the sign in the sky seen by Constantine. Nor were "natural disasters" necessarily signs of God's wrath. These disasters, from the great flood in the time of Noah to the lesser ones of our own day, are more often than not the result of man's failure to be responsible for the land that supports him. (The Dust Bowl of the 1930s offers but one modern example.) War, pestilence, and famine are outward and visible signs of man's inhumanity to man. Sickness may well be the result of bodily weakness, but pestilence is, by and large, the result of human irresponsibility. Thus, in our day, AIDS is not necessarily the result of human sin, but its irresponsible spread from now on most certainly is.

Nicholai's conclusion to all of this must be stated in his own words:

> The Creator of men is not an idle unemployed God, as a philosophic sect of bygone times supposed him to be. He is not passive but the most active being that exists. He causes many efforts in manifold ways to save men, i.e., to make them in this temporary life fit for the life everlasting. He signalizes his holy will to men through the stars, through animals, through events, through famine, through abundance, through catastrophe, through war and peace, through diseases and dreams. With this same desire, to save men, He makes one man signal another man, and one nation another nation. A spiritual person observes this divine procedure every day, and gets the confirmation of this. The Holy Book of God, as a record book of God's intentions, plans and procedures, serves as the unshakeable touchstone of everyday experiences. . . .
>
> The symbolism of things, however, is ever before our eyes and minds; and always as new and clear as the newest edition of a book. Our guide through that forest of symbols and signals is God the Holy Spirit. Different colored lights on the crossways serve as signals to a traveller—which way is right and which wrong, and where is a danger and where a free passage. Even so God, through innumerable signs and symbols, as though a mimicry of nature, reveals the way we ought to travel in security.
>
> Who knows whether searching for the substance of things has ever made a man better? It is doubtful indeed. But it is well known that a knowledge of the significance of things and events has made innumerable souls more enlightened, better, and happier.

Glossary

ABACUS: The rectangular table that forms the topmost member of the *capital* at the top of a column.

ABBOT: A title, ultimately derived from the Greek word for "father," used to describe the ecclesiastical head of certain ancient and independent religious orders, such as the Benedictines.

ABLUTION: The ceremonial cleansing of the chalice after communion.

ABSOLUTION: In liturgical churches, the declaration of forgiveness of truly repented sins. In such churches, only bishops and priests may make such a pronouncement on behalf of the Church.

ABSTINENCE: Doing without something on a day on which the Church requires an extraordinary act of devotion.

ABUTMENT: The solid supporting masonry next to an arch.

ACANTHUS: Conventionalized leaf-form characteristic of the Corinthian style of architecture.

ACOLYTE: A server at the Holy Eucharist; anciently, one of the highest of the minor orders; now, a layman specially trained.

ADVENT: The season of the Church year that Anglican piety devoted to the consideration of the end of the world—the second coming (advent) of Christ.

AFFUSION: The *pouring* of water in baptism, as opposed to total immersion.

AGNUS DEI: An ancient hymn to Christ as the "Lamb of God," sung with

two petitions for mercy and one for peace. In requiems, the petitions are "Grant them rest" and "Grant them rest eternal." As a symbol, the Agnus Dei is a lamb, seated or standing, carrying over its shoulder a cross-topped staff with a *pennon* (a flag ending in two points) attached, bearing a red cross, which is shown to the full extent of the pennon's height and length. The lamb has a tri-radiant *nimbus* (a halo with three wedge-shaped rays forming the top three arms of the cross).

AISLE: One of the lateral divisions of a church, bounded by columns, piers, or walls. (Technically, the space between successive rows of chairs is called an "alley".)

ALB: A narrow-sleeved, ankle-length, and close-fitting white garment ordinarily used by the clergy and the servers at the Eucharist.

ALMS DISH or ALMS BASIN: This is the "decent plate" required by Church rubrics for the reception of the people's alms. The seventeenth- and eighteenth-century Church used it instead of a cross as a decoration on the altar up to the point of the offertory, on the theory that it was a symbol of the Eucharist. The lack of altar crosses in Eastern Orthodox usage lent support to this practice.

ALMUCE (AMYSS): The fur-faced or fur-lined tippet occasionally worn by archbishops, bishops, deans, and canons in certain English cathedrals; popular through the sixteenth century and lately enjoying some revival. In some continental cathedrals, it is carried over the arm.

ALTAR: The popular name for the holy table used in eucharistic rites; technically, the "high place"—the sanctuary.

AMBON: The platform in front of the choir, which holds a pulpit. In many ancient churches, ambons appear in pairs.

AMBULATORY: A processional passageway around the back of the high altar; used during the litany when it is sung in procession.

AMPULLA: A ceremonial vessel for the oil of anointing. The one used in the English coronation service is in the form of an eagle.

AMEN: The Greek word for "yes" or "truly." Its liturgical use is reflected in stational titles, such as the Amen Court, where the canons of St. Paul's Cathedral live, or the Amen Corner, a crosswalk near the cathedral. (See AMEN CORNER.)

AMEN CORNER: In early American churches, a special set of seats toward the front of the building that were reserved for the church's deacons and, of course, properly called "the deacons' bench." "Amen Corner" was a satirical epithet.

AMICE: A square of linen that is placed over the head to form a hood when dropped back over the other vestments after they have been put on.

ANALABYS: The epitrachelion-like scapula of an Eastern Orthodox monk.

ANALOGION: A movable lectern used in the services of the Eastern Orthodox church.

ANASTASIS: The Greek word for "resurrection." Iconographically, it is the Harrowing of Hell, showing Christ standing on the gates of hell and raising Adam and Eve.

ANCHOR: See CROSS.

ANCONA: A large sacred painted image dominating the *apse*. The word itself is a Latin form of the Greek word *icon*.

ANGLICAN: Characteristic of the churches that are in communion with the See of Canterbury and recognize its archbishop as first and senior of their primates.

ANGLICAN CHANT: Fixed four-part melodic structures designed to enable people to sing psalms and canticles (and the two liturgical hymns) on a fixed reciting note with a metrical ending to each half-line.

ANNULUS: The technical name for a bishop's ring. The late medieval habit of wearing a ring over a *chirothecae* (pontifical glove) demanded that the ring be worn on some other and larger finger than the third when no glove was involved.

ANTE-COMMUNION (PRO-ANAPHORA): The service of Holy Communion up to, but not including, the offertory.

ANTEPENDIUM: The *vide* (over-frontal) of an altar. In certain famous instances, for example, the Wanamaker silver altar in St. Mark's, Philadelphia, such frontals may be made of metal rather than cloth.

ANTHEM: A motet of devotional nature, appointed to be sung after the third collect at evensong, or during the offertory in the communion service.

ANTIPHON: A verse of Scripture appointed to be sung before (and after) a psalm, a group of psalms, or a canticle.

ANTIPHONAL: The responsive division of text between two different voices or groupings of voices.

APPAREL: A decorative strip of material applied to any vestment, frontal, or hanging.

APSE: The end of a church housing the high altar.

ARCADE: A series of arches supported (at least on one side) by freestanding columns or piers.

ARCHBISHOP: One of the principal hierarchs of a liturgical church. The archbishop's symbol is the crossed staff rather than the pastoral staff. In the Eastern church, the title can be honorary.

ARCHDEACON: An official representative of the bishop of the diocese in the conduct of the church's business. In the Anglican communion, archdeacons are priests with the title of "Venerable." In the Eastern church they are deacons, but with much the same function.

ARCHIMANDRITE: An Eastern Orthodox abbot or head of a principal monastery church.

ARCHPRIEST: An important priest of the Eastern church dignified by a special title and a special pectoral cross. In the Russian church, some archpriests are granted the mitre.

ARCOSOLIUM: Originally, any niched recess in the walls of a catacomb. This seems to find its continuation in the Easter Sepulchre, an arched recess in which the Sacrament was buried on Maundy Thursday and brought forth on Easter Even.

ARTOPHORION: A small, rich structure generally in the shape of a miniature church (FIG. 398) placed on the altar. It is the container of the consecrated elements of the Eucharist and of the holy myrrh.

ASHES: In the Western church, the officiant on Ash Wednesday marks the people on their foreheads with ashes. These ashes are from the burning of the previous Palm Sunday's palms. The marking is accompanied by some such phrase as "Remember that thou art dust, and unto dust thou shalt return."

FIG. 398

ASHLAR: Regular stones, regularly laid.

ASPERGES: The ceremonial purification of a church and its people done by the sprinkling of holy water.

ASPERGILLUM: In the Western church, a metal wand with a bulbous end that is used for sprinkling holy water (FIG. 399); in the Eastern church, hyssop, pussy willows, palms, or a great brush are used for this function.

ASPERSORIUM: The handled bucket used for carrying holy water. It should be noted that a fixed basin for holy water is properly called a *stoup*.

FIG. 399

ATRIUM: An open courtyard, surrounded by a form of cloister, which constitutes the entry to a church. The word is derived from civil architecture. More often than not, in ancient times there was a fountain in the center of the atrium.

AUMBRY: A wall cabinet (recessed or attached) for the safekeeping of the Sacrament that is reserved, and for the holy oils blessed for special uses by the bishop.

AVE MARIA: The opening antiphon of the prayer asking for the Blessed Virgin's help and prayers, particularly at the hour of death. The versicles and responses are drawn from the Gospels.

BACULUM: The Latin name for the hooked-top scepter, the ancient symbol of authority that ultimately came to be used by Christian bishops.

BALDACHINO: Technically, a canopy of rich cloth (deriving its name from the Italian word for "the cloth coming from Baghdad"). Loosely, a canopy made of any kind of material.

BALM IN GILEAD: From the King James Version of the Bible, Jeremiah 8:22: "Is there no balm in Gilead: is there no physician there?" The word "balm" was Coverdale's translation of the Hebrew word for "resin." The beauty of the phrase and its statement of God's concern has endeared it to saints and poets for over four centuries.

BAMBINO: The Italian word for "baby," used particularly to refer to the figure of a Christ child in a manger scene.

BANDS: The two matching pendants of white linen worn at the neck by clergy in full choir or academic habit. (They are common to the Anglican

communion, to the Roman Catholic churches of France and Spain, to the Presbyterian church apart from continental Europe, to many Lutheran churches, to universities, and to the legal profession in Great Britain and in many parts of the British Commonwealth.) They are vestigial remains of the "falling band collar" that became popular in the seventeenth century. The development of the collar is, of course, related to the clerical collar. It started by being the simple top of the shirt worn under the cassock (FIG. 400). The top of the shirt soon became decorated (FIG. 401). The collar then became more restrained and fell on either side of the neck (FIG. 402). Its fullest development was in the middle of the seventeenth century (FIG. 403). It is interesting to note that Cardinal Richelieu and Oliver Cromwell both wore the same kind of collar (FIG. 404). In a relatively short time, the collar came to be joined in front and somewhat shortened on the sides (FIG. 405). By the

FIG. 400 FIG. 401 FIG. 402

FIG. 403 FIG. 404 FIG. 405

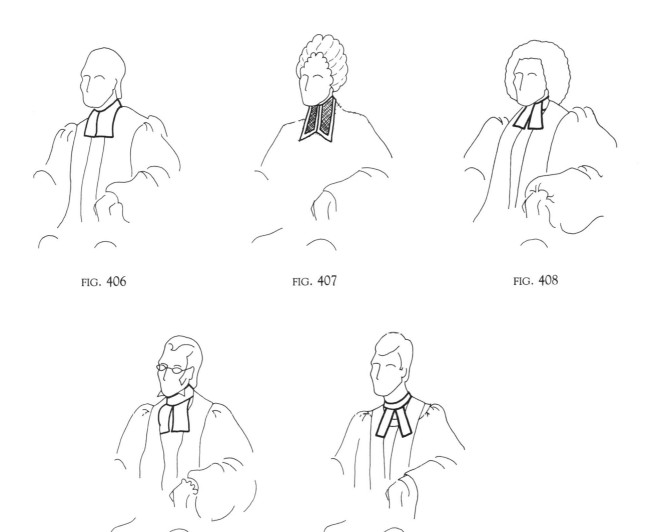

FIG. 406 FIG. 407 FIG. 408

FIG. 409 FIG. 410

end of the century, the principal body hung down at the front, and the sides almost completely disappeared (FIG. 406). A side note is in order: the French clergy of Gallicanist sympathies wore black bands with white edges, in mourning for Louis XIV. These are still to be seen in France and are still symptomatic of the wearer's allegiance—whether to Gallicanism or to Papalism (FIG. 407). By the end of the eighteenth century, bands, and that means just the bands in front, became separate items held in place by a cloth neck band called a stock (FIG. 408). The nineteenth century saw bands and stock worn over a wing collar (FIG. 409). As of the current writing, the so-called clerical collar (the dog collar) derives from the stock. Bands, when worn, are held in place so that they seem to be attached to the bottom of the collar (FIG. 410). In the strictest sense, they are the remains of the only "clerical collar" there was until the latter portion of the sixteenth century.

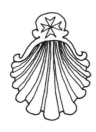

FIG. 411

BAPTISMAL SHELLS: Silver or mother-of-pearl shells in scallop shape (FIG. 411), popular in the nineteenth century but rarely seen nowadays.

BAPTISTERY: A separate building, or the separated section of a church building, where the baptismal font is located, and where baptisms take place.

BASILICA: Either a domestic or civic rectangular building characterized by an atrium and a raised apse at one end (FIG. 412). Originally, it referred to a town hall.

FIG. 412

BAY: An integrated division of the side of a building, determined by structural components such as arches, columns, or piers.

BELFRY: The portion of a building, generally a tower, in which are mounted the parish's bells.

BELL:

CHURCH BELL: Ancient canon law required each church to have a bell rung daily at the time of divine service.

HANDBELL: A small bell rung by a server to indicate that the Sacrament is being carried to the sick.

PASSING BELL: In early times, the ringing of the church bell in accordance with a prearranged code to inform the parishioners that a fellow Christian was dying. Later, it came to be the announcement of a death in the parish. This is the custom to which John Donne refers in the phrase "Never send to know for whom the bells tolls; it tolls for thee."

PEAL: Use of the peal meant the ringing of bells in a particular order to avoid repetition. Four bells are used for the Westminster chime or the Cambridge chime, which technically allows for the bells to be

rung twenty-four times without duplicating the order in which they are rung. From Charles Earl Funk's delightful book, *A Hog on Ice*, we learn that a twelve-bell peal can be rung 479,001,600 times without repetition, though Funk notes that this is "possible, but not probable." The greatest number of continuously rung variations ever reported is sixteen thousand, taking more than nine hours. One particular peal, the Nine Tailors, is central to one of Dorothy L. Sayers's most fascinating detective stories. In characteristic form, she became an expert in campanology for the sake of accuracy.

SANCTUS BELL: Until recent times, a small bell used at the altar at the time of the sanctus to signal the sexton to ring the church bell, so that the sick and the shut-in might follow the service at home.

BEMA: The raised platform that constituted the sanctuary in early churches. From the placement of the holy table on the *bema*, the word *altar*—or "high place"—is derived.

BENEDICTUS QUI VENIT: A portion of liturgical text translated as "Blessed is he that cometh in the Name of the Lord. Hosanna in the highest." Its traditional position is immediately after the Sanctus.

BIDDING PRAYER: An ancient form of hortative prayer, originally the exhortations to prayer for which the litany grew up as a response. One of the most popular forms of prayer in the vernacular, it survived the Reformation due to its ancient association with the sermon. It is now generally used as a form of introduction to some special service, particularly an ecumenical one.

BIER: The framework trestle on which a coffin is placed during a church funeral.

BIRETTA: The Italian name for a type of medieval cap, which, being made of four pieces, was the common parent of the academic "mortar board" (which developed through the hardening of the top surface), the "square cap" (which emerged from a hardening of the four sides of the cap), and the "biretta" (which developed from a hardening of the upper seams of the cap).

BLACK LETTER DAYS: Originally, those recognized saints' days for which the English Prayer Book provided no special propers. In the 1662 Prayer Book these were printed in black. Special propers are now available throughout Anglican communion.

BOAT: A container in which incense is brought to the altar (FIG. 413).

FIG. 413

BOSS: An ornamental projection at the point where architectural supports meet or intersect.

BRASSES: Portrayals of men or women in full ceremonial dress done in brass and ordinarily sunk into the pavement of a church. These brasses were popular from the middle of the thirteenth century until the sixteenth. Brass rubbings taken from them are enormously popular and highly decorative.

BREAD BOX: A covered canister designed to hold the breads for use at the communion service (FIG. 414).

FIG. 414

BRIDGE CHAPEL: A hostel or chantry chapel set up on a bridge or at one entrance to it. These chapels were built so that the souls of their founders (generally the builders of the bridge) should be remembered constantly.

BURSE: A stiffened, booklike cloth purse in which the corporal is carried (see p. 155).

BUSKINS: The medieval name for the special footgear worn anciently by bishops when fully vested.

BUTTRESS: A mass of masonry added to the outside of a building to carry the additional weight and thrust of a supporting arch. A buttress is referred to as a "flying buttress" when it touches the surface of the building only at critical points of support.

BYZANTINE: The style characteristic of the great Eastern empire that developed in the fifth century and continued to the fifteenth.

CAEREMONIARIUS: The Latin name for the master of ceremonies, an official necessary for the efficient running of complicated religious services.

CALVARY: From the Latin *calvarius,* the Mount of the Skull, or Golgotha.

CAMPANILLE: The ordinary term for a freestanding bell tower.

CANON: A fixed rule; a definitive list; an invariable prayer; a musical composition formed by the repetition of invariable melodies—"a round"; or a member of the chapter of a cathedral church.

CANTICLE: A continuous passage (or a *cento*) from Scripture used as a fixed liturgical song. ("Song" does not mean that it may not equally appropriately be spoken.)

CANTORIS: The ecclesiastically north, or gospel, side of a divided choir.

CAPITAL: The uppermost portion of a column.

CAPPA MAGNA: The Latin name for an academic doctor's cope. At Cambridge University, where it is still used, it is a scarlet cloak with a deep, capelike hood made of white fur.

CAPPA NIGRA: A hooded black cloak used by the clergy during the choir offices (which originated in an era when churches were unheated) and during outdoor processions.

CAPSULE: A small receptacle for holy relics.

CARDINAL: A member of the highest body of clergy in the Roman Catholic church. The pope is chosen from their number by election. A cardinal is ordinarily in major Holy Orders. A unique use of the word *minor* certainly is the specification that "two minor canons" of St. Paul's Cathedral, London, be "cardinals"—Senior and Junior. (Their whole body is The College of Minor Canons. It is a Royal Chartered Corporation.) The identification of red as a cardinal's color was a gradual process not widespread until nearly the fourteenth century.

CARILLON: A range of a minimum of fifteen bells, designed for the playing of polyphonic music.

CASEMENT WINDOW: A window opening in door fashion, rather than by sliding up and down within vertical grooves.

CASSOCK (SOUTANE): The basic garment of ordinary people in the Middle Ages. In Italy it was known as the *casacca*, from which is derived the word *cassock*. Another name for it, however, is included in the word *surplice*, which means a garment to be worn over the ordinary peasant, fur-lined coat—*sur pelisse.* Until recently it was the basic garment of the Church, over which all other vestments were added. The Latin cassock buttons down the front (FIG. 415). It will often have an additional small cape covering the shoulders but not having buttons (FIG. 416). Such a cape having buttons is called a *mozetta*

FIG. 415 FIG. 416

FIG. 417 FIG. 418 FIG. 419

FIG. 420 FIG. 421

and is designed to be part of the choir habit (FIG. 417). The Greek cassock buttons at the neck, waist, and cuffs (FIG. 418). The cincture is a broad ribbon that ties in front. The Russian cassock buttons at the neck and the waist but buttons from right to left instead of from left to right (FIG. 419). The Anglican cassock is double-breasted and buttons at the waist and at the shoulder (FIG. 420). The Jesuit cassock is like the Anglican, but it buttons at the center of the neck rather than at the shoulder (FIG. 421).

CATACOMBS: The subterranean burial niches popular in Rome until the eighth century.

CATHEDRA: The chair or throne of the diocesan bishop. The ancient practice of delivering formal statements from this chair is responsible for the phrase *ex cathedra.*

CATHEDRAL: The adjective describing the church in which the bishop has his chair. In strict historical terms a cathedral does not have a parish. A parish church serving for a cathedral is technically a *pro-cathedral.* This is a distinction not observed in ordinary usage. In English terms, a cathedral is headed by a dean, a pro-cathedral by a provost.

CATHOLICON: The main church of a monastic establishment.

CAUTEL: A particular and detailed direction covering some aspect of the administration of Holy Communion.

CELEBRANT: The one officiating at the service of Holy Communion.

CENSER or THURIBLE: A metal vessel, suspended by a chain or chains, with the necessary perforations in the movable top cover to enable the smoke of the incense to rise. Along with the censer must go an *incense boat,* a ship-shaped container opening at one or both ends from which the gum incense is spooned onto live coals in the censer. One of the technical names for an incense boat is a *navicula.*

CERE-CLOTH: A waxed cloth that was placed upon a stone altar to prevent the consecration oils, soaked into the stone, from staining the linen. It is, of course, unnecessary where the problem does not exist.

CHALICE: The cup used for the wine at the Eucharist, often made of copper gilt, enamel, malachite, ivory, or other precious material (FIGS. 422–428). In the ancient Church, the chalice was large and two-handled, much like a loving cup today. By the Middle Ages, the chalice had become much smaller, since it was used only by the priest or bishop. It also lost the handles, being handled by the long stem and knop. When the laity began to receive the cup

FIG. 422

FIG. 423

[185]

FIG. 424 FIG. 425 FIG. 426

FIG. 427 FIG. 428

again in Tudor times, the chalice retained the medieval shape, but the bowl was enlarged. In Queen Anne chalices, the knop is vestigial, but the eighteenth century saw a revival of the Tudor chalice. The nineteenth century, with its gothicism, went back to the medieval chalice but kept the larger bowl.

CHALICE VEIL: A square of cloth designed to cover the pall, paten, purificator, and chalice when "vested." It should be large enough to reach the altar on all four sides.

CHANCEL: The portion of the church set apart for the clergy after the time when screens were introduced (*cancellus* means "screen"). Now used for any area of the church in which the principal altar stands.

CHANTRY: A separated chapel, ordinarily containing the tomb of the founder or builder of a church, a monastery, or a portion thereof. Anciently, it often carried with it a special endowment to cover the maintenance of services said on behalf of the donor's soul.

CHAPEL: Any physically or organizationally subordinated enclosure or building housing an altar other than the principal altar of a cathedral parish or church.

CHAPLAIN: A cleric who ministers to a special congregation or person.

CHASUBLE: This word comes from the Latin word *casula*, meaning "little house." In classical times, it was a capacious cloak, often hooded, worn either cape-fashion or poncho-fashion. This classic garment was the ancestor of both the familiar all-encompassing vestment often worn by the celebrant at Holy

Communion, and the cope—the rich and often elaborately decorated ecclesiastical cape.

CHEVET CHAPEL: The term used for one of the chapels opening on an ambulatory circling an apse. Medieval fancy thought of the Lord's body covering a cruciform church; hence, the *chevet,* or "pillow," would support his head.

CHIMERE (MANTELLONE): The long, sleeveless outer garment worn by bishops and doctors. Bishops wore black wool for outdoor, black satin for court dress. When made of scarlet cloth and worn by bishops, the garment is called the "convocation habit." The scarlet cloth chimere, when faced with the color with which a doctor's scarlet hood is lined, is known technically as a "doctor's habit." The doctor's habit is, on certain occasions, worn over the black silk "un-dress" doctor's gown (exactly like an M.A. gown) and, on other occasions, over cassock and surplice, or cassock and rochet, depending on whether the doctor is in priestly or episcopal orders; or, in Oxford, worn by doctors on convocation days.

CHOIR: The portion of a church building that marks the change from congregation to ministry. The word is also in more general use to describe the group of singers officially involved in a service. Many experts prefer to distinguish the section of a church in which a monastic or collegiate body sat by using the spelling *quire.* Thus, *quire* is used increasingly to distinguish a section of a building, architecturally considered, from a place where singers may be located.

CHRISM: Oil and myrrh mixed together and blessed by a bishop for use during baptism, confirmation, consecration of churches, etc.

CHRISOM: The white garb of baptism (which accounts for the "white" of Whitsunday).

CIBORIUM: The word occurs in two contexts: the inverted cup structure that housed the high altar, and the covered cup in which the reserved Sacrament is kept.

CINCTURE (CINGULUM): A broad sash or rope used for binding a cassock at the waist; also called the *fascia.*

CLERESTORY: The top horizontal division of the nave of a church, having three or five aisles.

CLOISTER: An external covered passage ordinarily surrounding (or forming) a square. The square thus formed is called a *garth.*

CLOSE: The enclosed confines of a cathedral's ecclesiastical, educational, and domestic property. The exterior walls are generally formed by the backs of these several buildings.

COADJUTOR: A bishop assisting the diocesan bishop. In some areas there is but one coadjutor, and that one has the right of succession upon the resignation or death of the diocesan bishop.

COLLECT: A brief prayer that precedes the liturgical readings at the Eucharist. In ancient days, the prayer that concluded a previous intercession.

COLLEGIATE: The adjective describing a church the members of whose governing body have equal voice in its control.

COLOR SEQUENCE: The earliest definite knowledge of the use of specific color in the service of the Church is Clement of Alexandria's recommendation of white as suitable to all Christians. The canons of Hippolytus assigned white to the clergy as becoming their office. The medieval development of color symbolism is examined in the *Rationale Divinorum* of Durandus. This thirteenth-century prelate explained the meanings of all colors but, interestingly enough, said nothing about a standard use or a standard meaning.

Fixed directions first appeared in the early fourteenth century. Innocent III described four liturgical colors: white, red, black, and green. It was not long, however, before modifications of these came about. Saffron was prescribed for the feasts of confessors, and rose and ivory came to be regarded as proper substitutes for red or white. The great scholar Wickham Legg lists sixty-three totally different "uses."

The ancient use of liturgical colors was relatively simple; since vestments were classified as the best, the second-best, ordinary, and, in some places, black. The Eastern Orthodox church still adheres to this practice. Insofar as "the best" is concerned, it is still required by the Dominican order's Rule to be worn on the highest feasts, irrespective of its color.

In the Middle Ages each cathedral had its own "Use," and although this use was in no sense binding on the diocese involved, it was inevitable that some sequences should become popular and that, ultimately, certain "Cathedral Uses" should grow wider even than the diocesan ones in their influence. It must be remembered, however, that on Ascension Day in the sixteenth century, one could still have seen "the best" vestments used in Salisbury; white, in Westminster; blue, in the College of St. Bernard at Romans; yellow, in Prague; red, in Utrecht; and green, in Soissons.

The color sequence of the Roman Catholic church is now very largely that

common to the Court of Rome in the sixteenth century. It is often referred to as the "Western Use." The sequence is as follows:

White: Christmas and days of its Octave; Circumcision; Epiphany and Octave; Maundy Thursday; Easter Even through the fifth Sunday after Easter; Ascension Eve through the Vigil of Pentecost; Trinity Sunday; Corpus Christi and Octave; Transfiguration; Christ the King; feasts of St. Mary the Virgin; All Saints' and Octave; Michaelmas; feasts of confessors, doctors, virgins, and holy women.

Red: Pentecost and Octave; feasts of apostles and evangelists (except St. John, whose feast is a white one); feasts of martyrs; the Holy Innocents' (only if that feast falls on a Sunday).

Violet: Advent Season—except the third Sunday, "Gaudete"; Septuagesima through Maundy Thursday—except the fourth Sunday, "Laetare"; Ember Days apart from the Octave of Pentecost; Rogation Days; Vigils; Holy Innocents' if not on a Sunday.

Green: The Sundays (and Ferias) after the Octave of the Epiphany through the Eve of Septuagesima; the Sundays (and Ferias) after Pentecost (or, after Trinity) through Advent.

Rose: The third Sunday in Advent; the fourth Sunday in Lent.

The preceding color sequences have been worked out to meet the physical and psychological settings of the people involved and of the habits to which they are heirs. As might well be expected, the Far East has totally different associations. White is the color of mourning and would never be used on the days known to us as "White Feasts." The color expressive of joy and triumph there is red. Combinations of red, gold, and blue tend to make up the Far Eastern color scheme. In India and Sri Lanka some of the liturgical Christian churches have taken on the use of the saffron color made popular through both Hindu and Buddhist practice.

COLUMN: The basic form of freestanding support. Its three main divisions are: base, shaft, and capital.

COMMUNIO: A sentence once said or sung during the communion of the clergy or the people, but now, when used, said before the postcommunion.

COMPLINE: The ancient evening office of the Church—one of the two offices that Archbishop Cramner, following Spanish precedent, combined to make the Office of Evening Prayer.

CONFESSIONAL: Technically, the area of a church reserved for the sacrament of penance. This could be by a priest's chair or a place near the altar in a

chapel. From the sixteenth to the twentieth centuries, confessionals were more often than not separate, closetlike structures that allowed for audibility but not visibility between priest and penitent. New church buildings tend to be equipped with a spiritual conference space rather than confessionals.

COPE: A rich cape worn in the course of the most solemn religious services. (See CHASUBLE.)

COPING: The functional capping placed on the top edge of a wall.

CORAL: In certain areas of Europe, coral was worn as protection against the "evil eye."

FIG. 429

CORBEL: A projection from a wall, so placed as to furnish the support for the beams that hold up the roof (FIG. 429). Occasionally, these are richly carved.

CORNICE: A projection forming the top, or crown, of any vertical surface.

CORONA: A large, decorative crown suspended from the ceiling of a church, which is designed to hold a large number of tapers.

CORPORAL: A rectangle of linen (carried in the burse) on which the eucharistic vessels are placed when they are on the altar. Other linens that are habitually used are the *purificator*, a small napkin; the *lavabo towel*, a large napkin; and the *pall*, a stiffened rectangle used to cover the chalice when Church rubrics permit.

CORPUS: The body of Christ as shown on a crucifix.

COTTA: An abbreviated surplice.

CRECHE: The feed trough for cattle, used in devotional scenes of the Nativity. It was in such a trough, or manger, that Christ was laid at his birth. The use of the creche at Christmastime is due to St. Francis of Assisi. It is frequently termed *praesepio*.

CREDENCE: A table so placed as to have the bread and wine convenient for the appropriate use at the time of the liturgical offertory.

CROCKET: The projecting, foliated ornamentation of the angles of spires, gables, and pinnacles. The same word is used for any Gothic ornamentation, whether it be on a monumental or miniature scale; e.g., a tabernacle or a pastoral staff.

CROSS: It was not until nearly the sixth century that the Church became concerned with the cross of crucifixion, which was T-shaped. The ordinary

cross of early Christian devotion seems to have been derived from formalization of the sacred monogram, XP.

CROSS RELIQUARY: Cross-shaped receptacles, some of remarkable beauty, fabricated to receive relics of the "True Cross."

BOUNDARY CROSS: A cross erected in the Middle Ages to mark a land boundary—an important thing in lands without regular enclosures.

ELEANOR CROSSES: When Queen Eleanor, beloved wife of Edward I, died in 1290, the king had a superbly beautiful cross erected wherever her body had rested in the great final funeral procession. Of the fifteen original crosses, three still exist: in Northampton, Gedington, and Waltham.

HIGH CROSS: In the Middle Ages, town meetings were held at the high cross, a structure in the middle of the town. Some were elaborate, running to two stories.

MARKET CROSS: A freestanding cross, usually covered with a vaulted structure, designed to protect traders and tradesmen from the weather.

PALM CROSS: A cross erected to mark the stations of the cross in the procession on Palm Sunday.

PREACHING CROSS: In ordinary, parochial terms, a preaching cross is a cross set up outside a parish church, where preaching took place. In addition, all public notices, religious or secular, were given here. The most famous preaching cross is St. Paul's Cross, in constant use from 1241 until it was destroyed by the Puritans in 1643. Paul's Cross, situated in the northwest angle where the transept and the nave met, was an elaborate structure with seats for high-ranking visitors. Sermons at Paul's Cross were considered so important to the secular state that the most prominent preachers in the realm were brought there as guests of the lord mayor of London. It is interesting to note that to this day, the preacher at the principal service in St. Paul's Cathedral receives, in lieu of entertainment, a gift from the lord mayor of London.

WAYSIDE CROSS: A freestanding cross placed along a roadway during the Middle Ages as an object of devotion for travellers. The need for regular devotion on a journey was a measure of how dangerous travel was in those days.

WEEPING CROSS: A cross placed on the grounds of a parish church to commemorate either a statement of personal grief or an imposed penance.

CROSSING: The rectangular area marking the intersection of the full width of the nave and the full width of the transept. Such a term is applicable only in cruciform, or cross-shaped, churches.

CROZIER: A cross (or crook) staff. The original scepter form eventually acquired two balanced, curved extensions at the top. In the Eastern church, this has developed into the T-shaped or double-serpent head of the bishop's "scepter." In the West, this particular form developed into the cross staff borne in front of archbishops and metropolitans. The single hooked form, characteristic of Western bishops, eventually came to be regarded as a form of shepherd's crook. It is common in Anglican practice to refer to this latter form as the "pastoral staff."

CRUCIFER: One who carries a tall cross in the course of an ecclesiastical procession.

CRUCIFIX: A cross with the representation of the *corpus* of the Lord attached. The portrayal of a naked figure upon the cross dates from the tenth century. The earlier forms, dating from the seventh century, had the figure fully clothed. The earlier form is still seen in portrayals of "Christ the King."

CRUCIFORM: A term (literally meaning "cross-shaped") used to describe ecclesiastical buildings with transepts. It stands in contrast to *basilica* (see definition). It is to be noted that transepts were added, originally, for practical rather than devotional reasons. The word *cruciform* is a pious observation about a previously existing practice. (See TRANSEPT.)

CRUET: A vessel for holding wine or water (FIG. 430).

CRYPT: A vault beneath a building, which may be used to house a chapel or a cemetery, etc.

FIG. 430

CUBICULUM: A hollowed-out alcove that was the immediate and temporary resting place for the body of a saint.

CUPOLA: A hemispherical roof.

CUSP: The pointed termination of Gothic ornamentation.

DADO: The lower portion of a wall, treated in decoration as though it were a separate unit.

DALMATIC: A long, wide-sleeved garment originating in the ordinary dress of Dalmatia, introduced to the West by the emperor Commodus at the end of the second century. In the third century it became an imperial dress and,

centuries later, a garb worn only by imperial favor. It is probably for this reason that the bishop of Rome vested his own deacons in dalmatics. It is to be noted that English monarchs are, in the course of the coronation, invested with a dalmatic-like vestment, which is the *sakkos* of Orthodoxy and the Byzantine emperors.

DEACON: One of the three chief orders of the hierarchical ministry known technically as *holy orders*. Also used to designate the minister performing, in the course of the celebration of the Eucharist, the portion of the service anciently prescribed for the deacon.

DEAN: The English form of the Latin word *decanus*, "one set at the head of ten."

DECANI: The ecclesiastically south, or "epistle," side of a divided choir. (*Decani* thus means "side of the Dean.")

DEISIS: An icon of the seated figure of Christ with figures of the Blessed Virgin and St. John the Baptist standing at either side.

DESK: Ecclesiastically, any form of support for books used in the course of a service. Thus, a "kneeling desk" supports a book or books the officiant will use while kneeling. A "litany desk" supports a book in which the litany is printed, etc.

DIAPERED: The continuous repetition of a pattern in order to do away with the starkness of an unrelieved surface. This same repetitive process is also known as powdered.

DIPTYCH: Two clay tablets in a book-cover–type case. On these, in ancient days, were scribed the names of those to be prayed for in the course of the liturgy. The diptych is parent to the triptych (three-leaved) and polyptych (multileaved) forms of altar partitions, or *reredos.*

DISCALCED: Describes religious orders that in theory go barefoot. In modern times, living conditions may well require the wearing of sandals.

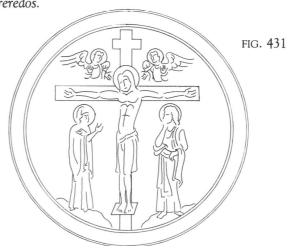

FIG. 431

DISKOS: The Eastern form of the paten, the diskos is a plate supported by a stemlike base (FIG. 431). This style of paten also became popular in the English church in the eighteenth century.

DOG-TOOTH: A crude form of dart that distinguished early English ornamentation.

DOME: The practice of erecting a cupola on God's chief house—the cathedral church (*duomo* in Italian; *dom* in German)—led to the cupola being called a dome.

DORMER: A window gaining its height by rising above the slope of a roof.

DOSSAL and RIDDELS: The vestigial remains of the back and side curtains from the Byzantine altar, which actually had curtains on all four sides of the ciborium (FIG. 432). The dossal is the back curtain; the riddels are the side curtains. Technically, they are part of what is called the "English altar."

FIG. 432

DOVE: The biblical likeness for the Holy Spirit.

EAGLE: A book-rest in the form of an eagle (FIG. 433). Until modern times, this was used only for the epistle or gospel.

EAST: The altar end of a church or chapel, regardless of actual position by compass.

EAVE: That portion of the bottom of a roof that projects beyond the face of the supporting wall.

FIG. 433

Glossary

ECCLESIASTICAL HAT: (See illustrations p. 158) There developed in heraldry a formal depiction of the clerical hat, which was known originally for its use by cardinals. All sorts of regulations for these hats have emerged over the years. Under the present regulations of the Holy See, the number and color of tassels has been strictly regulated.

ELEMENTS: The technical term for bread and wine that have been consecrated.

ELEVATION: Liturgically, the ceremonial raising of the consecrated elements. Architecturally, the plans for the vertical construction of a building.

EMMANUEL: The Hebrew word for "God with us." It may also be spelled Emanuel or Immanuel.

ENCOLPIUM: A cross or reliquary worn upon the breast.

ENTABLATURE: The vertical surface of a wall immediately above the row of columns (colonnade) that supports it.

ENTASIS: The increase in the diameter of the middle of a column that is necessary to prevent the optical illusion of decreased dimension that a uniform diameter will produce.

EPICLESIS: The Greek-derived name for the invocation in the prayer of consecration at the Holy Eucharist. It is regarded by the Eastern Orthodox church, and by several churches of the West, as the culminating act of consecration within the structure of the liturgy.

EPISTOLER: The bishop, priest, deacon, or lay reader who reads the epistle. Anciently, this was the work of a subdeacon—a title now often interchangeable with epistoler.

EPITAPHION: A large, ceremonial cloth carrying the embroidered icon of the dead Christ. It is an important item in the Great Friday and Great Saturday services of Holy Week in the Orthodox church.

EUCHARIST: From the Greek word for "thanksgiving": the central act of worship of the liturgical churches. Also known as the Great Thanksgiving, Mass, the Holy Mysteries, the Holy Oblation, Holy Communion, and the Lord's Supper.

EUCHARISTIC CANDLES: A pious misnomer for the two ordinary candles on an English altar, which were confused with the Latin rite's nineteenth-century low-mass lights.

EUCHARISTIC VESTMENTS: The special clothing worn by the celebrant, gospeller, and epistoler (who are known as "the sacred ministers"), when performing the service of Holy Communion. See also ALB, DALMATIC, GIRDLE, MANIPLE, STOLE, and TUNICLE.

EVENSONG: The 1549 official term for evening prayer, which is still in common use, and in some provinces remains the official term.

EWER: A large, uncovered metal pitcher used to carry water to the baptismal font (FIG. 434).

FIG. 434

EXHORTATION: Any extended theological bidding. Some of the older ones are now of no use, since there no longer exists any general problem of infrequent communion—a problem that was a peculiarly medieval one. Few modern Christians are aware of how infrequently the people of the Middle Ages made their communions, a practice that continued up to the time of the Counter-Reformation in Europe and the Caroline Divines in the British Isles.

FACADE: The external west front of a church (regarding the altar as east).

FAIR LINEN: A cloth covering the top of the altar (FIG. 435). Sometimes, throughout its history, it has gone to the floor on all four sides. Recently, it has been shortened so that it overhangs both the front and the back by its own hem (approximately three inches) and goes to within three inches of the

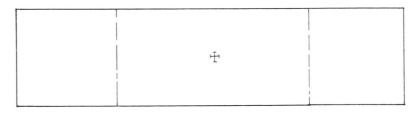

FIG. 435

floor at either end. In the Western church, it is marked within the confines of the top of the altar with five crosses: one in each corner and one in the center. These memorialize the five consecration crosses cut into the altar itself and anointed at its consecration.

FALDSTOOL: A light, backless chair, used chiefly by bishops for confirmations and ordinations.

FANON: An omnibus word referring to skullcap, maniple, corporas (a folded corporal—see PALL), and infulae.

FAST DAYS: The two days in the Church year on which an absolute fast is expected: Ash Wednesday and Good Friday. Loosely speaking, the days of abstinence on which special self-discipline is expected—actually, over a quarter of all the days in the year.

FERETORY: A reliquary coffin with a roof that is barrel-vaulted.

FERIA: Describes any weekday for which no special collect, epistle, and gospel are appointed.

FERIOLA: A ceremonial cape worn over a cassock, made of rich material and handsomely faced. It is held together at the top by broad ribbons tied in a bow. The color is determined by the rank of the wearer.

FIDDLEBACK: The contemptuous name given eighteenth-century chasubles because of their cut.

FILLET: A narrow, flat band used to separate ornamental moldings.

FINIAL: The decorated top of a pinnacle—a decorated, freestanding extremity (FIG. 436).

FLAGON: A large covered pitcher of either metal or glass that is used in the preparation of the eucharistic elements; in ordinary terms, a cruet (FIGS. 437 and 438).

FIG. 436

FIG. 437

FIG. 438

FLECHE: A light, slender spire set on the roof-line, generally at the center of the crossing of the roof lines of the apse and nave with that of the transepts.

FLUTING: The vertical grooves on the shaft of a column.

FONT: A ceremonial tank, or basin of metal or stone, designed to hold water for the administration of baptism (FIGS. 439 and 440). Anciently, fonts were deep enough to contain waist-high water. With the modern emphasis on congregational participation, portable fonts have come into favor, since they can be placed in a position to which the congregation is used to giving its attention.

FIG. 439 FIG. 440

FOOT-PACE: The horizontal level that immediately supports the altar. (A foot-pace must extend a minimum of forty inches in front of the altar.)

FORTY: Forty is a number that occurs again and again in the Scriptures. The flood in the days of Noah lasted forty days; the children of Israel wandered in the wilderness for forty years; Moses returned from exile to see his brethren, the children of Israel, after forty years in Midian; Moses was on the mount for forty days; the wall of the tabernacle in the wilderness was required to have forty sockets of silver; the men who set out to search for the Promised Land completed their work and returned in forty days; the children of Israel and their land knew rest for forty years when Othniel was judged; Eli judged Israel for forty years; David reigned over Israel forty years; Solomon's Temple was forty cubits long; Solomon reigned over all Israel for forty years; Elijah fasted for forty days; forty days was appointed as a testing period for the people of Ninevah, as warned by the prophet Jonah; Jesus' fast in the wilderness was forty days in length; and the Resurrection appearances continued for forty days, ending with the Ascension.

FRACTION: The breaking of the eucharistic bread.

FRESCO: Wall painting—anciently done while the plaster was wet, the usual medium being tempera.

FRIEZE: The middle, horizontal division of the entablature. Its decoration has made the word come to mean any continuous horizontal decoration at an upper level.

FRONTAL: A cloth, leather, or metal cover, which, when placed upon the altar, completely covers it on all four sides (FIG. 441). Altars attached to the east wall or to a reredos can, of course, be covered only on the front and on the sides; since the fair linen goes almost to the floor on the sides, often only

FIG. 441

the front surface is covered. Any addition at the top is called a "super-frontal." (The illustration for DOSSAL and RIDDELS has a frontal.) Note: The Laudian frontal covers four sides of the altar and each corner, with a free-hanging quarter-circle at the bottom. Also, an artificial distinction is frequently made between a Laudian frontal and a Jacobean frontal, which is rectangular rather than rounded at the corners.

GABLE: The vertical, triangular section of a wall formed by the inverted "V" of a roof.

GALILEE: A gallery, or long porch, in which a chapel for penitents has been installed.

GALLERY: A continuous passage in an upper story.

GARB: Heraldic designation for a sheaf of wheat, appearing frequently in Western heraldry in reference to the parables.

GLOSSARY

GARGOYLE: A Gothic water spout terminating in a grotesque figure. In many ways, gargoyles expressed the medieval concept of the alien and dangerous powers and elements at loose in the world outside the Church. Many ancient collects still reflect the fear of night and darkness. The Greeks, on the other hand, considered the dangerous time of day to be midday, which excited panic. Modern hospital statistics tend to support the classic Greek view.

GENEVA GOWN: A full black gown with wide bell sleeves. At one time in its history, it opened all the way down; but now it is generally worn closed.

GIRDLE: The long white cotton rope, which, when doubled, is tied around the waist to keep an alb in place.

GLASTONBURY THORN: From the legend that Joseph of Arimathea planted Christianity in England in the same year in which he planted his thornwood staff. Even the current thornbush in the ruins of Glastonbury Abbey more often than not blossoms around Christmas Day. By legend it has a special relationship with the British royal family.

GOSPEL SIDE: The north side of the church, considering the altar as east.

GOSPELLER: The minister (regardless of order) assigned to read the gospel in the course of the Eucharist.

GOTHIC: The ordinary term describing the type of stone construction characteristic of Western Europe from the thirteenth to the sixteenth centuries. The term itself was unknown in this period. It originated in the seventeenth century as a term of abuse for anything regarded as barbaric; hence, Moliere's statement, "The rank taste of Gothic monuments, These odious monsters of the ignorant centuries, Which the torrents of barbarism spewed forth."

GRADINE: A raised ledge behind the altar (and, technically, free of it), on which reliquaries were placed in medieval times. Also called a "super-altar."

GRADUAL: The psalm, or the portion of it, that is sung between the epistle and the gospel.

GREMIAL: In the Western rite, this word refers to an apron that used to be placed in the bishop's lap during those periods of the communion service when he was ordinarily seated.

GROIN: Any one of the angles formed by the intersection of the ribs supporting a vault.

GUILD: A particular group of people bound together by a common interest, common pursuit, or common trade. Guilds were the labor unions of the Middle Ages. They had remarkable provisions for taking care of their own and seeing that no brother or sister came to or was left in grief. Their official life centered around the Church, each guild having its own patron saint, its own day of corporate celebration, and frequently its own ecclesiastical equipment, such as chalices, reliquaries, and monstrances. The word *guild* itself comes from *guildan,* which means "money to pay." One of the most important distinctions in the United Kingdom is to be made a member of one of the great London guilds, thus becoming a freeman of the city of London. The guilds came into being in the twelfth century, and their ancient privileges were confirmed in the fourteenth century. These are bodies of immense distinction with simply splendid titles: the Worshipful Company of Goldsmiths, the Worshipful Company of Haberdashers, etc. One of the ornaments of London is the Guildhall. It is to be noted that this has to do strictly with the old city of London, the two square miles around St. Paul's Cathedral.

HABIT: The clothing worn by a particular person or group at regular or agreed-upon times. For example, the choir habit is the customary garb of clergy attending a choir office; i.e., the cassock, surplice, hood, and black scarf of Anglican clergy, or the cassock and surplice of the Holy See.

The EPISCOPAL HABIT is the characteristic garb of a bishop, referred to in Church rubrics for the consecration of a bishop.

A DOCTOR'S HABIT is a scarlet cloth mantle, much like a bishop's *chimere,* which is held closed by two buttons at the neck; the buttons and the interior facing are of the color of the lining of the doctor's hood. It is used by doctors of divinity of Oxford and Cambridge (or any university using their basic color schemes). It is worn on occasions over the black silk master's gown (doctor's "undress") and, on extremely formal occasions, over the choir habit, the sleeves of the surplice being pulled through the armholes. The doctor's habit for a bishop is technically the same vestment with the facings turned out to show. (Certain English tailors follow the practice of making the open facings appear as deep lapels.) Note: Strictly speaking, a nondoctor bishop attending an academic ceremony would wear a black silk chimere, since this is the ancient Master of Arts or Bachelor of Divinity habit.

A CONVOCATION HABIT is a plain, unlined, unfaced scarlet chi-

mere worn by bishops at meetings of convocation. The Bedell of Convocation of the University of London insists that this garment is an anomaly, since it is nothing other than a doctor's habit for nondoctors. In the United States the problem is different, since it would be impossible to face the habit with most linings derived from the multicolored American Intercollegiate System. The problem in the United States is not nondoctor bishops but nonreproducible hood linings.

The MONASTIC HABIT takes the color and form of the robes appropriate to a particular religious order.

HAGIOSCOPE: An oblique opening cut through a wall in order to make it possible for people in obscure or hidden places to see the altar. (The ordinary English word for this is "squint.")

HALF TIMBER: A wooded construction in which the space between the timbers is filled with stucco or brick.

HAMMER-BEAM: A termination where, anciently, a tie-beam would have been continued. The term is applicable only to room construction.

HATCHMENT: A funerary, diamond-shaped panel hung on the walls of a church or chapel displaying the coat of arms of a deceased person. If the left-hand half of the background (as you face it) is black, it means that the husband has died; the right-hand and white half indicates that the wife has survived. The combinations, of course, progress to a background completely black, which means both husband and wife have died.

HEARSE: Originally, a harrow-shaped triangular candle holder used at the Holy Week service of TENEBRAE (see definition). Later, the word came to mean a framework structure placed over a coffin (or the cloth-wrapped body) to hold up the funeral pall and additional candles. It has now come to mean the car or carriage in which a coffin is transported. In medieval language, the word *serge* referred to the hearse lights, not to cloth. It becomes even more confusing when one is reminded that the French word *herse* means the barbed, latticed metal gate to a castellated structure—a "portcullis," in English. The ancient English spelling of the word was *herse.*

HOLLY: There is plentiful evidence that in the sixteenth century each parish had a holly bush covered with lighted candles, which was suspended before the cross during Christmastide.

HOLY WATER: Liturgically blessed water used for both personal and ceremonial purposes. It is always reminiscent of the lustrations prescribed in the Bible, and of baptism as well.

HOOD: The cowl-like head covering on the back of a cape or cope. The academic hood is a formalized version of the medieval scholar's hood that is now granted by universities and colleges and certain learned societies. The color of the exterior and the interior and the shape of the hood indicate the specific degree and the university that granted it. (The American Intercollegiate Code indicates the particular faculty by the color of the velvet used on the outermost exterior edge of the hood, the university by the color or combination of colors of the lining, and the degree by the length and shape of the hood.)

HOUSELING CLOTH: A piece of linen held before communicants to cope with any possible accidents.

HUMERAL VEIL: A long, wide scarf of rich material used by the subdeacon in the celebration of mass according to the Western rite. It is also used by priests carrying the Sacrament solemnly. In the strict sense, the monastic hood is also a veil. The meaning of the phrase "take the veil," is obvious concerning women religious. The veil worn by the Eastern Orthodox religious still has the general look of the hood, but nowadays it is made of lightweight material and is almost always worn over the cylindrical hat known as the kamilavka. The Armenians in monastic orders wear a veil of watered silk, which in turn is worn over a conical hat.

ICON: A two-dimensional picture painted under strict theological guidelines.

ICONOSTASIS: The liturgical screen separating the sanctuary from the nave in Eastern churches. The screen is penetrated by three doorways—the central one being termed the *royal doors*. The placement of each icon is according to strict rule, and the order in which they are placed is invariable. The deacon's movement in and out of the sacred area accounts for his being referred to as "the angel of the congregation"—the one who transmits messages to heaven, and, in turn, from heaven to earth.

INTONE: Strictly, the announcement of a liturgical melody according to prescribed rules.

INTROIT: A psalm or a hymn sung during the entrance of the clergy, celebrating the Holy Communion.

JAMB: The side of the opening for a door or a window.

JUDAICA: The ceremonial objects required in the synagogue for worship—such as the *rimonim*, the finials for the Torah.

KEYSTONE: The uppermost, central, and (theoretically) binding stone in an arch.

LACE: First introduced into the Church in Europe during the late sixteenth century, when it was common to men's clothing. Its use in the Church is subject to only one requirement for consistency: if lace is considered appropriate for the clergy of a particular parish, then it is appropriate on the altar; otherwise, not. (Note: Under no circumstances is lace tolerable on a pall: its use invariably leads to accidents with the chalice.)

LANCET: A narrow, pointed arch, niche, or window.

LANTERN: An open tower erected over the crossing of a cruciform church. The term is used only if windows in the upper portion of the tower admit light to the crossing below.

LAVABO: The ceremonial washing of the celebrant's hands following the offertory.

LECTERN: A desk to hold the scriptures for public reading (FIGS. 442, 443), frequently made in the form of an eagle (*vide*). Anciently, these lecterns faced the high altar (as the lectern still does in Canterbury). The bookmarks were there for practical purposes and could, of course, be seen from the congrega-

FIG. 442 FIG. 443

tion. When, in the nineteenth century, lecterns were turned to face the people, the bookmarks were put in a position where they would still be visible to the congregation. Hence, the French rudeness about identifying an Anglican church: "Look for the eagle with the suspenders." Monastic institutions frequently had double-desked lecterns, used basically for music reproduced in large enough form to be read by a number of people at considerable distance.

LECTIONARY: The regular listing of the psalms and lessons appointed to be read on each day of the year.

LESSON or LECTION: A passage of Holy Scripture appointed to be read at a particular office.

LINTEL: The beam or the stone over an opening in a wall.

LITANY DESK: See DESK.

LYCH GATE: A covered gateway at the principal entrance to a church's property, arranged internally to make it possible to rest a coffin there for the opening portion of the Burial Office. (*Lych* is the Anglo-Saxon word for "dead body.") It should be noted that coffins were not in general use until the seventeenth century, at which time the parish had one coffin made that was at the service of every body. An astonishing law that became effective after March 25, 1667 (the old New Year's Day), demanded that all corpses be buried in wool, and wool only, on penalty of a considerable fine. For obvious reasons, the great families did as they pleased and paid the fine. This absurd piece of protectionism gradually disappeared and the act was repealed in 1814.

MACE: Originally a weapon for maintaining public order, the mace has become, over the course of years, a symbol of legal authority in an appropriate jurisdiction. Thus, a mace borne before a diocesan bishop is a symbol of his authority as the ordinary. The U.S. Senate and the House of Representatives, the British House of Commons together with the House of Lords, and numerous universities in both the New and the Old Worlds can meet formally only when their ceremonial maces are in evidence.

MANIPLE: A short, stolelike scarf worn on the left arm when eucharistic vestments were worn, used until recently in the Western church. It is a vestigial hand towel, anciently used to wipe the sweat from the brows of the communicants.

MANTELLETTA: A knee-length version of the chimere.

MARTYRIUM: The structure over the resting place of the relics of martyrs.

MASS: The medieval title for the Eucharist, derived from the conclusion of the Latin service: *Ite missa est*—"Go, it is finished." It is also, of course, half of the words *Christmas* (Christ Mass) and *Michaelmas* (Michael Mass).

MATINS (MATTINS): The 1549 Prayer Book's title, still used in monastic communities, for morning prayer.

MAUNDY: The Thursday in Holy Week, the day before Good Friday. Maundy Thursday derives its name from *mandatum novum*, which is referred to in the beginning of Christ's statement "A new commandment give I unto you . . . ," and is demonstrated by his washing the disciples' feet—hence, the Latin term *pedilavium*. The pedilavium service, still part of the Maundy Thursday liturgy, is expressed in various ways: actual washing of feet by the clergy, the washing of hands (regarded as the contemporary equivalent of the original action), or the distribution of alms to the poor (known as "Maundy money") by the British sovereign.

MENORAH: The famous seven-branched candlestick of Israel (FIG. **444**), appearing in places of worship, on the Israeli president's flag, and on the state arms. Note that the Chanukah lamp has eight candles rather than seven.

FIG. **444**

MENSA: Literally, "table." *Sacra mensa*, "holy table," is used often to indicate the top surface of an altar.

METAL: Silver and gold are the symbols of heavenly splendor or, negatively, of attachment to this world. Silver is also a symbol of purity and, along with honey, of great preaching ability. Negatively, it stands for the betrayal of Christ. Iron is almost universally a symbol of torture and suffering.

MISERERE: A stall, also called a MISERICORD, with a seat which folds up. The ancient habit of facing the wall during prayers meant that men knelt into such seats. The grotesque carvings under these seats are monuments to the humor (and possibly boredom) of medieval churchmen. The members of the British House of Lords turn to face the wall during prayers because their ancient seating was monastic in style.

MISSAL: Anciently, the book from which the Mass was said, now an ordinary name for any altar service book.

MISSAL STAND: A movable desk placed upon the altar to hold the altar service book.

MITRE: Anciently, a band bound around the forehead of an athlete. In Western countries, it came to be bound around a cloth head covering. Ultimately, the part that hung down the back was cut away, and the mitre, once bulbous on both sides, came to be peaked back and front. Only the infulae (the two bands hanging down the back) maintain a vestigial relation with the original cord for binding. They were first worn indoors in the eleventh century. In the East, the episcopal headgear is called a crown and has its origin in the crown of the Byzantine emperors.

MONSTRANCE or OSTENSORIUM: A rich vessel in shrine form, the object of which is to display the consecrated host (FIG. 445).

MORSE: The clasp at the front of a cope.

MOSAIC: A medium of decoration that uses small squares of colored glass, marble, or stone to form a pattern or picture.

FIG. 445

MOZZETTA: A Latinate version of the antique form of the doctor's hood: a shoulder-length cape with a small hood attached at the back of the neck and buttoning down the front.

MULLION: One of the vertical divisions of a window.

NAVE: The principal portion of a church building, west of the choir's triumphal arch, or the crossing. The word is derived from both the Greek word *naos*, which meant the principal area in a temple, and the word *nave*, from *nava*, the Latin word for "ship," the obvious reference being to the Ark of Salvation, as in Noah's Ark.

NARTHEX: Originally, a deep porch at the entrance to a church. Nowadays, any vestibule, or enclosed porch, at the entrance to the nave.

OBLATION: The bread and wine offered at the Eucharist.

OECUMENE: The Greek word for the "whole world." The ordinary form, *ecumenical,* is the adjective used to describe worldwide Christian concern. It is also part of the title of the patriarch of Constantinople, the "ecumenical patriarch."

OFFERTORIO: The technical name for the offertory sentence in the Eucharist.

OFFERTORY: The action in the liturgy that involves the bringing up of the alms and the oblations, and their presentation at the altar.

OFFICE: Morning prayer or evening prayer, or some specially constructed form of public worship appropriate to a special occasion, such as the Burial Office.

OFFICE-LIGHTS: A loose term used for six candles on an altar, derived from a mistaken theory that there were certain candles that could be lighted only at the time of the Eucharist.

OFFICIANT: The principal minister at any liturgical service.

OIL-STOCK: The glass or metal container for carrying consecrated oils.

OIL: Three forms of consecrated oils are used: one for catechumens, one for the sick, and one for the holy chrism.

ORATORY: A small chapel designed for private prayer rather than the public administration of the sacraments.

ORDERS (HOLY): Status in the Church's ministry. The major orders are bishops, priests, and deacons, and, anciently, in certain areas of the Western church, subdeacons. The minor orders are acolyte. lector, and ostiarius.

ORDINAL: A book appended to the Anglican Prayer Books, containing those "occasional" services particularly requiring the ministration of a bishop.

ORDINARY: The title applied to a diocesan bishop in all matters in which he is concerned by jurisdiction rather than by order.

ORIENTATION: In theory, church buildings run east and west with the altar at the east end. In actual practice, the "east" is always the altar end of the church, regardless of its direction on the compass. Since the north was the land of the barbarians, the Gospel was anciently proclaimed on the north side under the rule just mentioned. This would mean that the gospel was proclaimed on the altar's own right—again, regardless of the compass.

ORPHREY: A band of contrasting material attached for purposes of design to a chasuble, cope, frontal, etc.

PAENULA: A pre-Christian, semicircular cape that in time came to be closed down the front and was the basis of both the chasuble and the cope.

PALL: A starched, folded corporal, or a linen-encased square of some hard material—either is used to cover the chalice. The same word, for obvious reasons, describes the cloth that covers a coffin during the Burial Office, or

FIG. 446

requiem (FIG. 446). It is fundamentally the same shape as the Jacobean frontal, or *vide*. Such palls have, in the course of history, been made of every known color and material. Historically, pallbearers were the people walking between those bearing the casket. One may still see pallbearers in this sense at important Soviet funerals.

PALLIUM: The later form of *himation*. A very long and wide piece of cloth (the "seamless robe") wrapped around the body with both ends crossing over the left shoulder, but forming a loop under the right shoulder so as to leave the right arm completely free. It was a characteristic dress of scholars and teachers. By the fourth century, it was no longer a practical piece of clothing, but it folded lengthwise and was used as the official badge of great imperial officers. As such, the more important Christian bishops were awarded it; but in short time it came to be regarded as a symbol of ecclesiastical rather than imperial dignity. And it came to be thought of as belonging to bishops by right rather than by gift. In later days, in the Western church, it again reverted to the symbol of patriarchal approval. Since the clergy wore it over a paenula, it was impossible to pass it under the right arm, so it went over the right shoulder. Thus, in the West, through the inevitable process of tailoring, the pallium became a single Y-shaped yoke, hanging down both the front and the back. In the West it is made of white wool, has black "crosses paty fitchey" on it, and is best known by its use of the coat of arms of the archbishop of Canterbury. In the East, the pallium still basically maintains its fifth-century form, though now it is a single strip of cloth (generally of very rich material), held in position by buttons on the pallium and ornamented with gold rather than with the ancient black crosses.

PARAMENT: A decorated fitting for an altar or its appurtenances. This word is in common use in Lutheran churches.

PARAPET: A chest-high protective wall at the edge of a roof.

PARCLOSE: An area of a church separated from the main body by a screen.

In many parish churches a parclose is on the north side, closing off the north transept for chapel or storage purposes, or both.

PARVIS: A chamber above a church porch used both for hermits and as libraries. The word derives from *paradise*.

PASCHA: The proper name for Passover. In Christian terms, "Christ is our Passover." *Easter* is the Anglo-Saxon word for "in the East"—as in dawn. Thus, precise usage would rule out "Easter Sunday" against "Easter Day." The Eastern church insists on the use of *Pascha*.

PASCHAL CANDLE: The large ceremonial candle lighted on Easter Even that burns during all services through Pentecost.

PASTORAL STAFF: See CROZIER.

PATEN: The plate used for the Host during communion (FIGS. 447–451). Medieval patens in the Western church were shell-shaped plates, while Victorian patens were more like saucers with an indentation to keep them in

FIG. 447

FIG. 448

FIG. 449

FIG. 450

FIG. 451

place on top of the chalice. The famous Queen Anne gifts to colonial churches, marked "Anna Regina," had standing patens that served as covers for the chalices when not in use. Note that great ecclesiastical institutions in France and England displayed their patens on the high altar at all grand services, even nonsacramental ones such as the Te Deum.

PATERESSA: The Greek Orthodox word for baculum, a "bishop's staff."

PATER NOSTER: The first words of the Lord's Prayer in Latin; *paters* when referred to in continual repetitions. (Thus, the rosary is made up of "Paters" and "Aves.")

PEAL: A chime of from three to eight bells, musically tuned to one another. The only melodies regarded as appropriate are the complicated permutations known as "changes."

PECTORAL CROSS: A ceremonial cross worn upon the breast, common to bishops since the latter portion of the seventeenth century. Formerly, such crosses were personal ornaments and, if worn by clergy in the Western church, they were worn under rather than over the vestment. In the Eastern church a bishop wears a *panagia,* a circular or oval icon generally surmounted by a crown—the Eastern form of mitre.

PEDIMENT: The classic equivalent of a gable.

PENDENTIVE: Curved triangular supports placed in the upper corners of a square so as to hold a circular or rectangular dome.

PEW: Anciently, a separated and completely protected enclosure (containing chairs and kneelers) built for the principal family of a parish. In the seventeenth century, the term came to be used for any bench for two or more people that did not have separations between the seats.

PHRYGIAN: A conical or domed hat worn anciently by bishops of the Western church. The domical form eventually became the mitre, and the conical form, the papal tiara. Both are still ultimately related to the classic *mitra.*

PIER: Any form of vertical supporting mass that is not a column.

PINNACLE: Technically, the conelike terminus of a mass of stone placed in a position where additional weight is needed. In nontechnical terms, the word is often used to describe the pointed tops of Gothic decorations.

PISCINA: A sink in which the drain goes directly to the earth rather than through the regular sewer system. Located in the wall on either side of an altar.

PITCH: The angle of a roof's inclination toward the level.

PLAINCHANT or PLAINSONG: The fixed introductions, reciting notes, and endings used for the nonmetrical singing of psalms, hymns, and canticles.

The musical reforms inspired by St. Gregory have given these later constructions the popular name "Gregorian."

PLANETA: A rich, fifth-century form of the paenula.

PLINTH: A freestanding support or, technically, the lower square member beneath the bottom of a column.

PONTIFICAL: Having to do with any bishop in terms of his order rather than in terms of his authority or jurisdiction. Thus, a "pontifical sedile" is a seat that may be used by any bishop, as contrasted with a cathedra, a seat that may be used only by the bishop of the diocese. "Pontifical" is also the name given an ordinal of the medieval church.

POTTERS' FIELD: A piece of ground outside the city of Jerusalem that the chief priests bought with the thirty pieces of silver returned to them by Judas. It became the cemetery for the poor and the homeless. In theory, the clay of the field had at one time been used by potters; hence the title, now a common one in many big cities.

PREBENDARY: Anciently, a cleric receiving a stipend (prebend) from a cathedral or collegiate church. The title is still in use, but the only obligation or stipend seems to be a fixed opportunity to preach. St. Paul's Cathedral in London, for example, gives its preacher at the main service on Sunday a small check and a bottle of sherry from the Lord Mayor of London.

PRECES: The antiphonal petitions following the Creed at morning prayer and evening prayer.

PREDELLA: See FOOT-PACE.

PRESBYTERY: Anciently, the semicircular bank of seats behind the freestanding high altar. The bishop's cathedra (chair or throne) was in the center of this bank. Now the word is often applied to a space for seating that is provided between the choir and the altar.

PRESIDENT: The liturgical officer presiding over the Eucharist.

PRIE-DIEU: See DESK (kneeling).

PROCESSIONAL CROSS: Anciently, the hand cross carried in procession to the altar for use there. This was the only cross used ceremonially in the early Church. From medieval times onward, it meant any cross on a staff of sufficient length to insure its visibility when carried at the head of a procession.

PROPER PREFACE: The liturgical text inserted in the ordinary preface to state the particular reason for the Church's song of praise on a particular day.

PROPERS: The collect, epistle, and gospel appointed for a particular day or occasion.

PROTHESIS: A small chapel to the side of the high altar that is used for the preparation of the eucharistic elements. This is of prime importance in the Russian Orthodox and Sarum rites.

PULPIT: A raised platform for public speaking. Anciently, a preacher sat rather than stood; hence the phrase *ex cathedra* and the French title for a pulpit, *chaire,* a corruption of *cathedra.* The seventeenth and eighteenth centuries saw the invention of the "three-decker," the popular name for a single structure combining, at different levels, a clerk's desk, a lectern, and a pulpit. It was characteristic of Georgian churches and was, despite its unpopularity with nineteenth-century Gothicists, one of the best-devised methods ever conceived for the proper placement of the lay readers and clergy involved in conducting the divine service. Pulpits generally had sounding boards above them. These were needed for acoustic reasons, as was the added height of the three-decker that enabled the preacher to address the people seated in the galleries.

PURIFICATOR: A small folded napkin used in the ceremonial cleaning of the chalice or paten.

PYX: Any covered vessel in which the consecrated elements are kept.

QUATREFOIL: Technically, in architecture, a circle divided into four equal leaves.

RABAT: A dickie or a waistcoat designed to replace the upper portion of a cassock when street dress is worn.

RECTOR: In the United States, the priest instituted as chief minister in an independent parish. In England, the term generally means the one controlling the appointment to such a position.

RED LETTER DAYS: Those feasts for which special propers are provided. So named because they were listed in red in the calendar of the 1662 English Prayer Book.

REFECTORY: A collegiate or conventual dining hall.

REGISTER: A book in which information required by canon law is kept as a matter of permanent record, e.g., a marriage register.

RELIGIOUS: A man or woman bound by the vows of monastic life.

RELIQUARY: Any object—cross, chest, casket, or *ostensorium* (monstrance)—designed primarily to hold a relic. In the ancient Church, relics were regarded as reminders of heroic saints and only incidentally as objects of devotion.

RENAISSANCE: In architecture, the revised classical aspect of design characteristic of fifteenth- and sixteenth-century Europe. The arbitrarily fixed date for the ending of the Middle Ages is 1453, the year in which Constantinople fell to the Turks.

REPROACHES: The name for a singularly moving part of the Holy Week rites of the Western church. The liturgical text centers around the question, "O my people, what have I done to thee, or wherein have I wearied thee? Answer me."

REQUIEM: A celebration of the Holy Communion associated with prayer for the repose of the faithful departed.

REREDOS: A rear dossal behind an altar, invariably made of wood, stone, or metal since the twelfth century.

RETABLE: A shelf between the altar and the wall, which is designed to support the reredos.

RIB: A projecting linear support of a roof or a vault.

RIDDEL POSTS: The vertical posts that support the bars from which the dossal and riddels are suspended.

RIDDELS: The side curtains of an English-style altar, properly always at right angles to the dossal.

RIDGE: The uppermost edge of a roof.

ROCHET: A surplice with alb sleeves. Until the seventeenth century the cassock sleeves were turned back over the sleeves of the rochet, so the visible terminus of the sleeve was the black or scarlet of the cassock. After this, the edge (either hem or ruffle) of the shirt-sleeve was permitted to show at the wrist. It is from this latter practice that the "Bishop's sleeves with Bands and

Ham-frills" so popular in the eighteenth and nineteenth centuries came to be regarded as essential to the rochet. Rochets are characteristic of the Episcopal habit, but are by no means exclusive to it. Servers often wear them plain, winged, or sleeveless.

ROCOCO: Renaissance architecture gone exuberant, fanciful, and undisciplined. Though it can be imaginative and exciting, it often seeks effect at the cost of structural integrity.

ROOD: The figures of Christ crucified, the Blessed Virgin, and St. John the Evangelist. Their placement between the nave and the chancel accounts for such phrases as rood screen, rood beam, hanging rood, and rood loft.

ROSARY: In the West, five decades of beads separated by single beads. At the end of the string, there are five more beads and a crucifix. In the Eastern church there is no mathematical division of beads, and the culmination is a plain cross, ordinarily with a tassel suspended from it. The Eastern monastic rosary is ordinarily completely made out of yarn. The Western rosary is a kinesthetic association with the Ave Maria. The Eastern Orthodox emphasis is upon the Jesus Prayer.

ROSE WINDOW: A circular window, the mullions of which form petal-like openings.

RUBRIC: Originally a ceremonial direction printed in red; now, any ritual or ceremonial direction.

SABBATH: Technically, the seventh day of the week. The Orthodox Jewish rules for observing the Sabbath are strict, being positive as far as religion goes and unbendingly negative as far as any work is concerned. The Christians took as their holy day the first day of the week, Sunday, but the Jewish background still dictated an observance of the Sabbath. Ultimately, the Sabbath restrictions were moved to Sunday and, even from ancient times, were astonishingly severe. The Enactments of Ine in 688 absolutely forbade any work on Sunday—considered the Sabbath. If a nobleman ordered a slave to work on Sunday, the slave was freed and the nobleman had to pay a thirty-shilling fine. If a slave worked of his own volition, he was flogged or fined. If a freeman worked on Sunday (the Sabbath), he either lost his freedom or was fined sixty shillings. If a priest broke the rule, the punishment was doubled. The Puritans were not inventing anything new with their rigid Sabbatarian views.

SACERDOTAL: Anything basically concerned with necessary priestly equipment or priestly obligation.

SACRAMENT HOUSE: A cabinet for the reserved Sacrament, attached to a wall or standing on a column (contrasted with an *aumbrey*, a cabinet *in* a wall).

SACRED VESSELS: Chalice, paten, ciborium, and flagon.

SACRIST: One responsible for the oversight of services and ecclesiastical property. *Sacristans* are under his direction.

SACRISTY: Technically, a room or area set apart for the immediate preparations for a religious service.

SANCTUARY: The altar area, whether enclosed or not. The word has also been used for centuries in a different sense. *Sanctuary,* from the time of a West Saxon law dated 693, meant "refuge in a church building or some special area thereof." The person fleeing justice could spend up to forty days within the safety of the church building, free from any persecution, during which time he was expected to make compensation and thus "compound" for his offense. Failing this, he had to abjure and quit the realm. As a matter of archaeological interest, the great bronze door knocker at Durham Cathedral was installed for the use of a person seeking sanctuary. In some churches a particular seat—a *fridstol,* the "chair of peace"—was the symbol of safety. The Hexham and Beverly churches still have such chairs.

SANCTUARY LAMP: Any lamp hanging in a sanctuary. (The presence of the reserved Sacrament is technically indicated by a colorless clear crystal or glass lamp.)

SANCTUS: The angelic hymn of praise recorded in Isaiah 6, together with an ancient response. It constituted part of the ancient synagogue service. One popular translation is "Holy, Holy, Holy, Lord God of Hosts . . ."

SANDALS: The cloth or leather slippers worn over the buskins by fully vested medieval bishops.

SANHEDRIN: The ancient governing council of Judaism—prior to Rome's destruction of the Jewish state.

SARUM: Having to do with the Diocese of Salisbury in England. Used chiefly in reference to characteristics of that diocese's ancient liturgical and ceremonial customs.

SCAPULA: A free-hanging panel of cloth that hangs down both the front and the back. It is in use by many religious orders and also has of late become popular as augmentation for the vestments of acolytes and choristers.

SCARF: The more accurate term for a *tippet*, a broad, black scarf worn over the hood and surplice and over gowns by doctors of divinity, dignitaries, and bishops' chaplains. (Full academic dress for one in holy orders is cassock, cincture, gown, bands, hood, and scarf.) It is made of silk for bachelors of divinity, masters, and doctors, and of "stuff" for all others.

SCREEN: A division between the *quire* and the nave. Medieval and Jacobean screens were elaborately carved structures of wood or stone. From the Latin word for screen, *cancellus,* the separated area came ultimately to be known as the *chancel.* See ICONOSTASIS.

SCRIPTORIUM: The space set aside for the creation of manuscripts.

SEDILIA: A fixed grouping of seats on the epistle side of the sanctuary. These seats are reserved for use by the celebrant, gospeller, and epistoler (from their function as the "sacred ministers"). See PONTIFICAL.

SEE: The locale from which a bishop exercises jurisdiction; hence, the place where his *cathedra* is put.

SENTENCES: The scriptural quotations provided for use at the beginning of morning prayer and evening prayer. These sentences were first introduced as part of the penitential structure in the Prayer Book of 1552. They have now changed their character completely, since the penitential beginning is required only at morning prayer on fast days and days of abstinence, and even then only on days when neither the litany nor the Holy Communion is to follow.

SEQUENCE: A hymn sung during the moving of the gospel book. (Anciently, this was sung after the *gradual* on great holy days.)

SERVER: One who assists the clergy ceremonially in the course of a religious service.

SEXTON: A word derived from *sacristan,* now used to describe any layman whose full-time occupation is the care of a church building, particularly with reference to its readiness for services.

SHAFT: The vertical, circular part of a column that rests on the base and supports the capital.

SPAN: The width of open space between supports.

SPANDREL: The triangular area bounded by a vertical, upright support, a horizontal beam, and the curve of half of a supporting arch.

SPIRE: The pointed end of the protecting roof built on top of a tower.

SQUARE CAP: A stiff, square cap, flat on the top. It is made out of velvet for bishops and doctors, out of silk for masters and doctors of divinity, and out of "stuff" for all others. Bishops wear purple or black; all others wear black.

SQUINCH: A structure on the corner of a square upright—which, when applied to all four corners, reduces the square to an octagon, making it possible to cover the area with a dome.

STALL: A fixed seat, appointed for use by a particular official or functionary.

STATION DAYS: A fixed feast on which the bishop of Rome celebrated in a particular church or basilica of his city. Station days have left a strong mark on the propers for certain saints' days.

STATIONS: A series of fourteen pictorial reminders of some sequence of events in the life of Christ, so arranged as to enable people to perform a complete pilgrimage within the confines of a parish church. Hence, "stations of the cross."

STEEPLE: A tower and a spire, considered as one unit.

STIGMATA: A plural of the word *stigma,* indicating marks of tragic association visible on the bodies of such mystic saints as St. Francis. They reproduce the wounds on the body of Christ.

STOCK: When the word is used alone, it means a container for carrying blessed oil.

STOLE: Originally, a very large towel, preeminently the badge of a servant. Until the fourth century, its use by the clergy was confined to deacons (over the left shoulder), and, after that, by the higher orders. The ancient words for it are *sudarium* or *orarium.* In the ninth century the Latin word *stola* was applied to it (just how the ancient Greek word *stole,* meaning a "long robe," came to be applied to anything folded down to five or six inches in width is still a mystery). An increasing number of scholars identify it with the "prayer shawl" of Jewish practice.

STONES: Joshua set up twelve stones of witness, and in like manner, the new Joshua, Jesus, chose the Twelve Apostles as his stones of witness. Stones are, of course, the symbol of St. Stephen's death and of St. Jerome's penitential habit of beating his breast with a stone.

STOUP: A bracket holding a bowl for holy water (FIG. 452). Originally placed at the principal entrance to a church (the narthex) and then, ultimately, at all entrances.

FIG. 452

SUBDEACON: The fourth in the minor orders of the medieval Church (still so in the Roman Catholic church). In the Anglican communion many of the specific duties of a subdeacon were carried on by the *clerk*—a title and office popular in the Church from the seventeenth to the nineteenth century (the official, legal designation of a priest of the Church of England is still "clerk in holy orders"). Much that the clerk did is now done by a lay reader. The term *subdeacon* is often used interchangeably with the term *epistoler*. The word *clergy* is derived from the plural of *clerk—clerici*.

SUFFRAGAN: A bishop who stands in a position of assistance to a superior. Thus, any English diocesan bishop is a suffragan to the archbishop of his province. Assistants to diocesan bishops in England are known as bishops suffragan; in the United States, they are termed suffragan bishops.

SUPER-FRONTAL: The upper apron of a frontal, when attached as a separate piece.

SURPLICE: A wide-sleeved long vestment of white linen, now worn as part of the choir habit. Historically, it was worn only for warmth and had no ecclesiastical significance whatever. It is unknown in the Eastern church.

SURSUM CORDA: The technical name for the portion of the communion service that introduces the preface. "Lift up your hearts" is its translation into English.

SYNAGOGUE: An assembly of people. In usual terms in America it means the place where Jewish worship is held. In strict terms, however, it also describes the familiar Hebrew word *Knesset*.

SYNAXIS: The coming together of a group of people for the purposes of public worship—especially the Eucharist.

TABERNACLE or AUMBRY: A structure for housing the reserved Sacrament

FIG. 453

FIG. 454

(FIGS. 453 and 454). From the Renaissance until recently, such structures were practically miniature churches. The medieval Church and the English church have persisted in a fondness for hanging tabernacles, whether structured or in the form of a dove. It is to be noted that in cathedrals, the aumbry contains not only the reserved Sacrament but also the three oils used in anointing.

TAPESTRY: This word, derived ultimately from the French word *tapisserie*, described cloth in which designs or pictures had been woven. It should be noted that all the principal churches had tapestries arranged on the walls or wound around piers and columns, not for decoration but rather to keep the terrible cold of the stone from harming the people. Such cold was, and still is, the principal cause of Bell's Palsy.

TENEBRAE: This literally means "darkness," the technical name for a service made up of psalms and lessons used on the evenings of the Wednesdays before Easter, Maundy Thursday, and Good Friday. The service involves the gradual extinguishing of the candles on a *hearse* (*herse*) and ends in complete darkness as the last candle is removed from sight amid the crackling sounds reminiscent of an earthquake. Its obvious reference is to the snuffing out of the Light of the World.

TESTER: A cloth, wooden, or stone canopy over an altar or a pulpit.

THURIBLE: A *censer* (FIG. 455). In the East, the chains are short, since only one hand is used in the censing. In the Western church, the chains can be long, since if the left hand holds the top of the chains, the right hand will grasp the chains just slightly above the censer itself.

THURIFER: The server designated to carry the *thurible,* or censer.

TIARA: The triple-crowned *phrygian* used by the pope. The single crown dates from the beginning of the thirteenth century, the second crown from

FIG. 455

the end of that century, and the third crown from the second third of the fourteenth century.

TIPPET: See SCARF.

TONSURE: In ancient days, the shaving of some portion of the head as appropriate for a religious. In terms of ordination, it is to be noted that the size of the tonsure varied greatly from place to place: the portion of the head required only an area large enough to receive the anointing oil on the bare skin. In the Eastern church, the rules run rather in the other direction, and strict religious are expected to let their hair and beards grow.

TORCHES: Large candles fixed in sockets attached to the ends of wood or metal staffs for purposes of carrying in processions.

TRACERY: The ornamental, filigreelike pattern, which gives the appearance of piercing through solid masses of stone or wood. It was characteristic of Gothic architecture. In common with all other aspects of Gothic architecture, it was originally thought through in terms of lightening the weight of a particular mass.

TRANSEPT: A crosswise extension of a church building. Originally, transepts were added to provide more space on either side of the altar.

TREFOIL: Literally, "three leaves." See QUATREFOIL.

TRIFORIUM: The second arcade above the floor on either side of the nave of a church; the space between the tops of aisle vaults and the slope of the roof, hence the *triforium gallery.*

TRIPTYCH: A picture or icon with half-doors attached to its outer edges so that, when shut, the picture is completely covered. See DIPTYCH.

TRUMEAU: A freestanding pillar dividing the principal doorway.

TUNICLE: A shorter form of the *tunica talaris,* or *tunica alba* (see ALB) that came to be worn as an external garment by subdeacons and those in minor orders from about the sixth century. Since the ninth century, it has been scarcely distinguishable from the dalmatic. It is now often seen on epistolers and crucifers. In the Western rite, it is still worn by subdeacons.

TURRET: A small, hollow tower, generally designed to enclose a circular staircase.

TYMPANUM: The area immediately above one of the principal doors to a church. Technically, it is the triangular space (the upper sides being either

straight or curved) bounded by a pediment at the bottom and the slope of the roofs on the upper two sides.

ULTRAMONTANE: Literally, "beyond the mountains." Used by Romans to describe the people beyond the Alps, and used by the people beyond the Alps, particularly the French, to describe pro-papal sympathies.

UMBRELLA: The umbrella, or *ombrellino*, was a ceremonial covering originally designed to protect someone from the sun. Even in Egyptian times, it had become a symbol of royalty. It should be noted that the ordinary umbrella was not used against rain until the eighteenth century. It is still used in an imperial sense by the chief hierarchs of some Eastern churches as a symbol of basilican status (a metropolitan church with the dignity of a cathedral) and as a covering for a cross or relic in solemn procession. The colors are quite arbitrary: the basilican color, for example, is green.

UNCTION: The ministry of healing through anointing or laying on of hands by a priest.

UNDERCROFT: A completely finished-off space beneath a church or other ecclesiastical edifice. Technically, an undercroft is below ground level.

VAULT: An interior arched roof made of brick or stone.

VEIL: The Orthodox church uses three veils: one to cover the paten, one to cover the chalice, and a third that covers both. The Western church uses a chalice veil, a veil for the ciborium, a monstrance veil (which covers the monstrance or ostensorium when on the altar but not in use), and a humeral or offertory veil (the humeral veil is used when, apart from the liturgy, the Sacrament is in motion). A veil was used when the crucifix and the Host were carried to the Easter Sepulchre on Good Friday, and there are instances of the Host being placed in the breast of the corpus on the cross at this service. Latin rubrics require that the tabernacle be covered with a veil. Until fairly recently, a veil at the door of the tabernacle was regarded as sufficient. The offertory veil is used in the Sarum rite when the offertory gifts are brought to the altar.

VERGE: A staff ornamented at the top with some symbol appropriate to the dignity of the person before whom it is carried.

VERGER: One who carries a verge or ceremonial mace before a dignitary or a group of dignitaries in the course of the movements involved in a liturgical service.

VESTIBULE: An enclosed entranceway. Were the south transept of a building to have a narthex, it would technically be called a vestibule.

VESTMENTS: The clothing appropriate to any person performing a purely ecclesiastical function in the course of a religious service, hence, "choir vestments" or "eucharistic vestments." The altar is said to be "vested" when it is completely covered, because it is treated as a person. The term "vestment" in sixteenth- and seventeenth-century language means, in modern terms, all the vestments appropriate to a particular office. It is to be noted that vergers wear gowns, since their functions are not confined to ecclesiastical services.

VESTRY: Literally, "the place for vesting." The title "vestryman" seems to have been derived from the custom of having the vicar, the wardsmen, and the sidesmen meet in the vestry to conduct fiscal business.

VEXILLUM: A rectangle of white silk attached to the base of the crook on the pastoral staff, or immediately below the cross on the cross staff. Note: in a large number of instances, special cloths are provided to keep one from handling metal directly.

VIA CRUCIS: The Way of the Cross. In Jerusalem, it marks the path of Jesus going from Pilate's house to Calvary. In Latin countries, it is a devotion that English-speaking people know as the stations of the cross.

VICAR: One designated by a rector to take over the cure of souls in a particular place—in England, at a parish church; in America, at the ministry or chapel of a parish church, or at a mission of the diocese.

WAFER BREAD: Unleavened bread in the form of disks, commonly called hosts. A priest's host is simply a larger version of the same thing. Note: the early Church used leavened bread, ideally in a single loaf (the ordinary Greek word used for "loaf" is the same word used for "body").

WATCHING LOFT: The name for an elevated floor or gallery, whether used in a church or in some other large meeting place, such as a great hall of an ancient college. Technically, although probably not actually, the galleries in most chapels royal would be watching lofts.

YEW: This much-beloved tree provided boughs to decorate the church on Christmas, Easter, and Whitsuntide. See HOLLY.

ZUCCHETTO: The Italian name for a skullcap.

Bibliography

Addleshaw, G.W.O., and Frederick Etchells. *The Architectural Setting of Anglican Worship*. London: Faber and Faber, 1948.

Andrews, William. *Curious Church Gleanings*. The Hull Press, 1896.

————. *Old Church Lore*. The Hull Press, 1891.

Atwater, Donald. *The Avenal Dictionary of Saints*. New York: Avenal Books, 1981.

The Benedictine Monks of St. Augustine's Abbey, Ramsgate. *The Book of Saints*. New York: Macmillan, 1944.

Benson, George Willard. *The Cross: Its History and Symbolism*. Buffalo: privately printed, 1934.

Boutell's Heraldry, revised by C. W. Scott-Giles. London: Frederick Warne, 1950.

Bromley, John, and Heather Child. *The Armorial Bearings of the Guilds of London*. London: Frederick Warne, 1960.

Byfield, Barbara Ninde. *The Book of Weird*. Garden City, NY: Doubleday, 1973.

Cardinale, Hyginus Eugene. *Orders of Knighthood Awards and the Holy See*. Gerrards Cross, UK: Van Duren, 1983.

Christe, Yves, Tania Velmans, Hanna Losowska, and Roland Recht. *Art of the Christian World* A.D. *200–1500*. New York: Rizzoli, 1982.

Circlot, J. E. *A Dictionary of Symbols*. New York: Philosophical Library, 1962.

Clarke, W. K. Lowther, and Charles Harris. *Liturgy and Worship*. New York: Macmillan, 1932.

Collins, Arthur H. *Symbolism of Animals and Birds*. New York: McBride, Nast, 1913.

Dearmear, Percy. *The Parson's Handbook.* Milwaukee: The Young Churchman, 1902.

Dir, Patricia. *Church Furnishings: A Nadfas Guide.* London: Routledge and Kegan Paul, 1978.

Dorling, E. E. *Heraldry of the Church.* London: A. R. Mowbray, 1911.

Douglas, Mary. *Natural Symbols.* New York: Pantheon Books, 1982.

Eliot, Elizabeth Ann. *The Crowned Knot of Fire.* New York: Vintage Press, 1980.

Ferguson, George. *Signs and Symbols in Christian Art.* New York: Oxford University Press, 1954.

*Fox-Davies, A. C. *A Complete Guide to Heraldry,* revised by J. P. Brooke-Little. London: Thomas Nelson, 1969.

*Franklyn, Julian, *Shield and Crest.* London: Macgibbon and Kee, 1967.

Friar, Stephen, ed. *A New Dictionary of Heraldry.* Sherborne, UK: Alpha-books, 1987.

Friedmann, Herbert. *A Bestiary for St. Jerome.* Washington, DC: Smithsonian Institution Press, 1980.

Gauthier, Marie Madeleine. *Highways of the Faith.* New York: Tabard Press, 1986.

Gayre & Nigg Staff and Gayre, Robert. *Heraldic Standards and Other Ensigns.* Edinburgh: Oliver and Boyd, 1959.

Gutmann, Joseph. *Jewish Ceremonial Art.* Thomas Yoseloff, 1964.

*Heim, Bruno Bernard. *Heraldry in the Catholic Church.* Gerrards Cross, UK: Van Duren, 1978.

Heiniger, Ernst A. and Jean. *The Great Book of Jewels.* Lausanne: Edita, 1974.

Hieronymussen, Paul. *Orders, Medals, and Decorations of Britain and Europe in Color.* London: Blanford Press, 1979.

Hornung's Handbook of Designs and Devices. New York: Dover Publications: 1932.

*Innes, Sir Thomas, of Learney. *Scots Heraldry.* Edinburgh: Oliver and Boyd, 1934.

Johnstone, Pauline. *Byzantine Tradition in Church Embroidery.* London, Alec Tiranti, 1967.

Jung, Carl G. *The Integration of the Personality.* London: Routledge and Kegan Paul, 1940.

Laliberte, Norman, and Edward N. West. *The History of the Cross.* New York: Macmillan, 1960.

Lehner, Ernest. *Symbols, Signs, and Signets.* New York: Dover Publications, 1969.

Lesage, Robert. *Vestments and Church Furniture.* New York: Hawthorn Books, 1960.

Lindsey, David. *The Saints and Symbols of All Saints.* Fort Worth, TX: Anchor Press, 1985.

Macalister, R.A.S. *Ecclesiastical Vestments.* London: Elliot Stock, 1896.

Marriott, Wharton B. *Vestarium Christianum.* London: Rivingtons, 1868.

Mayo, Janet. *A History of Ecclesiastical Dress.* New York: Holmes and Meier, 1984.

Merton, Thomas. *Disputed Questions.* San Diego: Harcourt Brace Jovanovich, 1960.

*Metzig, William. *Heraldry for the Designer.* New York: Van Nostrand Reinhold, 1970.

Milburn, Robert. *Early Christian Art and Architecture.* Aldershot, UK: Scolar Press, 1988.

*Moncrieffe, Ian, and Don Pottinger. *Simple Heraldry Cheerfully Illustrated.* London: Thomas Nelson, 1953.

More, Paul Elmer, and Frank Leslie Cross. *Anglicanism.* London: S.P.C.K., 1951.

*Neubecker, Ottfried. *Heraldry: Sources, Symbols, and Meaning.* New York: McGraw-Hill, 1976.

Otto, Rudolph. *The Idea of the Holy.* London: Oxford University Press, 1957.

Post, W. Ellwood. *Saints, Signs, and Symbols.* Wilton, CT: Morehouse-Barlow, 1974.

Rothery, Guy Cadogan. *Concise Encyclopedia of Heraldry.* London: Bracken Books, 1985.

Scott-Giles, C. Wilfrid. *Civic Heraldry of England and Wales.* London: J. M. Dent and Sons, 1953.

Smith, Whitney. *Flags Through the Ages and Across the World.* New York: McGraw-Hill, 1975.

Stafford, Thomas Albert. *Christian Symbolism in the Evangelical Churches.* New York: Abindon-Cokesbury Press, 1942.

Twining, Louisa. *Symbols and Emblems of Early and Mediaeval Christian Art.* London: Longman, Brown, Green and Longmans, 1852.

Vaughan, Lucy, and Hayden Mackrille. *Church Embroidery and Church Vestments.* Chevy Chase, MD: Cathedral Studios, 1939.

von Volborth, Carl-Alexander. *The Art of Heraldry.* Poole, Dorset: Blanford, 1987.

———. *Heraldry: Customs, Rules and Styles.* Poole, Dorset: Blanford, 1981.

Webber, F. R. *Church Symbolism*. Cleveland: J. H. Jansen, 1938.

West, Edward N. *A Glossary of Architectural and Liturgical Terms*. Greenwich, CT: The Seabury Press, 1958.

Wise, Terence, and Guido Rosignoli. *Military Flags of the World 1618–1900*. New York: Arco Publishing, 1978.

*Books applicable to heraldry as noted on page 44.

Index